BASIC DRAWING
Made Amazingly Easy

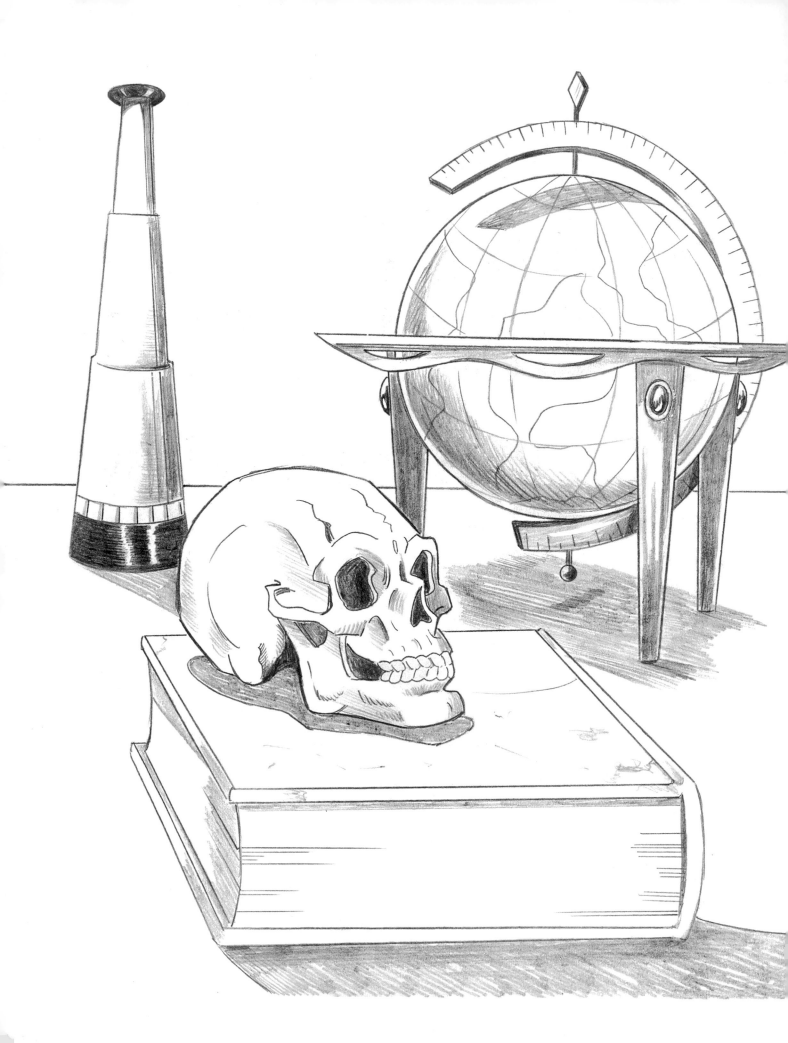

BASIC DRAWING

Made Amazingly Easy

Christopher Hart

Watson-Guptill Publications / New York

Library of Congress Cataloging-in-Publication Data

Hart, Christopher
 Basic drawing made amazingly easy / Christopher
Hart.—1st ed.
 p. cm.
 ISBN 978-0-8230-8276-6
 1. Drawing—Technique. I. Title.
 NC730.37 2011
 741.2—dc22

 2011012215

Printed in China
Cover design by Jess Morphew
Interior design by veést design
Front cover art by Christopher Hart
10 9 8 7 6 5 4 3 2 1
First Edition

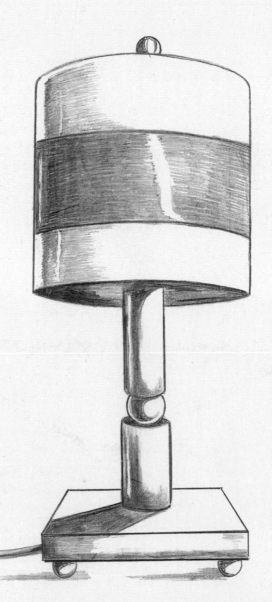

Dedicated to everyone who loves to draw;
also, to my old classmate
and animation buddy, Michael Horowitz

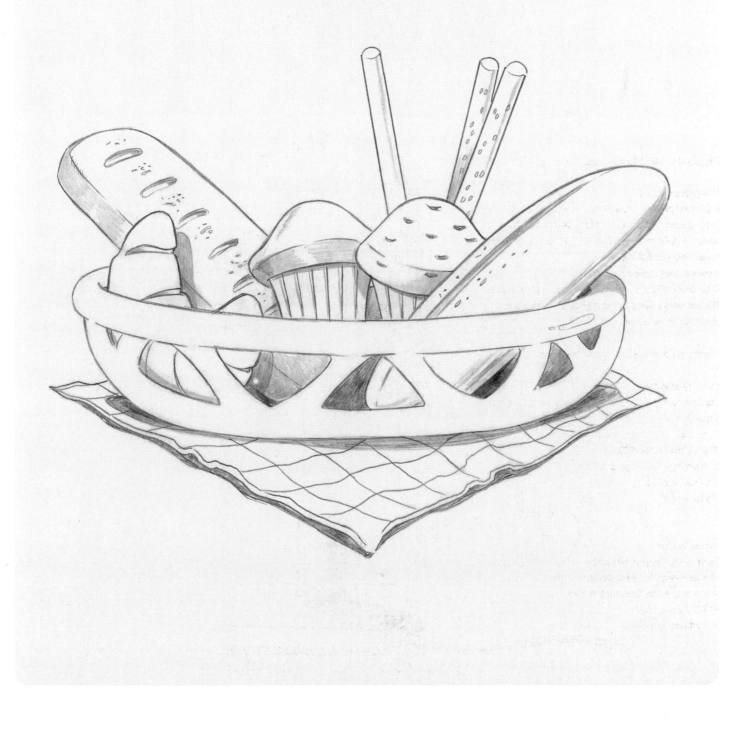

Contents

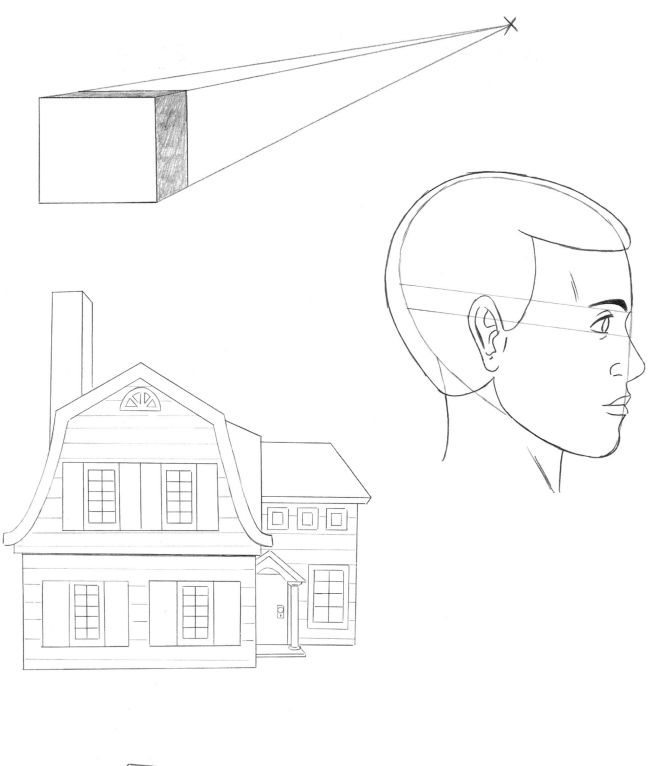

Introduction

Drawing is a fun and satisfying way to express your creativity, but learning to draw can be intimidating. Naturally, a beginning artist needs a solid foundation in artistic principles, but why can't those principles be clearly explained and illustrated?

Here is a complete drawing book for the beginning artist that focuses on getting you drawing right away, while giving you all the tools you need to build a solid foundation in art. In working through this book, you will learn how to "see" like an artist, in terms of form, line, and shadow. Each chapter gradually builds upon earlier lessons so that the experience of learning to draw is never too challenging. Confidence will replace your earlier doubt as you learn techniques that work, such as how to combine basic geometric and organic shapes to create almost anything, how to add depth and shading to your drawing, and how to handle composition, form, and perspective. Finally, you'll learn to draw the human body as a graceful and expressive figure, perhaps the most fulfilling accomplishment for the beginning artist.

Before reading this book, you may have shied away from, or perhaps never even considered, drawing certain subjects; however, I hope that as you go through these chapters you discover something wonderful—that in addition to improving technically, you're also becoming more creative. How is that possible? Good technique gives you the freedom to draw whatever is in your imagination. It gives you the tools to create. Before, your creativity was limited by your access to good information about technique. But now, in effect, we're about to unleash your creative spirit.

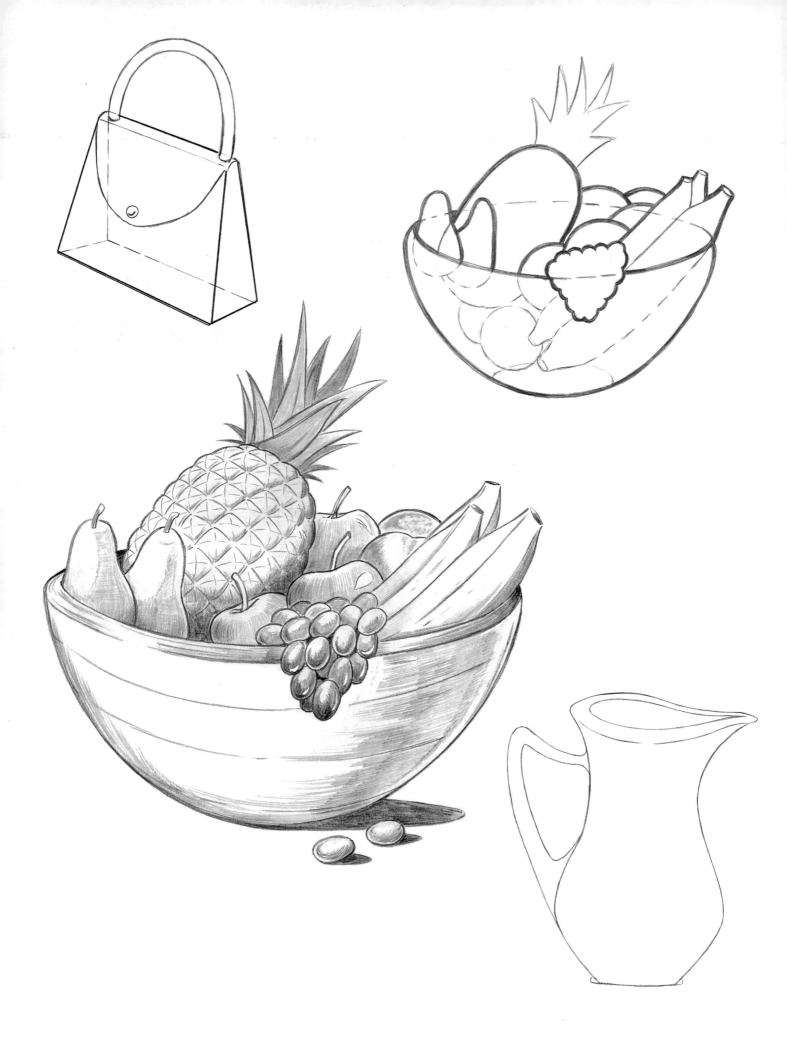

Drawing Materials and Basic Concepts

Before you start exploring your beginning drawing lessons, let's make sure you have all the supplies you're going to need. As an artist, it's important to have your materials at the ready—you don't want to be struck suddenly with inspiration, only to find that you're out of paper or lack the right drawing instrument.

Once you've got your supplies, you'll learn to see the hidden geometric shapes that make up just about any form you wish to draw. Seeing these basic shapes, and how they come together to build objects, is the first secret to easier, better drawing.

SUPPLIES

Unlike other forms of art, such as painting and sculpture, drawing is inexpensive and mess-free. Whether you're a beginner or a more experienced artist, we all use the same basic list of drawing supplies. You can get these at almost any art supply store, or you can order them online.

Artist's Pencils

Drawing pencils come in a variety of leads. The hardest ones make the lightest lines, and the softest ones make the darkest lines. The darkest pencils draw the smoothest, but they smudge like crazy and are all but impossible to erase. The lightest draw without any "give" and are so hard that they chisel into the paper, causing a groove that's visible even after you've erased it.

A pencil grade represents two things: the darkness of the lead and its softness. The softer the lead, the smoother the pencil is to draw with. B and HB grade pencils are excellent for sketching and drawing. The HB is a popular sketching pencil and right in the middle of the pack. Next are the F pencils, also excellent, though they may require a little extra pressure on the pencil to produce a dark, black tone. It's recommended to stay in the middle of the spectrum. I recommend picking up a few B, HB, and F pencils to see which you prefer.

Each pencil-grade notation is found at the top of the pencil. Erasers are absent from professional artist's pencils.

2H: Light tone. Good for initial sketching but will usually have to be drawn over in a darker tone once the drawing is completed. Also a good tone for light shading.

H: Same purpose as 2H, but slightly darker.

F: Creates a nice, dark line but is also capable of light shading. Not easy to create very dark tone with this grade, but it can be done. Can create black when pressed hard.

HB: Most commonly used grade. Creates a rich, dark line but can still be effectively erased, albeit with a few minor shadows.

B: Dark line. Gives a smooth sensation for drawing. A good choice when drawing images with long, flowing lines. It is harder to erase and may leave significant shadow lines. Creates solid black areas for shading, but smudging can be a problem.

Electric Pencil Sharpener

Why electric? With the exception of your pencil, you'll use your sharpener as much as or more than any other tool at your disposal. A hand-twist sharpener will end up driving you insane. I also don't recommend the light, battery-operated models. You'll want something heavy that sits on your desk and doesn't move every time you push a pencil into it.

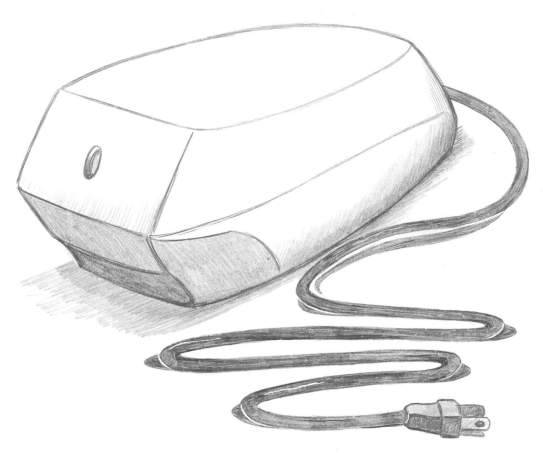

Erasers

My suggestion is that you buy pencil-tip erasers—dozens of them. You will use these for small corrections in your preliminary sketches. A bigger, handheld eraser is ideal for erasing larger sections.

Paper

As far as paper is concerned, go to a chain discount store and buy yourself a ream of 8.5 x 11–inch copy paper. It's what I use. It's easy to find and ridiculously inexpensive—usually 500 sheets, for a little over a penny a sheet.

Because the paper is lightweight, it becomes translucent when the light from a light box shines through it. This is helpful when you are polishing up rough sketches.

Art paper from art stores comes in a variety of measurements and thicknesses. The problem with thick, heavy paper is that you cannot see though it on a light box. Typically, it's also expensive, and you don't get many sheets per pad. I would also steer away from paper with tooth or grain, which is more frequently used for charcoal and pastel.

Sketchbooks

If you like drawing in sketchbooks, I suggest using spiral-bound ones. When you open them, they lie flat, which makes them a much easier surface for drawing.

Drafting Triangle

An inexpensive addition to your toolkit is a drafting triangle, also called a triangle ruler, which will allow you to draw straight lines. I prefer the triangle to a traditional ruler. It's less cumbersome and can be rotated quickly into place, whereas a ruler's length gets a bit unwieldy when drawing short, straight lines in tight spaces.

Light Box

You do not need to own a light box; it's something to add to your art "wish list." This is the only tool that could be considered a real expense—but even this is not outrageous. Light boxes run from $50 to over $100. It's essentially a box with lights inside that shine through a translucent plastic cover, which the artist draws on. Here's how it works:

An artist places a rough sketch on top of the light box and then places a clean sheet of paper on top of the rough sketch. Light shines through the transluscent plastic top of the light box, allowing the artist to clearly see the image of the rough sketch through the clean sheet of paper. The artist traces over the rough sketch onto the clean sheet of paper, being careful to omit the unwanted sketchy lines. The final result is a tight, clean, finished drawing.

If you do purchase a light box, make sure it's large enough so that it allows you a comfortable amount of space for drawing. You don't want to feel cramped into a tiny area with small dimensions.

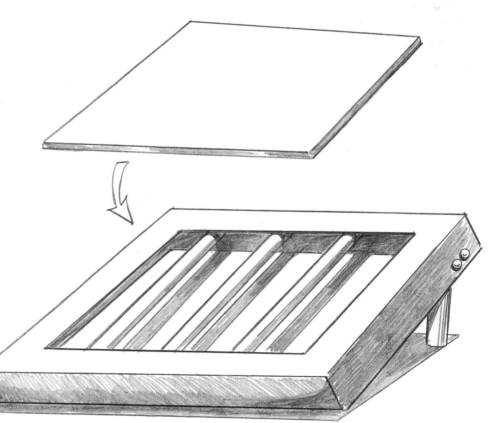

THE TONE WHEEL

It's not necessary to select a different pencil every time you want a slightly different tone. By varying the pressure you apply to the pencil, you can get a variety of grays. All of the shades presented on this tone wheel were made by the same HB pencil simply by pressing lighter or harder.

Artists use shading for several reasons: It softens an image's appearance, it makes an image look solid, and it adds variety.

This is your standard gray tone.

Dark gray is sometimes used instead of black; it's excellent for dark shadows.

Light gray, or "soft gray," is used to depict anything from skin to the sky. It's versatile but also subtle. Not a good choice if you need to make an impact.

True black is a great look, but it is also a total commitment. And once it's on paper, forget about erasing it.

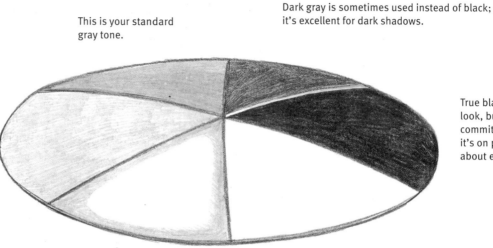

A slight gray tone around the edges softens an image. This is also used to give edges a rounded look.

White objects tend to look as if they were coming forward in the picture. Darker objects, on the other hand, tend to appear to be receding.

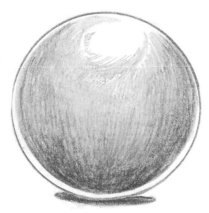

Here you can see a range of tones gradually progressing from white all the way to black.

TEXTURES

By offering a variety of textures, you highlight certain areas of the drawing, avoid visual monotony, and create a greater degree of realism.

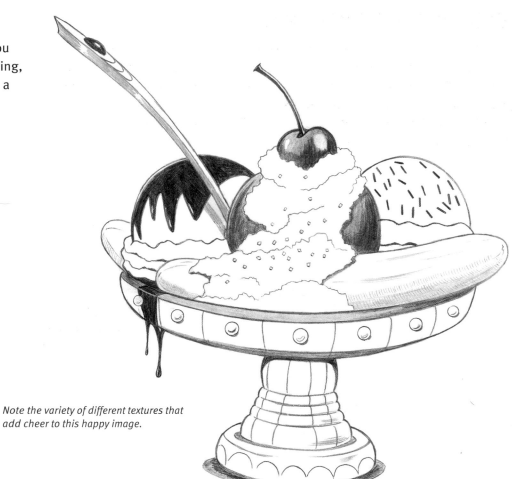

Note the variety of different textures that add cheer to this happy image.

BANANA

Small ridges, made with just a few light, short lines, add texture and bring a drawing to life.

EDGE OF SCOOP

Bumpy texture can be added with a few irregular lines drawn freehand.

SYRUP

A dark tone with noticeable shine creates a liquid effect.

CHOCOLATE SCOOP

Apply shading from light to dark to give an object more depth.

CHERRY

Shade the object, then erase a small shine section to create a glossy finish.

WHIPPED CREAM

A thin line with a light pencil can create a fluffy effect. This is a good technique for adding clouds to a background.

BASIC SHAPES

Often, at first glance, a subject will appear too complicated for a beginning artist. The truth is, almost all subjects are made up of shapes as basic as a square or an oval. Sometimes these foundations are called "hidden shapes," because the viewer doesn't even realize that the entire image is built upon them. Once you learn to recognize the basic shapes that are hidden in simple and more complex images, drawing becomes much, much easier. The key is to build onto those simple shapes in an orderly, step-by-step manner. Why is it easier to draw a subject if we first base it on a simple shape? Because basic shapes are easy to draw—therefore, even our complicated drawings will have simple foundations.

Oval

Circle

Pear

Bowl

Square

Rectangle

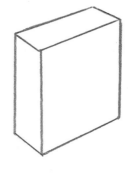

Cube/Box

Triangle

Cylinder

Cone

Basic Shapes in Everyday Objects

As you look at these familiar, inanimate objects, notice how the shapes constitute the foundations of each form. Using the hidden, basic shapes as your starting point is much easier than starting with the details.

Hidden shapes are not always readily apparent, hence "hidden." In fact, sometimes, you may have to invent a shape in order to give yourself a workable starting point for your drawing. In those cases, perhaps a lopsided oval will fit the subject matter better than a perfectly formed one, or a rounded square or a figure eight.

WOMAN'S HAT

This object is based on two ovals of differing sizes. Starting with ovals simplifies the artist's job and makes it easier to keep the hat symmetrical.

COFFEE MUG

This is a set of ovals within ovals, connected by vertical lines. If you keep the ovals evenly spaced between each other, you will end up with a coffee mug that looks accurate.

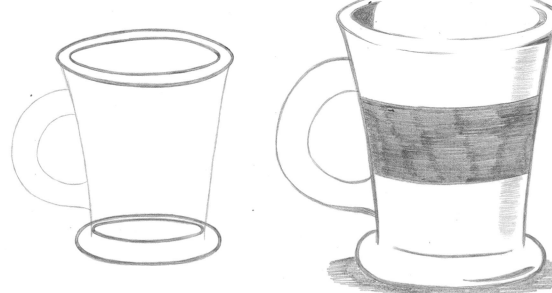

LOAF OF BREAD
The hidden shape in this loaf of bread is a rectangle.

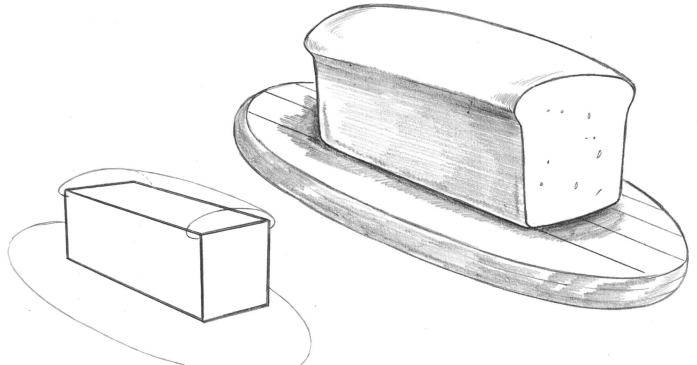

TRASH CAN
Getting the three-dimensionality of this object might seem difficult at first, but the trick is drawing the foundation rectangles at an angle. Then just add a triangle at the top, adjoined by a square within a square.

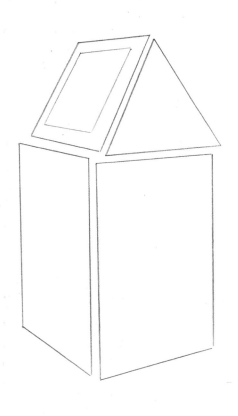

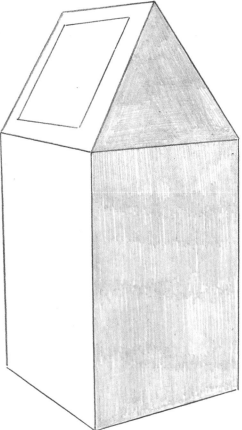

HAIR DRYER

This looks like a complicated object, but the foundation is still a basic shape. The circle is the nexus of the form, with a cylinder and elongated pear shape attached.

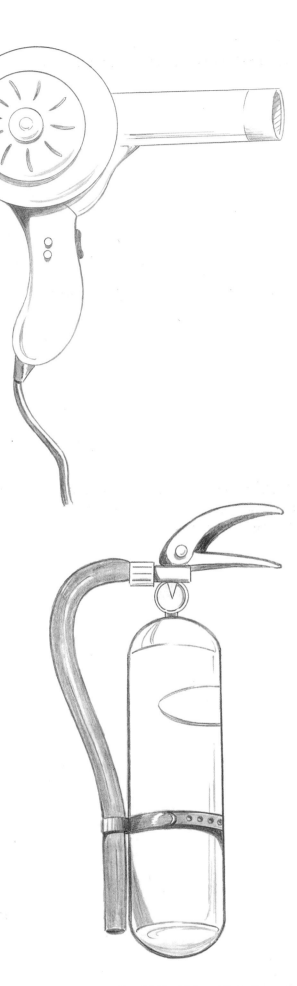

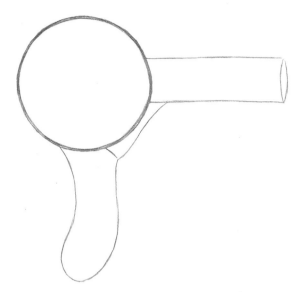

FIRE EXTINGUISHER

Starting with a simple cylinder, add a bowl shape to each end. Visualizing each component of a complex object as simple shapes will help you when you begin drawing.

ORGANIC SHAPES

Now that we've covered a few examples of drawing from basic shapes, you're ready to move on to subjects that require custom-made shapes for their foundations. Often what works best is a shape based on an approximation of the object itself, onto which more details are added.

Organic shapes are round and curved, instead of clear-cut geometric shapes. When drawing objects based on organic shapes, allow yourself the freedom to redraw and to use your eraser. Check your critical voice at the door. This is the time to learn, not to self-judge.

WOMAN'S SHOE

A woman's shoe typically features subtly curved lines juxtaposed against straight lines. A side view presents the easiest angle from which to begin. With the side view, your concern isn't to create the illusion of depth but instead to create a dynamic outline with flowing lines.

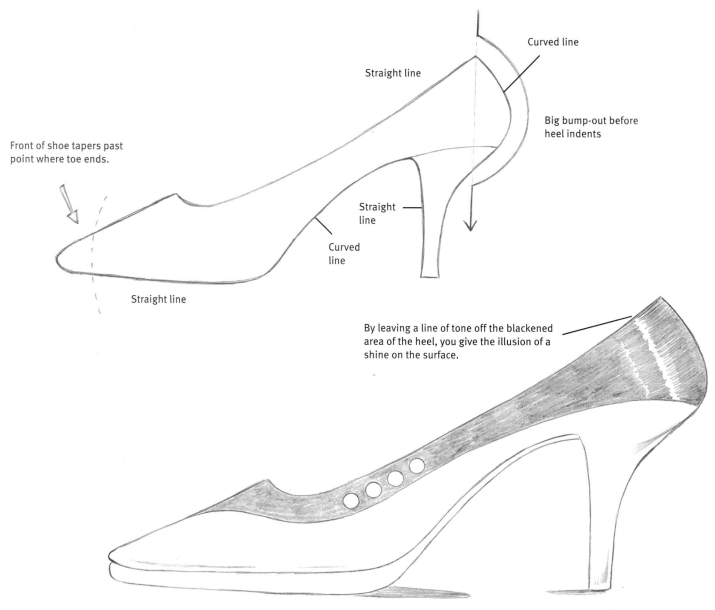

Curved line

Straight line

Big bump-out before heel indents

Front of shoe tapers past point where toe ends.

Straight line

Curved line

Straight line

Curved line

By leaving a line of tone off the blackened area of the heel, you give the illusion of a shine on the surface.

HAND-HELD CLUTCH

This organic shape is a rounded rectangle. The clutch is meant to be held in a woman's hand, so it must be thin and easy to carry. Save that stitched look for the last step. Texture, patterns, and accessories are usually drawn after the basic foundation is locked into place.

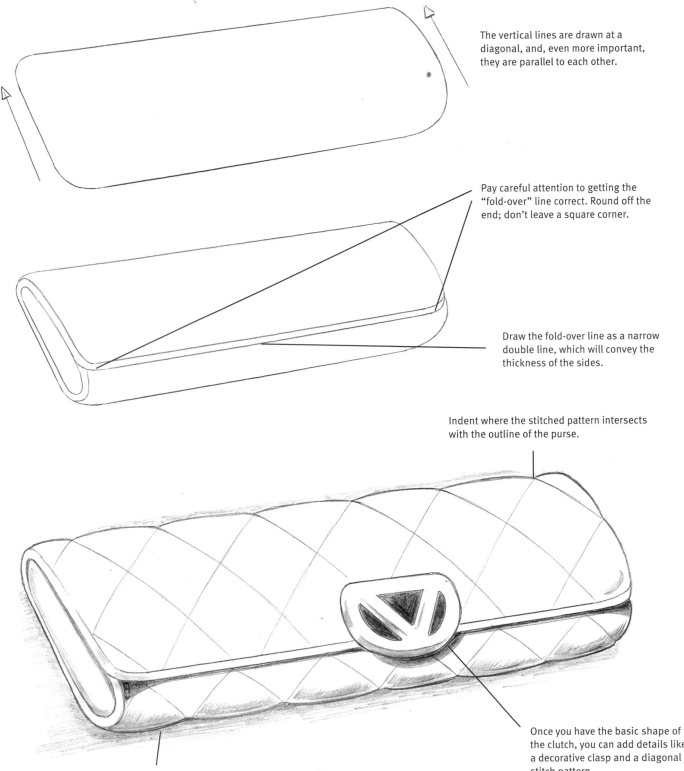

The vertical lines are drawn at a diagonal, and, even more important, they are parallel to each other.

Pay careful attention to getting the "fold-over" line correct. Round off the end; don't leave a square corner.

Draw the fold-over line as a narrow double line, which will convey the thickness of the sides.

Indent where the stitched pattern intersects with the outline of the purse.

Once you have the basic shape of the clutch, you can add details like a decorative clasp and a diagonal stitch pattern.

By shading the place where the purse touches the table, you give the purse the appearance of a solid form.

FASHIONABLE PURSE

Some shapes are iconic. An iconic shape is one that the viewer instantly recognizes as a particular object. Your goal is to establish the concept shape as early as possible, before adding in the details. This unique shape is quickly identified as a woman's purse, even without any details filled in.

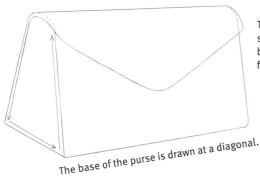

The cover flap extends slightly beyond the main body of the purse. Keep the flap rounded, not pointed.

The base of the purse is drawn at a diagonal.

Add thickness to the body of the purse by drawing double lines along the edges. Remember to reflect this thickness in the cover, as well.

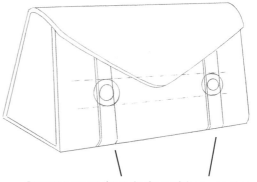

Draw two straps down the front of the purse. Be sure the straps are drawn parallel to the sides of the purse (the vertical lines on either end).

Draw the far handle so that it appears to run "through" the near one, rather than starting and stopping. It helps with placement and is how professional artists sketch.

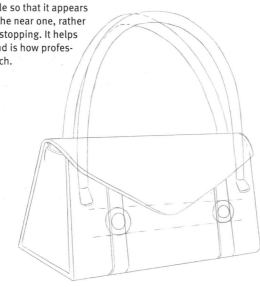

To add decorative buckles, you first need to add guidelines to make sure that they line up evenly. Draw two even sketch lines, parallel to the bottom horizontal line of the purse.

You've got your basic purse. Now comes the fun part. Add stripes, leopard spots, or whatever stylish accents you wish.

SYMMETRY

There's an easy way to guarantee symmetry when drawing simple, decorative containers, like vases and pitchers. Draw horizontal ovals, parallel to the bottom of the page. These ovals should be wide enough to make contact with the outline of the vase on both sides. Using this simple technique keeps both sides even and also helps you envision the depth and roundness of the object you're drawing. To practice this concept, you'll start by drawing a simple vase.

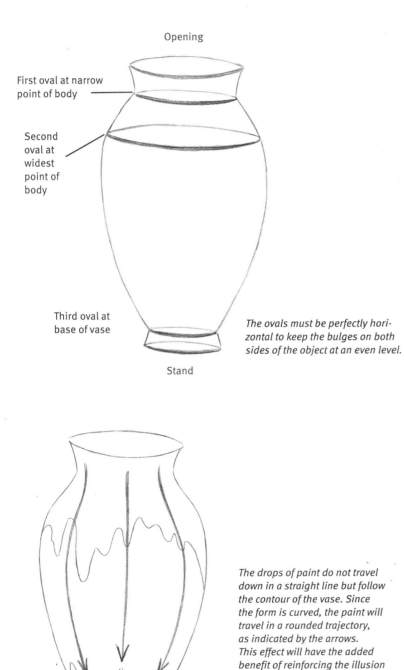

Opening

First oval at narrow point of body

Second oval at widest point of body

Third oval at base of vase

The ovals must be perfectly horizontal to keep the bulges on both sides of the object at an even level.

Stand

The drops of paint do not travel down in a straight line but follow the contour of the vase. Since the form is curved, the paint will travel in a rounded trajectory, as indicated by the arrows. This effect will have the added benefit of reinforcing the illusion of your drawing having three dimensions.

REVERSE CURVES

When curves travel in one direction, then curve again in the opposite direction, the result is sweeping, elegant lines. This technique is called *reverse curves*, and it is used to create many graceful subjects, from still life subjects to human figures.

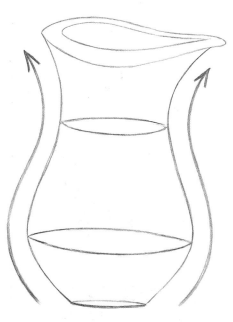

The outline of the pitcher shown here is based on two curving lines. Here, the reverse curves mirror each other, creating a symmetrical look.

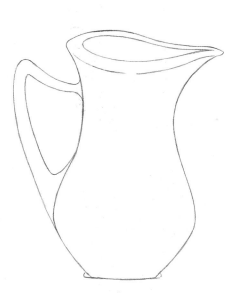

Gradually soften where the handle attaches to the body of the pitcher, rather than sticking it on abruptly. Note how the handle thickens as it descends.

PRACTICE: Symmetry and Reverse Curves

Utilizing the principles you've learned thus far, practice drawing a few different types of containers. You can re-create these examples exactly or use them as a springboard for your own designs.

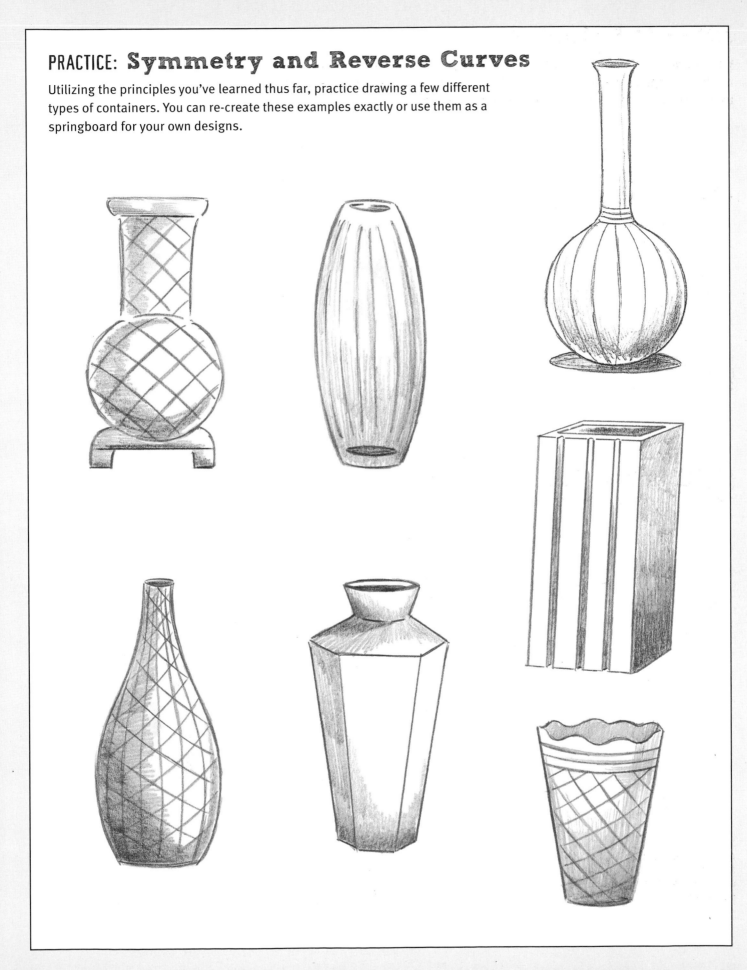

PERSPECTIVE

To draw objects with hard angles, such as tables, chairs, desks, houses—and even smaller objects such as books, frames, or jewelry boxes—you need to have a basic understanding of how perspective works. Otherwise, objects tend to look unconvincing and primitive. The reality is that perspective affects most things we draw. It's only a matter of degree. Even the human figure is affected by perspective. So you really can't avoid it. But once you see how perspective enhances your ability to draw, why would you want to?

Perspective on Round Objects

The ovals are still at work here to keep our drawing symmetrical—used as guidelines to create the top and bottom of the lampshade and the top and bottom of the base. However, perspective will now force us to alter the way we draw the ovals.

 The body of the lamp is based on a cone that's been chopped off on the top. The lampshade and the base are both fashioned after cones, too.

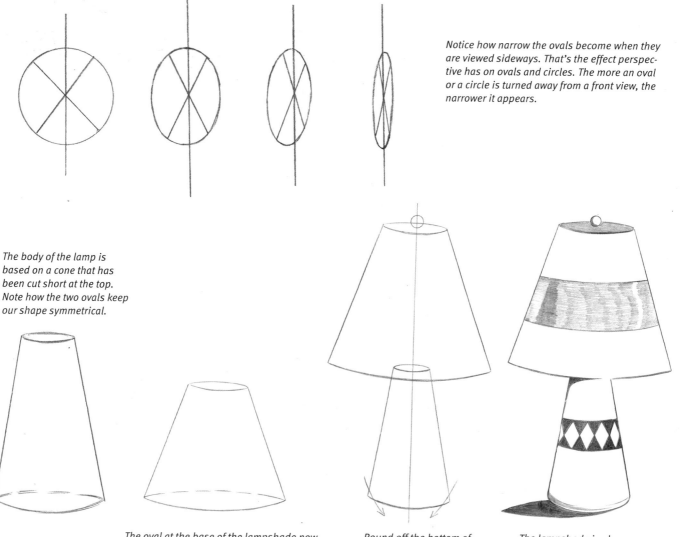

Notice how narrow the ovals become when they are viewed sideways. That's the effect perspective has on ovals and circles. The more an oval or a circle is turned away from a front view, the narrower it appears.

The body of the lamp is based on a cone that has been cut short at the top. Note how the two ovals keep our shape symmetrical.

The oval at the base of the lampshade now appears to be just a sliver, hardly circular at all. This is because we're viewing the oval from a side view, rather than from overhead.

Round off the bottom of the lamp stand to soften the look.

The lampshade is also cone shaped, but much wider than the lamp body.

One-Point Perspective

You may not know the term *one-point perspective*, but you'll recognize it once you see it. It makes sense on an intuitive level. One-point perspective is when an object, or an entire scene, faces the viewer in a front view. This is the easiest type of perspective to draw. We'll start here.

The Vanishing Point

The reason it's called *one-point perspective* is because everything converges to a single point on the picture, or *picture plane*, as it's called. This point where everything converges is referred to as the *vanishing point*. The vanishing point can be placed high or low on the page, but it must be in the middle, where the horizon occurs. You can move the horizon line, as well as vanishing point, up or down, but not side to side.

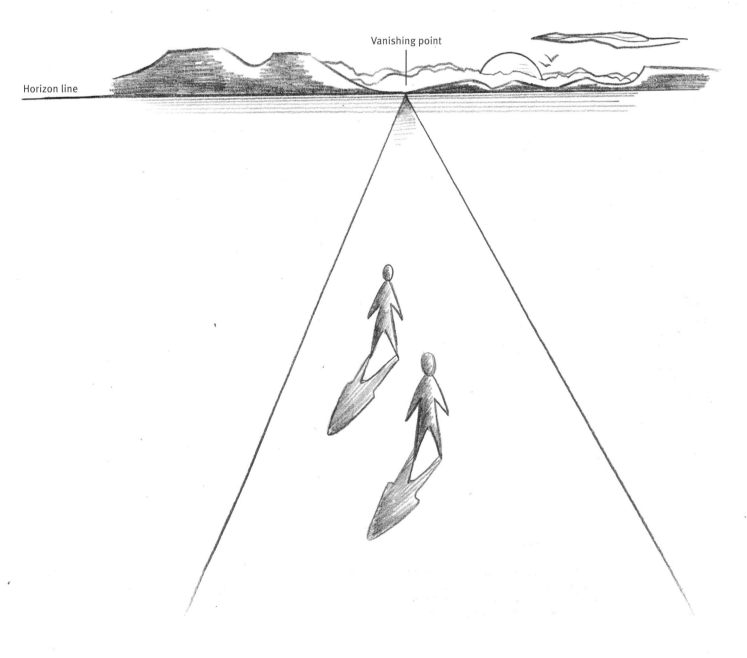

Vanishing point

Horizon line

PRACTICE: One-Point Perspective

You might be tempted to try drawing this couch by "eyeballing" it, hoping that it will come out right. Most likely, the final result wouldn't look three-dimensional. But by using the tools of perspective, even a basic drawing like this can take on a ne'

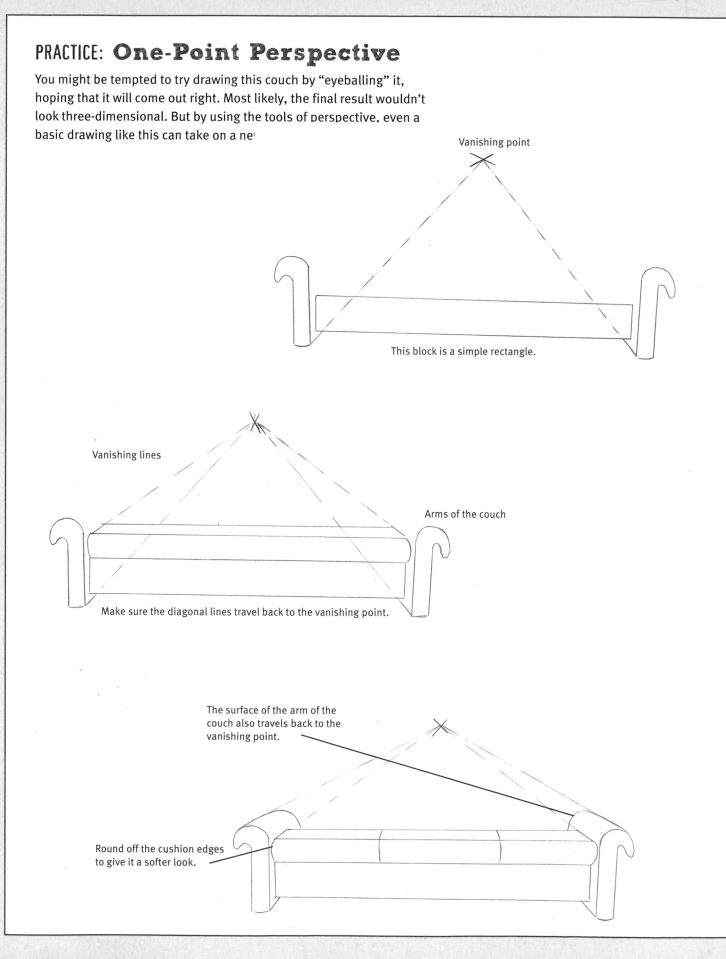

Vanishing point

This block is a simple rectangle.

Vanishing lines

Arms of the couch

Make sure the diagonal lines travel back to the vanishing point.

The surface of the arm of the couch also travels back to the vanishing point.

Round off the cushion edges to give it a softer look.

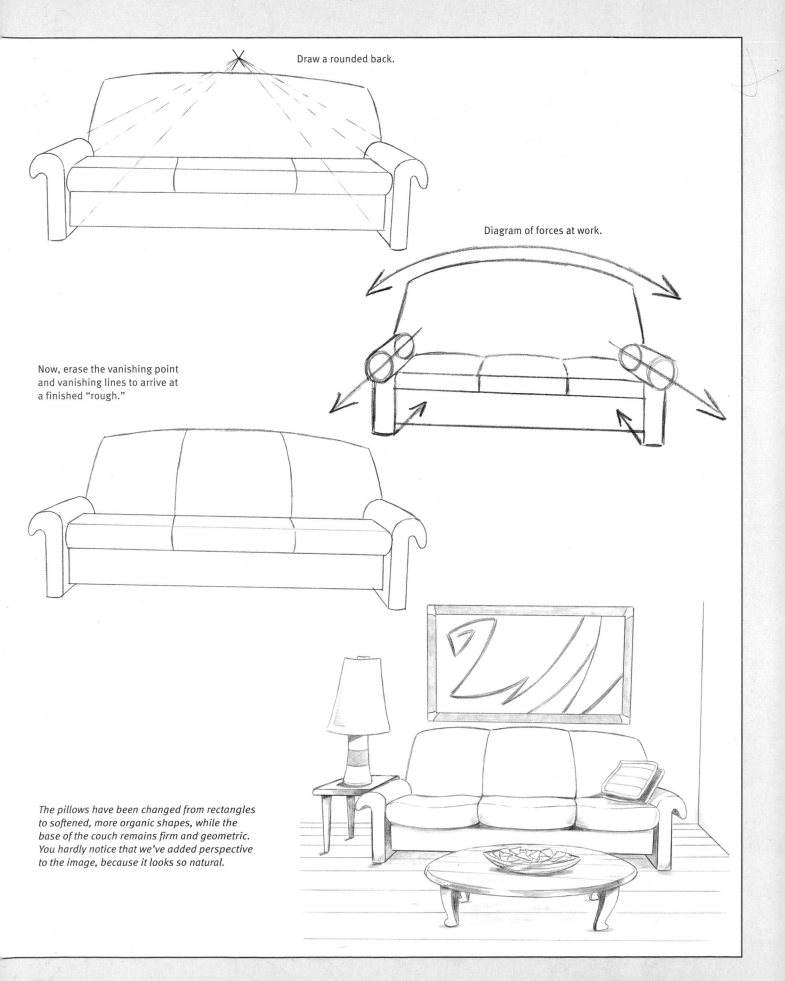

Draw a rounded back.

Diagram of forces at work.

Now, erase the vanishing point and vanishing lines to arrive at a finished "rough."

The pillows have been changed from rectangles to softened, more organic shapes, while the base of the couch remains firm and geometric. You hardly notice that we've added perspective to the image, because it looks so natural.

Two-Point Perspective

Two-point perspective is when an object is rotated so that a corner of the object is facing you. When this occurs, two vanishing points will appear instead of just one. This is the technique that separates the person who simply draws from the artist who knows how to draw. Two-point perspective looks complicated at first, but we'll break it down step by step, and soon you'll master it.

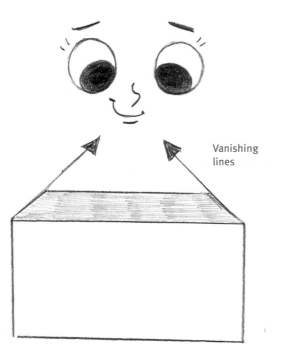

One-Point Perspective. Even though we are looking down at this block from an angle, the lines recede back straight along the middle of the picture plane—our clue that this drawing is in one-point perspective.

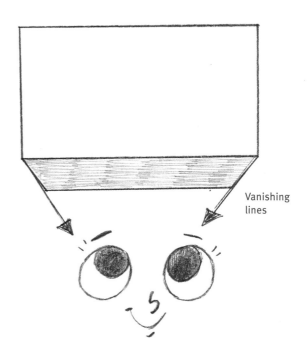

One-Point Perspective. Looking up at the block, the vanishing lines still recede toward the center of the picture plane.

Two-Point Perspective. The block is now turned so that a corner is facing front. As a result, the vanishing lines are traveling off in two different directions, neither of which is straight back down the picture plane. Turning the object at a two-point-perspective angle has also made an additional plane visible, which we have taken the opportunity to shade in a darkened tone. This enhances the three-dimensionality of the object. Remember this easy rule of thumb: Whenever you see a corner facing you, the object is affected by two-point perspective.

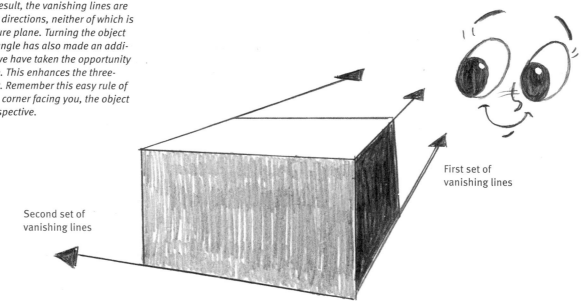

GETTING TWO-POINT PERSPECTIVE RIGHT

At this point, you may be wondering if you really need all those vanishing lines we've been talking about. Let's see what can happen when you don't let the principles of perspective guide you.

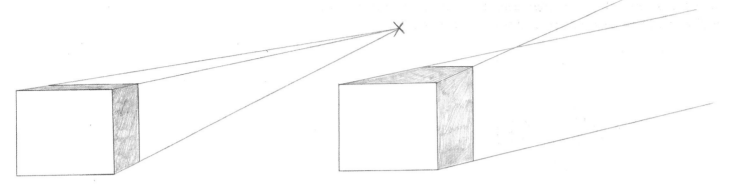

Correct Vanishing Lines. The vanishing lines converge to a single point, creating a cube that looks like a cube in real space.

Incorrect Vanishing Lines. Vanishing lines do not converge at a single point, and as a result, the cube doesn't look very cubelike.

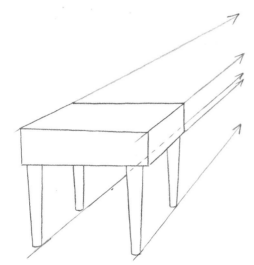

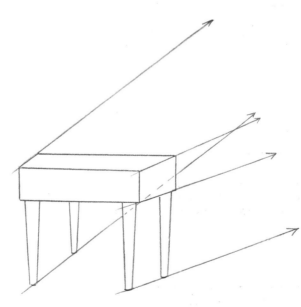

Correct Vanishing Lines. These converge toward a single vanishing point somewhere off to the right.

Incorrect Vanishing Lines. Note the odd shape of the drawer, which seems to actually grow larger as it recedes into the distance without vanishing points. The length of the legs is totally random.

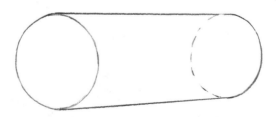

Correct Vanishing Lines. Two ovals for the openings.

Incorrect Vanishing Lines. Two circles for the openings.

PRACTICE: Two-Point Perspective

A great variety of common objects use a box (basic rectangle) as their foundation shape. Therefore, once you can draw a box in two-point perspective, you'll be well on your way to drawing many subjects that were previously difficult for you to master.

This line is called the horizon line. Like any sketched guideline, it's not a permanent part of the image. Its purpose is to serve as a reference for the artist.

This X marks the spot for the vanishing point on the left, called "vanishing point left."

This X marks the vanishing point on the right, called "vanishing point right."

This line represents the top left side of the box.

This line creates the other side of the box. Allow the lines to intersect. It doesn't matter how far the lines extend past the intersection point.

Starting at the point where the two lines intersect, draw a vertical line straight down. Stop at the horizon line.

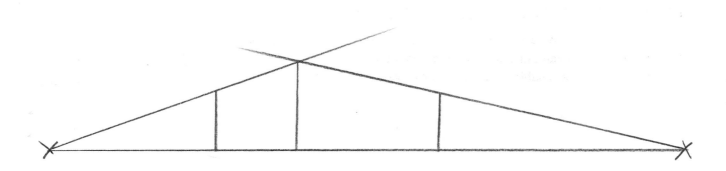

Add two more vertical lines to create the ends of the box. Where you place these lines depends on how wide you want the box to be. Too far apart, and the box would look weirdly long, too close together, and it would look too squat.

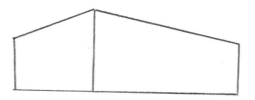

Erase the guidelines, including the horizon line, and this is what you're left with: a box in correct perspective.

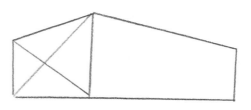

To take this practice one step further, we'll make the box into a sock drawer. Draw an X guideline to find the perspective middle. Draw an oval-shaped drawer knob at the point where the lines intersect.

With just a few more details added, the box has become a sock drawer—with one sock missing, naturally.

When Vanishing Points Are Too Close Together

This section could also be called When Good Vanishing Points Go Bad. Artists sometimes need to place the vanishing points so far apart that they are, in fact, off the page, where we can't see them. Yet, this placement may be correct. Still, some artists feel awkward about this, and therefore, mistakenly try to stuff both vanishing lines onto a single page. Failure to separate the vanishing points a comfortable distance apart will cause your image to suffer from distortion.

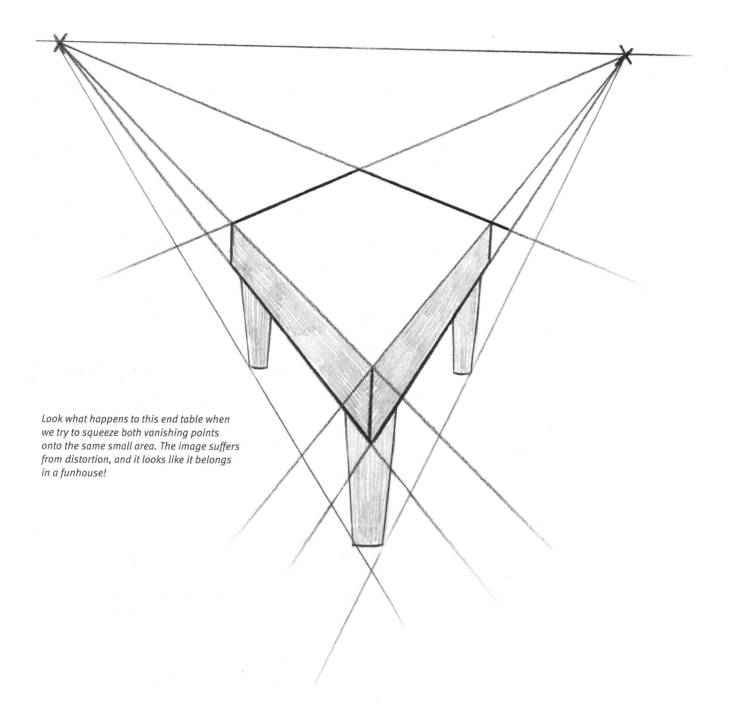

Look what happens to this end table when we try to squeeze both vanishing points onto the same small area. The image suffers from distortion, and it looks like it belongs in a funhouse!

PRACTICE: Drawing Below the Horizon Line

In the previous example, the line that indicated the bottom of the box and the horizon line were one and the same. But this isn't always the case. Often, we'll draw the bottom of a box or similar object so that it dips below the horizon line. This results in a slightly more exaggerated perspective. It also calls for an additional set of vanishing lines.

Top left line of box

Top right line of box

Vanishing point left

Horizon line

Vanishing point right

Add a vertical line that starts where the two diagonal lines intersect. Now continue that vertical line below the horizon line. The vertical line represents the overall width of the box. So decide how you want the box to be and draw the line to that length.

New vanishing line

New vanishing line

Now we're going to draw the bottom two lines of the box. These lines begin at the same vanishing points, left and right, crossing at the bottom tip of the vertical line.

Add two more vertical lines on either end to define the dimensions of the box.

Erase your guidelines, and you have a box in two-point perspective, where the bottom of the box falls below the horizon line. Note that by using this technique, the effects of perspective are more apparent.

Starting to Draw

Now that we've familiarized ourselves with an important variety of art techniques, we're going to apply some of what we've covered to drawing practical objects. For our first subject, let's begin with something that has aesthetic appeal; something with which we are familiar, something built on a solid foundation of shapes and two-point perspective. We'll start by drawing basic furniture—beds, chairs, and a standing secretary desk—and then move on to more detailed subjects, such as vehicles and houses. Finally, we'll put it all together to complete a classic subject—the still life.

FURNITURE

Most people draw chairs the same way they build them in their garage: They shave a little length off one leg, then they shave a little off another, then they go back to the first one, then back to the other one again, all the time hoping that, eventually, the legs will come out even. What they usually end up with is an eight-inch chair. We can be more effective than that by using vanishing lines, which will cause the chair legs to conform to the correct height.

Note: We'll refer to the vanishing point left as the VPL, and the vanishing point right as the VPR.

Easy Chair

An "easy chair" is an easy chair to draw. Because the shape lacks precision-straight lines, we can draw much of it freehand. We'll also simplify the perspective process, leaving out the horizon line (it's implied). One hint: Make sure to position the arms of the chair a comfortable distance apart from each other. Because of the flattened angle, it's easy to draw the arms a little too close together. But no one wants to sit in a supercramped easy chair.

This line goes toward vanishing point left (VPL), somewhere off the left side of the page.

The line goes toward vanishing point right (VPR), somewhere off the right side of the page.

Draw the middle chair leg first—at any length that feels right to you. Using this leg as your measuring point, draw two more vanishing lines underneath the first set—which are parallel to it. Now you've got two sets of vanishing lines. They'll serve as brackets, inside of which you'll draw the remaining two chair legs.

Because the chair is angled away from us and not facing front, the ends of the armrests are based on ovals, not circles.

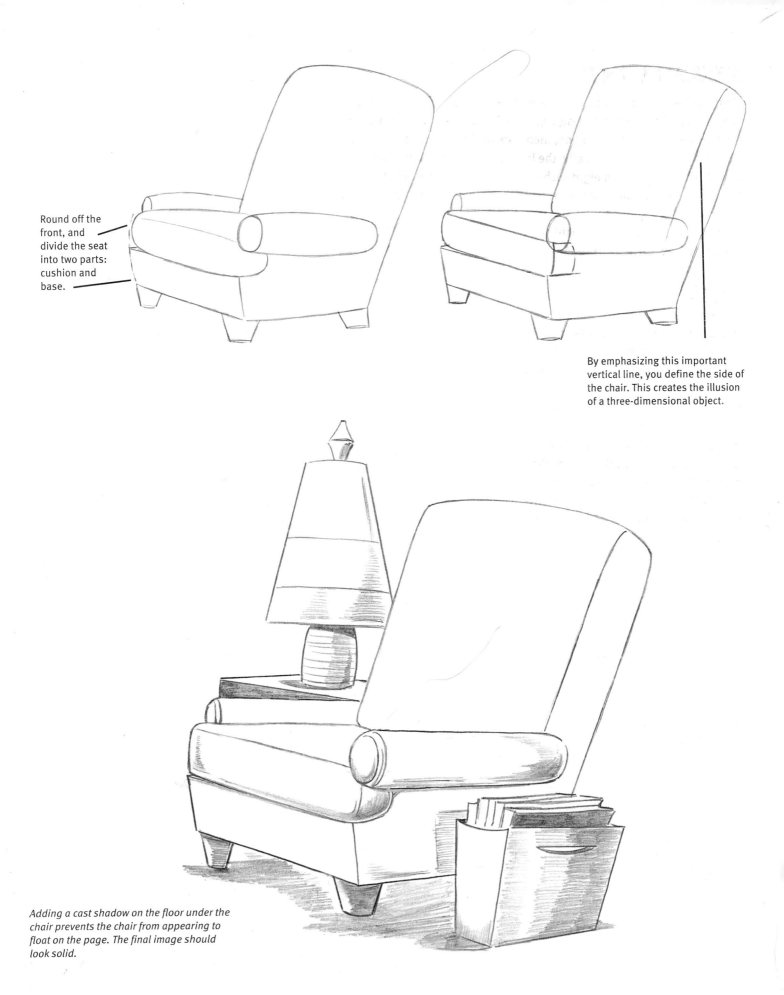

Round off the front, and divide the seat into two parts: cushion and base.

By emphasizing this important vertical line, you define the side of the chair. This creates the illusion of a three-dimensional object.

Adding a cast shadow on the floor under the chair prevents the chair from appearing to float on the page. The final image should look solid.

Dining Chair

Here is an armless dining room chair, drawn with a little flair. It's got four long leg posts to contend with, but does that make it harder to draw? The beginning artist may think so, but in reality, the size of the chair legs doesn't matter. We're only interested in placement at this point, not the correctness of the height.

Unfortunately, we can't extend vanishing points left and right from the chair seat, because, unlike the easy chair example, this chair seat is oval and there are no straight lines for the vanishing lines to follow into the distance. To solve this dilemma, we'll have to create a set of vanishing lines from scratch and impose them onto the chair legs.

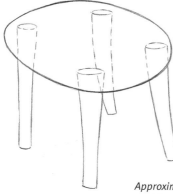

First, make an estimate where the four legs should attach to the seat.

Approximate the length and position of the chair legs. Be prepared to make necessary adjustments as your drawing progresses.

Next, draw two vanishing lines: one for the front row of chair legs and one for the rear row of chair legs. These vanishing lines converge at VPR, which occurs someplace off to the right. The bottoms of the chair legs rest on top of the vanishing lines. We can see that two of the chair legs are too long to fit, so we'll adjust them until they are the right length.

VPR

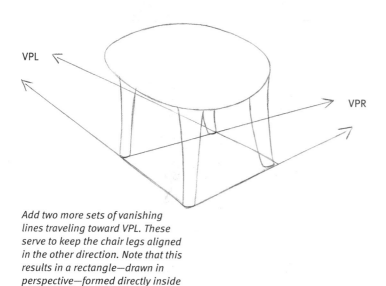

VPL

VPR

Add two more sets of vanishing lines traveling toward VPL. These serve to keep the chair legs aligned in the other direction. Note that this results in a rectangle—drawn in perspective—formed directly inside the four chair legs.

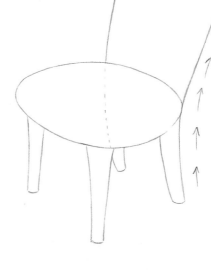

The chair back curves gradually.

The line of the rear chair leg continues upward, gradually becoming the back of the chair.

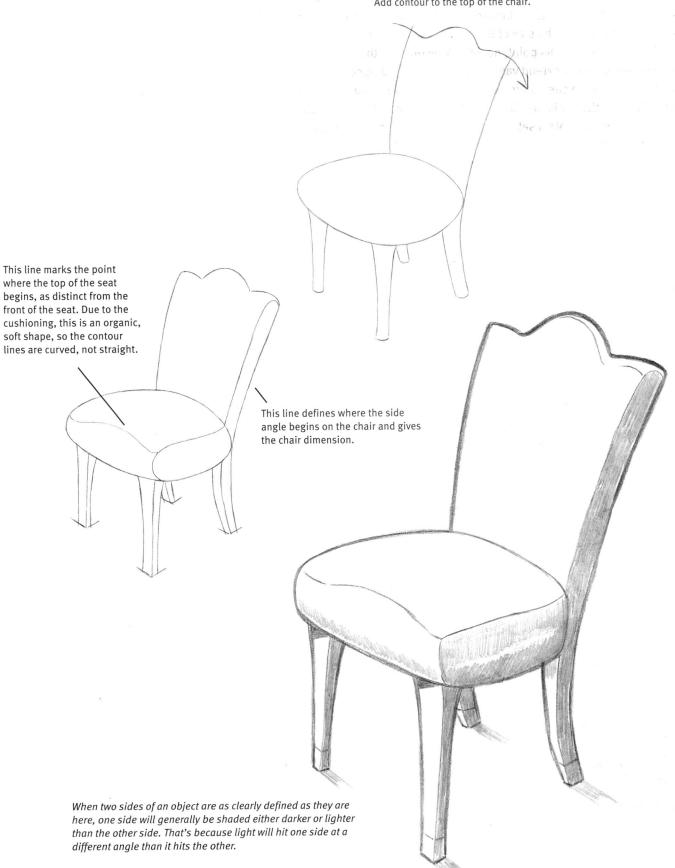

Add contour to the top of the chair.

This line marks the point where the top of the seat begins, as distinct from the front of the seat. Due to the cushioning, this is an organic, soft shape, so the contour lines are curved, not straight.

This line defines where the side angle begins on the chair and gives the chair dimension.

When two sides of an object are as clearly defined as they are here, one side will generally be shaded either darker or lighter than the other side. That's because light will hit one side at a different angle than it hits the other.

Modern Club Chair

This chair has a nice sweep to it, which is the essence of line flow. Line flow is the aesthetic use of a line that guides the viewer's eye along a winding path. In this case, the eye follows the line of the armrest around the chair without an abrupt shift in angle.

Notice that one corner of the chair (the nearest leg) is facing the viewer, so we know the chair is in two-point perspective.

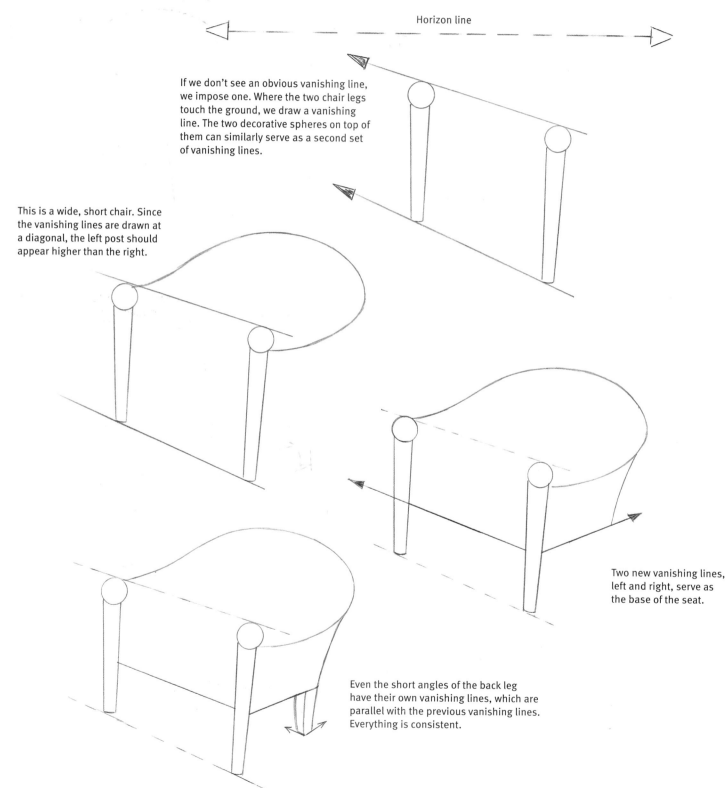

Horizon line

If we don't see an obvious vanishing line, we impose one. Where the two chair legs touch the ground, we draw a vanishing line. The two decorative spheres on top of them can similarly serve as a second set of vanishing lines.

This is a wide, short chair. Since the vanishing lines are drawn at a diagonal, the left post should appear higher than the right.

Two new vanishing lines, left and right, serve as the base of the seat.

Even the short angles of the back leg have their own vanishing lines, which are parallel with the previous vanishing lines. Everything is consistent.

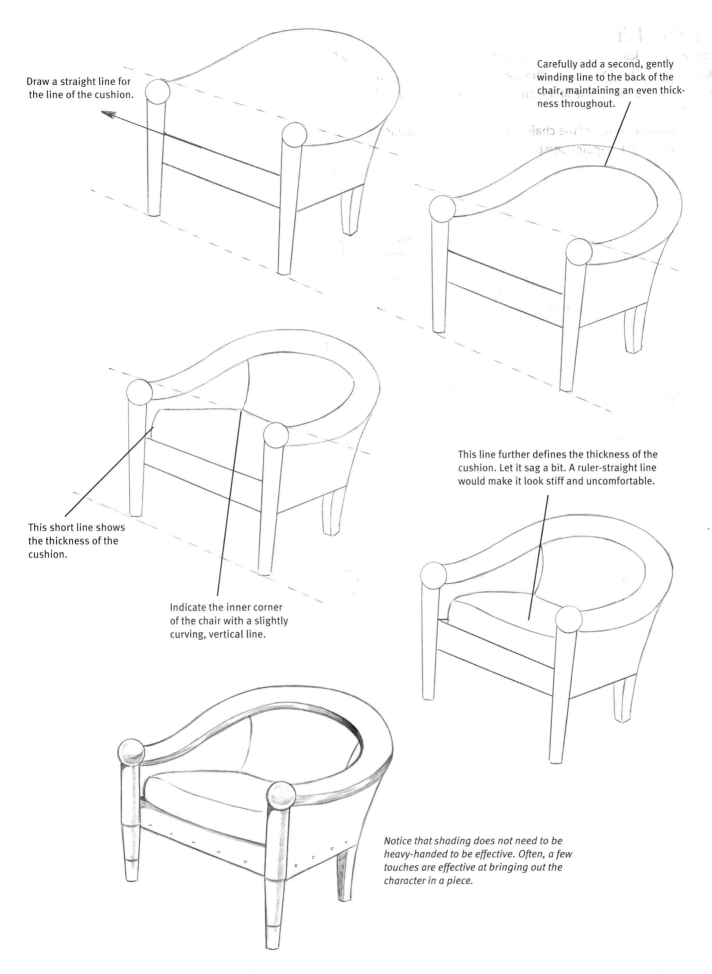

Draw a straight line for the line of the cushion.

Carefully add a second, gently winding line to the back of the chair, maintaining an even thickness throughout.

This short line shows the thickness of the cushion.

Indicate the inner corner of the chair with a slightly curving, vertical line.

This line further defines the thickness of the cushion. Let it sag a bit. A ruler-straight line would make it look stiff and uncomfortable.

Notice that shading does not need to be heavy-handed to be effective. Often, a few touches are effective at bringing out the character in a piece.

Bed with Posts

A bed is a good example of an ordinary shape that can be made interesting by choosing an appealing angle to portray it. If you were to draw a side view of the bed, it would look flat and uninteresting. However, if we turn the bed just slightly, all sorts of interesting visual dynamics come into play, which you'll see as you follow the steps.

This bed has a footboard in the foreground, a mattress in the middle, and a headboard in the background. And by rounding the mattress, instead of drawing it ruler-straight, we give the illusion that the pillows are receding in the distance, as if they were dipping below the horizon.

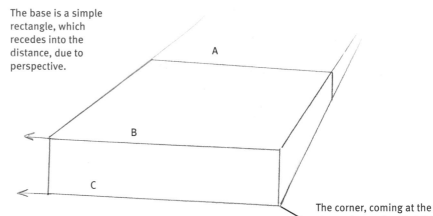

The base is a simple rectangle, which recedes into the distance, due to perspective.

The corner, coming at the viewer, is our clue that this is two-point perspective.

Lines A, B, and C slope very slightly upward, toward the left. This means that there must be a vanishing point somewhere off the page toward the upper left.

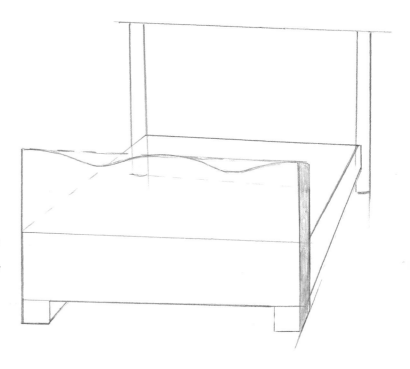

Extend the vertical lines downward to create posts to support the bed frame.

All the vertical lines are straight and therefore unaffected by perspective. Why are vertical lines unaffected by perspective? Because they aren't traversing toward us or away from us through the picture plane; they're only going up and down and therefore not covering any ground at all.

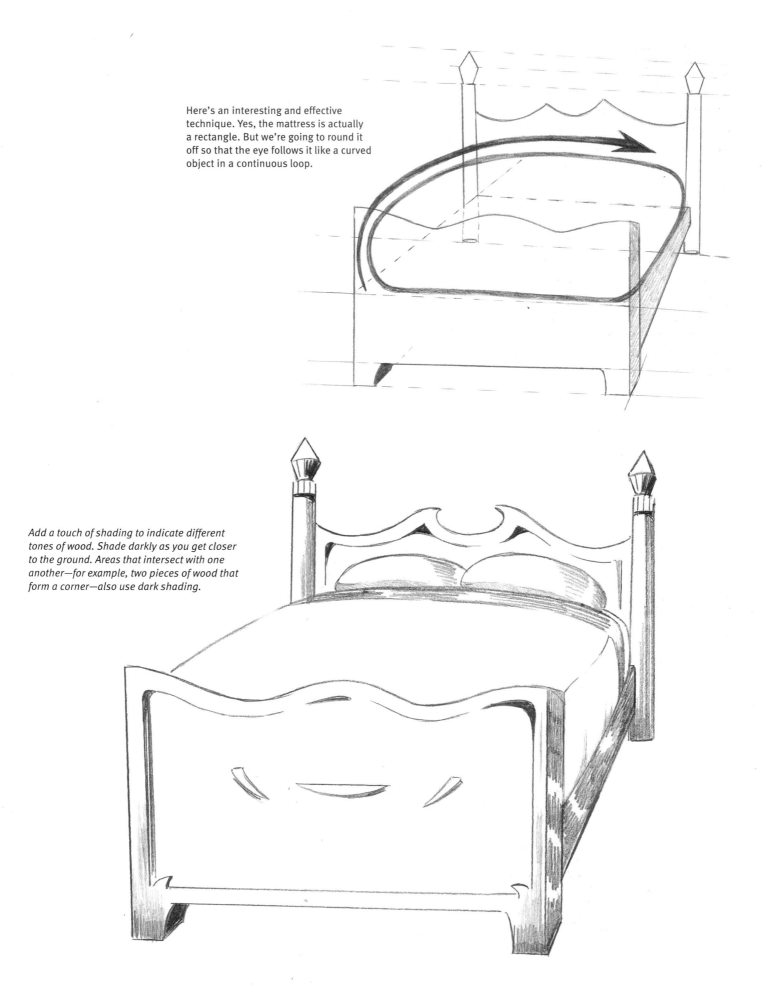

Here's an interesting and effective technique. Yes, the mattress is actually a rectangle. But we're going to round it off so that the eye follows it like a curved object in a continuous loop.

Add a touch of shading to indicate different tones of wood. Shade darkly as you get closer to the ground. Areas that intersect with one another—for example, two pieces of wood that form a corner—also use dark shading.

Standing Secretary

Believe it or not, by this point in the book, you already possess an understanding of all of the techniques necessary to draw this classic piece of furniture. Working this out will bring your understanding of form and perspective to a new level. Even if you don't quite finish it the first time, don't toss out your rough draft. You can complete it in stages, as an ongoing project.

The standing secretary gives us a sturdy rectangular box as our foundation. But the secretary also has two unique features that pose a challenge. First, it has a built-in desk that protrudes from the outline. And second, it has a set of glass doors, which means that we're going to draw the interior of the piece as well as the exterior—specifically, a set of shelves—in perspective.

Some of these steps display numerous guidelines, which may look intimidating. Don't let the presence of the sketch guidelines discourage you. You can do this! Just focus on the labels and hints provided on each step.

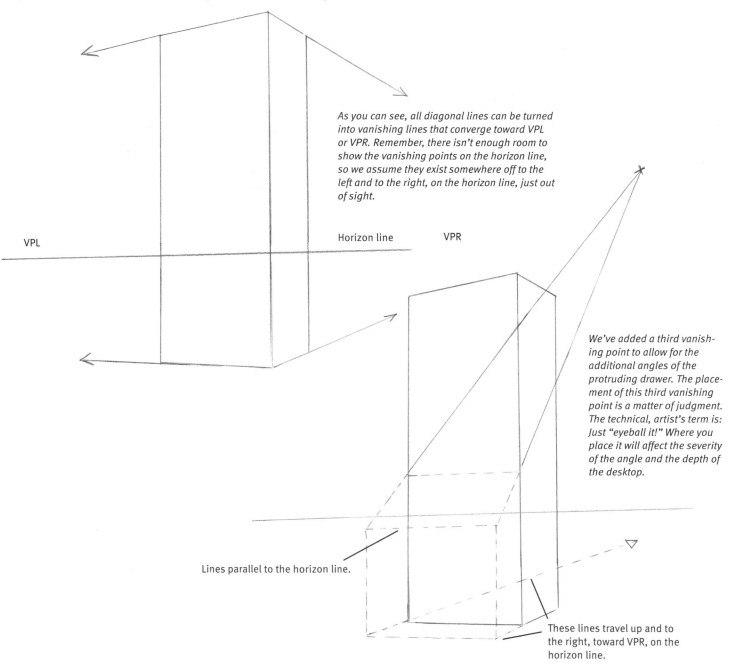

As you can see, all diagonal lines can be turned into vanishing lines that converge toward VPL or VPR. Remember, there isn't enough room to show the vanishing points on the horizon line, so we assume they exist somewhere off to the left and to the right, on the horizon line, just out of sight.

VPL Horizon line VPR

We've added a third vanishing point to allow for the additional angles of the protruding drawer. The placement of this third vanishing point is a matter of judgment. The technical, artist's term is: Just "eyeball it!" Where you place it will affect the severity of the angle and the depth of the desktop.

Lines parallel to the horizon line.

These lines travel up and to the right, toward VPR, on the horizon line.

Here's the basic shape of a secretary we've got so far, cleaned up of all guidelines. In only a few steps, it's already starting to look like something.

To draw the cabinet doors, we'll need to determine the center of the secretary. The "center" of an object appears to be in the middle, if the object is facing forward in a front view. But this secretary is turned to the left, causing the "center" to shift. To find the true center, we'll have to identify the perspective middle (see page 28). Mark the two rectangles with Xs and run a vertical line down the middle. Where the lines of each X intersect is the true middle. The middle rectangle doesn't get a line down the middle, because it's a solid piece of wood—the foldout of the desk.

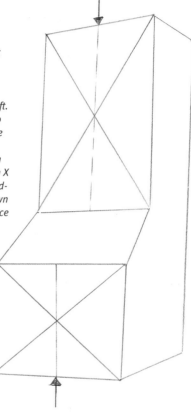

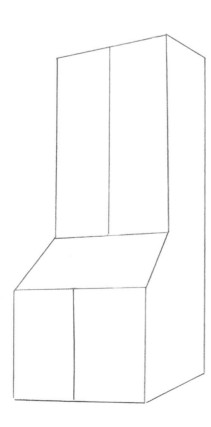

When the guidelines are erased, this is what the secretary looks like, with the cabinet doors drawn in the perspective middle.

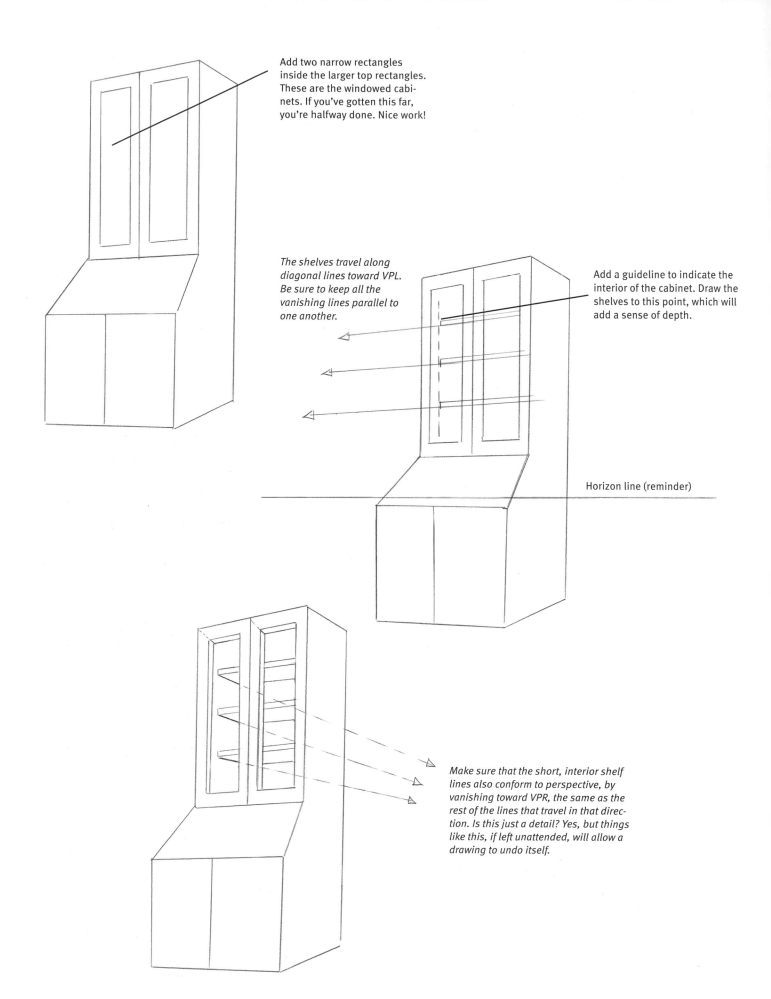

Add two narrow rectangles inside the larger top rectangles. These are the windowed cabinets. If you've gotten this far, you're halfway done. Nice work!

The shelves travel along diagonal lines toward VPL. Be sure to keep all the vanishing lines parallel to one another.

Add a guideline to indicate the interior of the cabinet. Draw the shelves to this point, which will add a sense of depth.

Horizon line (reminder)

Make sure that the short, interior shelf lines also conform to perspective, by vanishing toward VPR, the same as the rest of the lines that travel in that direction. Is this just a detail? Yes, but things like this, if left unattended, will allow a drawing to undo itself.

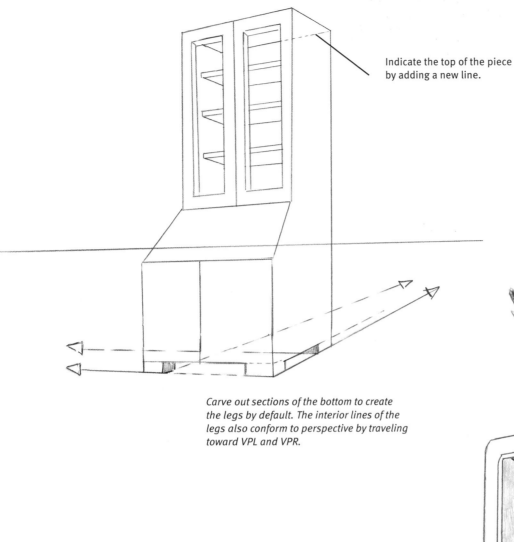

Indicate the top of the piece by adding a new line.

Carve out sections of the bottom to create the legs by default. The interior lines of the legs also conform to perspective by traveling toward VPL and VPR.

Note how each row of books diminishes slightly in size, starting off tallest on the right and getting smaller as it continues to the left. We've also allowed the interior of the bookshelf to fade into shadow. A line to indicate thickness has been added to the outline of the foldout desktop.

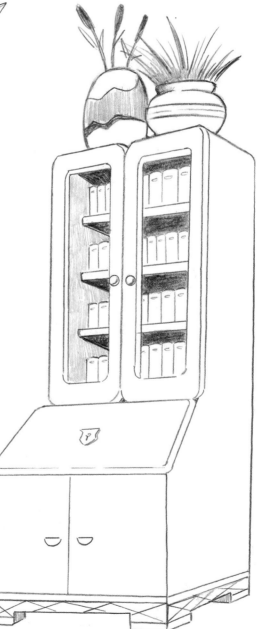

VEHICLES

Vehicles blend geometric shapes with organic, gently curved lines, resulting in aesthetically appealing designs. Some people love drawing cars; but even if it isn't your first choice of subject matter, it's good practice—and you may discover that you have a knack for it.

Luxury Automobile

Cars are expensive products that have been crafted by teams of designers. Every line, angle, and curve of a car has been carefully designed to create an aesthetic appeal. As an artist, your foremost goal is to create an image that looks convincingly like a car. To establish that with authority, focus on the car's outline and the length, height, and pitch of the body. Then try to capture the correct width of the tires' sidewalls (beginners often draw them much too wide) and the configuration of the window design. Once those elements are in place, you'll enjoy using a creative touch to draw smart lines that convey the sumptuous feel of a luxury item. And it may surprise you to learn that, with a few minor exceptions, cars are drawn entirely freehand, without a ruler or a triangle.

The outline of the body is made up of simple horizontal and diagonal lines. Note the curved lines for the front end and the rear end.

Slight slope in, where the rear windshield meets the trunk

Slight slope in, where the windshield meets the hood

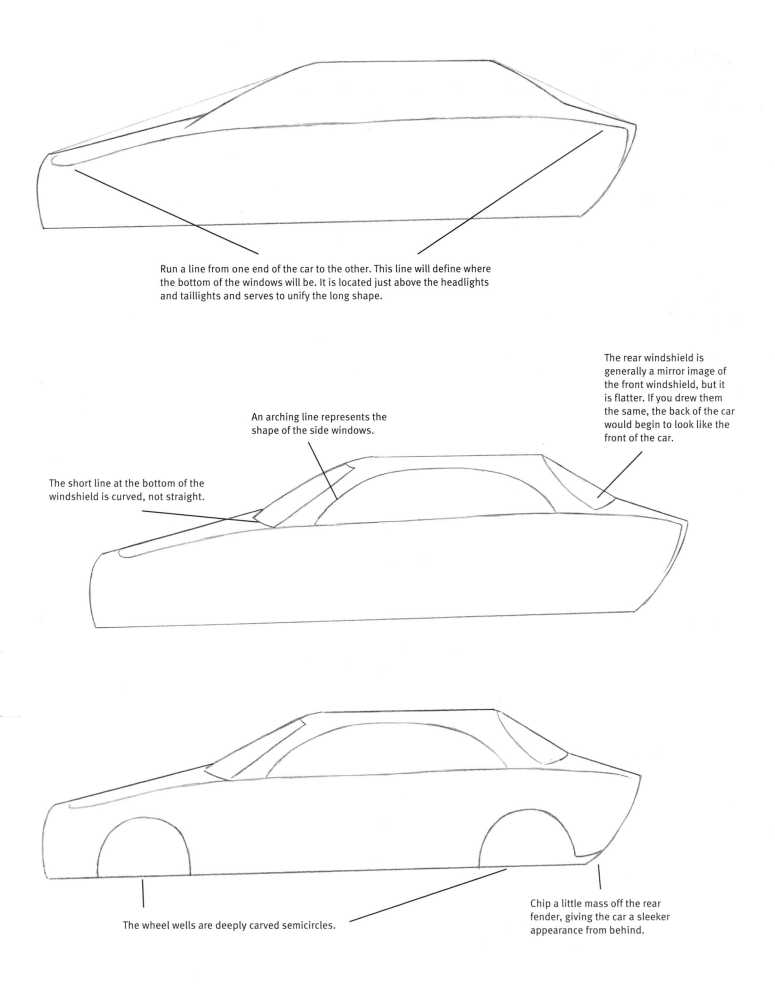

Run a line from one end of the car to the other. This line will define where the bottom of the windows will be. It is located just above the headlights and taillights and serves to unify the long shape.

The rear windshield is generally a mirror image of the front windshield, but it is flatter. If you drew them the same, the back of the car would begin to look like the front of the car.

An arching line represents the shape of the side windows.

The short line at the bottom of the windshield is curved, not straight.

The wheel wells are deeply carved semicircles.

Chip a little mass off the rear fender, giving the car a sleeker appearance from behind.

The sidewalls of today's tires are surprisingly narrow. Don't draw them too wide or they'll look old-fashioned and cartoonish.

Cars generally have rounded bodies. They often indent just below the door handle. Indicate this by drawing a curved line for the car door.

The driver's-side window ends where the door ends.

Create this quasi-rectangular shape, which indicates the concave area of the body.

Rocker panel

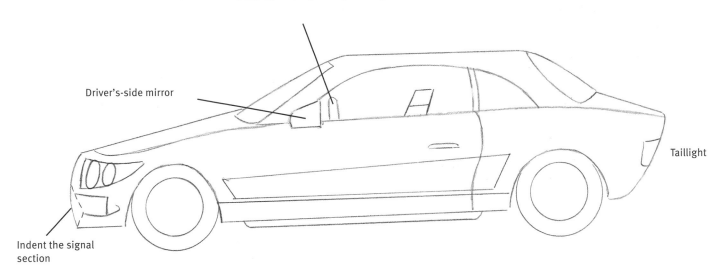

Steering wheel (partially hidden)

Driver's-side mirror

Indent the signal section

Taillight

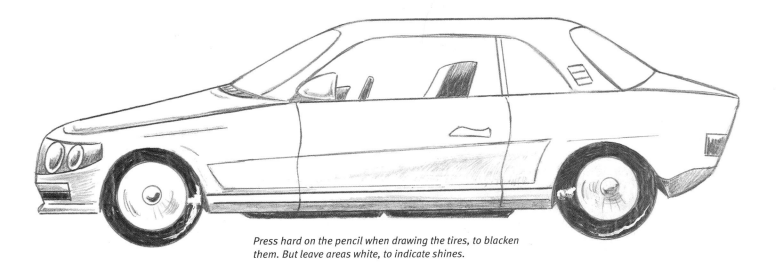

Press hard on the pencil when drawing the tires, to blacken them. But leave areas white, to indicate shines.

Motorcycle

A motorcycle has only two tires but can be trickier to draw than a car with four. With most objects, you draw the body first and then the individual parts. But a motorcycle doesn't have an overall outline—it's all individual parts! Many beginners simply barrel ahead, drawing part by part, hoping that it will somehow come together as a cohesive whole in the end. Not necessarily.

Instead, we're going to invent a composition and impose it on the motorcycle, which will make it easier to draw. We'll do that by connecting the two dominant shapes by a set of guidelines: the tires. Now we've got a foundation on which to build our machine.

Draw two ovals for the tires. Make the near one slightly larger than the far one in keeping with perspective.

Fastback windshield guard and body cover

This fin shape makes up a large section of the frame of the motorcycle. The lower line barely misses the rear tire.

Foot stop uses two parallel lines to indicate thickness.

Within the body of the bike, draw the seat and the gas tank.

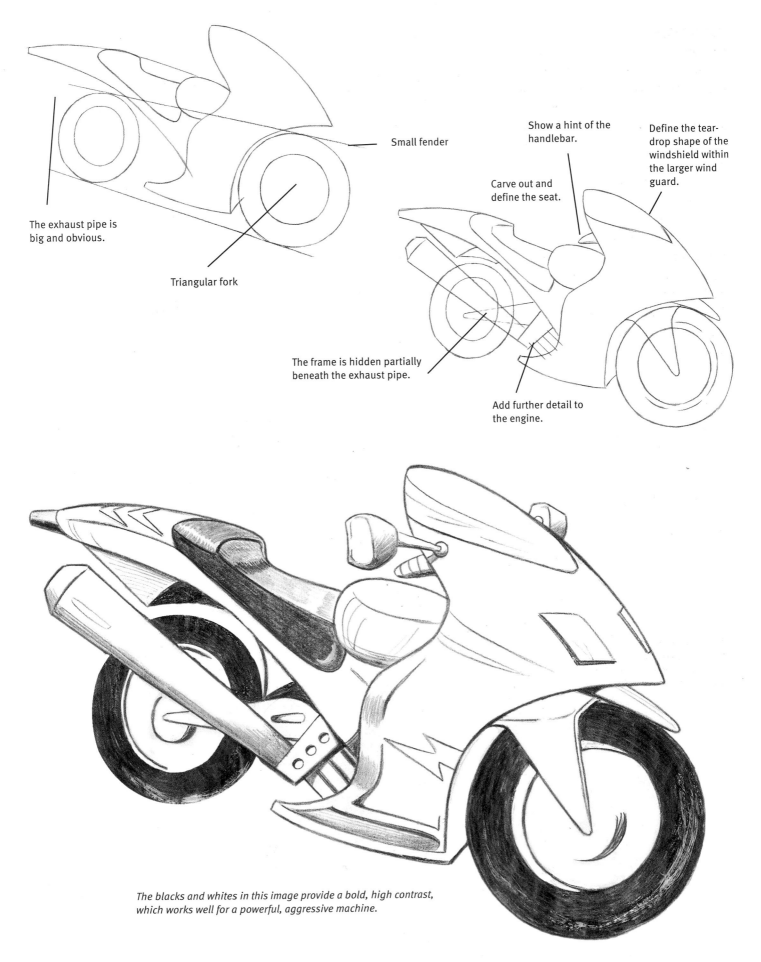

Small fender

The exhaust pipe is
big and obvious.

Triangular fork

Show a hint of the
handlebar.

Define the tear-
drop shape of the
windshield within
the larger wind
guard.

Carve out and
define the seat.

The frame is hidden partially
beneath the exhaust pipe.

Add further detail to
the engine.

*The blacks and whites in this image provide a bold, high contrast,
which works well for a powerful, aggressive machine.*

Yacht

The yacht is one serious toy. It's elegant and doesn't let an inch go by without some thought behind the design. Unlike larger seafaring, commercial ships, the yacht shows more of its top half in the water than its bottom half.

Everything about a yacht is stylishly crafted. Look to draw long, sweeping lines that join with other lines to create a continuous flow. Look, too, for strong diagonals, which create powerful images and serve to reduce wind drag.

Because we—the viewers—are looking down at this vessel, the image is going to be affected to some extent by perspective.

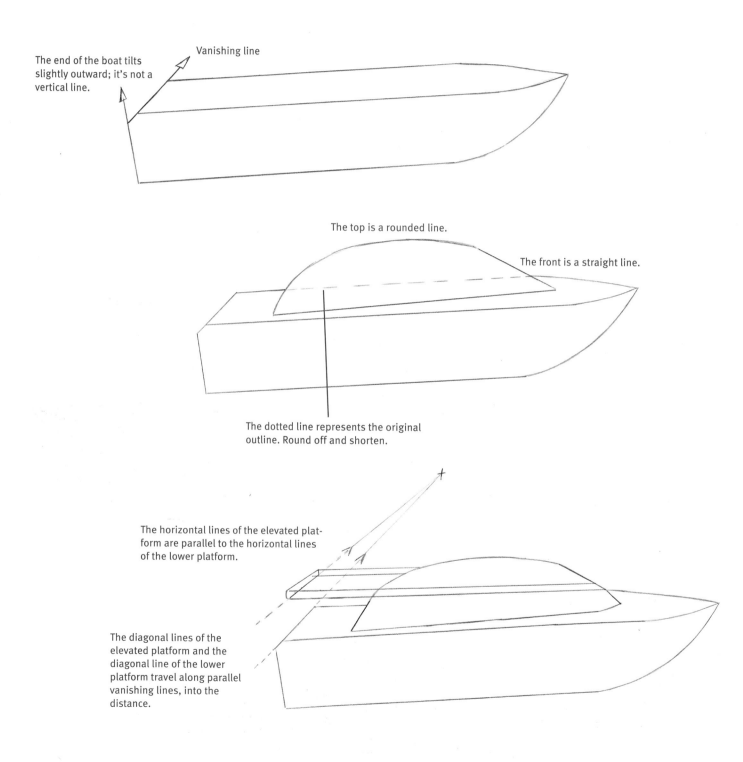

Vanishing line

The end of the boat tilts slightly outward; it's not a vertical line.

The top is a rounded line.

The front is a straight line.

The dotted line represents the original outline. Round off and shorten.

The horizontal lines of the elevated platform are parallel to the horizontal lines of the lower platform.

The diagonal lines of the elevated platform and the diagonal line of the lower platform travel along parallel vanishing lines, into the distance.

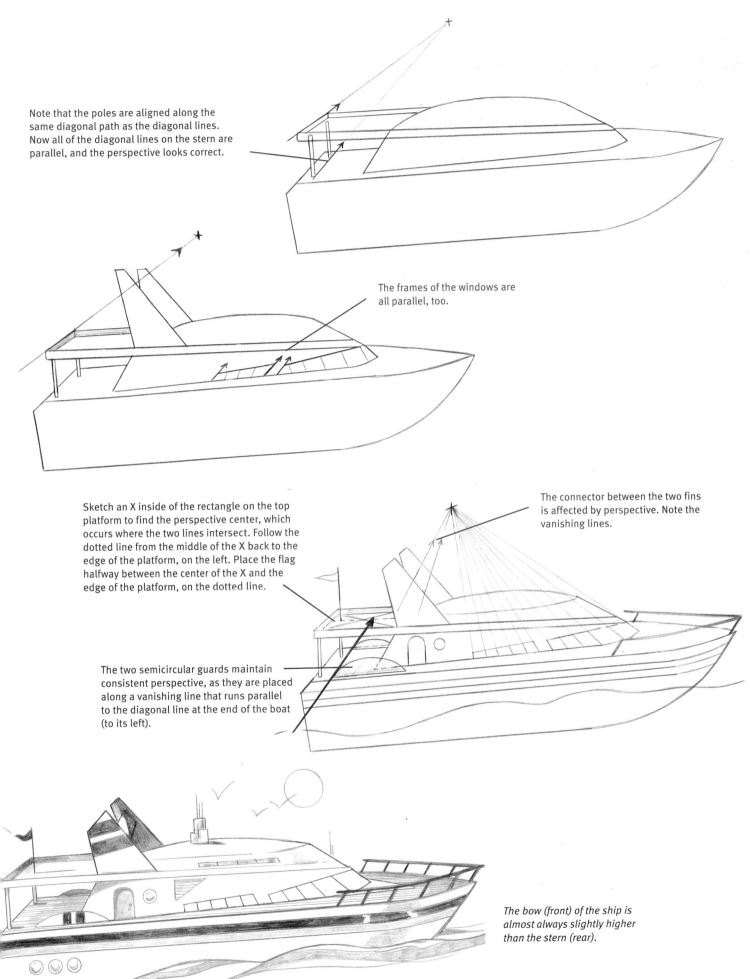

Note that the poles are aligned along the same diagonal path as the diagonal lines. Now all of the diagonal lines on the stern are parallel, and the perspective looks correct.

The frames of the windows are all parallel, too.

Sketch an X inside of the rectangle on the top platform to find the perspective center, which occurs where the two lines intersect. Follow the dotted line from the middle of the X back to the edge of the platform, on the left. Place the flag halfway between the center of the X and the edge of the platform, on the dotted line.

The connector between the two fins is affected by perspective. Note the vanishing lines.

The two semicircular guards maintain consistent perspective, as they are placed along a vanishing line that runs parallel to the diagonal line at the end of the boat (to its left).

The bow (front) of the ship is almost always slightly higher than the stern (rear).

Sailboats on a Lake

Not all projects need to be challenging for you to enjoy spending a little extra creative time working at them. Here's an example of a relatively easy scene that is breezy and atmospheric. If you're a painter or a watercolorist, or if you like colored pencils or pastels, you can use this as a basis for a color work.

We want our viewer to react positively to the scene we are about to create. But developing a scene takes more than simply drawing pretty pictures. We artists are like tour guides, and therefore we have to make sure that the viewer doesn't miss anything important in the scene we've created.

Here are a few general principles to keep in mind when composing a scene and how, specifically, we've used them here:

Exaggeration. The sailboat in the foreground is increased in size and appears to be coming at the viewer, thus involving the viewer in the scene.

Placement. The boats are arranged rhythmically, which is more pleasing than placing them randomly.

Depth. By drawing the boats at different sizes and placing them at different distances from one another and the horizon, we give the scene depth.

Horizon line. We've underscored the feeling of serenity by emphasizing horizontal lines, as opposed to diagonal lines. The horizon line, the line of the clouds, and the direction of the sailboats are all horizontal.

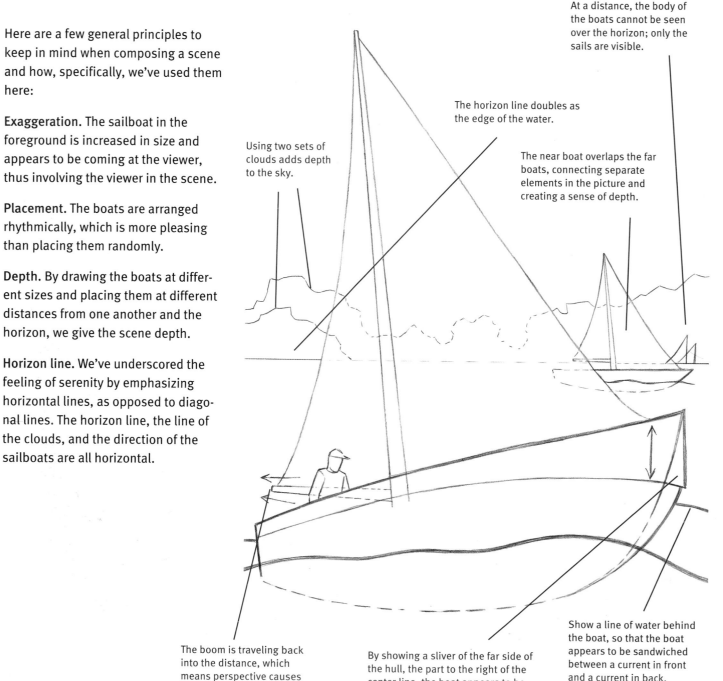

At a distance, the body of the boats cannot be seen over the horizon; only the sails are visible.

The horizon line doubles as the edge of the water.

Using two sets of clouds adds depth to the sky.

The near boat overlaps the far boats, connecting separate elements in the picture and creating a sense of depth.

The boom is traveling back into the distance, which means perspective causes it to taper.

By showing a sliver of the far side of the hull, the part to the right of the center line, the boat appears to be three-dimensional.

Show a line of water behind the boat, so that the boat appears to be sandwiched between a current in front and a current in back.

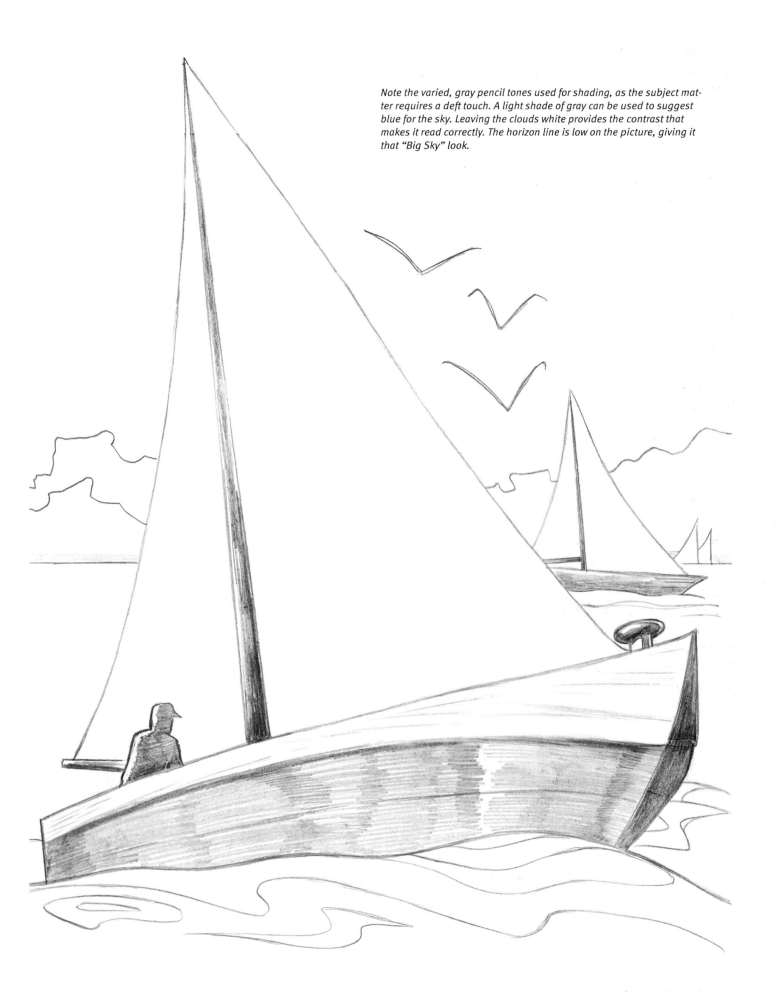

Note the varied, gray pencil tones used for shading, as the subject matter requires a deft touch. A light shade of gray can be used to suggest blue for the sky. Leaving the clouds white provides the contrast that makes it read correctly. The horizon line is low on the picture, giving it that "Big Sky" look.

HOUSES

You don't have to be an architect to draw attractive houses. With a little bit of concentration and attention to detail, they are surprisingly easy to master. It's simply a matter of starting with a basic foundation shape and adding to it, step by step, until you're done.

Houses are made up of many straight lines, hard angles, and very little freehand work. Because of that, you're going to make extensive use of a ruler or a triangle. Drawing a house will require many little decisions, such as, "If I move this line a tad this way, will the window look even or tilted?" Decisions like these are a natural and necessary part of the drawing process.

During the drawing process, keep an eye out for the symmetry of your work. Make sure that all the vertical and horizontal lines are parallel, that each element is carefully centered, and that the windows are spaced evenly apart at regular intervals. A house gets its pleasing look from its symmetrical repetition.

Traditional-Style Colonial

The colonial-style house is traditional and vastly popular. Everything about this stately house is straightforward and highly symmetrical. There are few, if any, curves to a colonial house. This makes our job as an artist even easier: We can draw just about everything as parallel lines or right angles, with the prominent exception of the long, diagonal lines on either side of the roof. These houses are built with clapboard: long, thin wooden planks that create light horizontal striations across the face of the house—another signature design element.

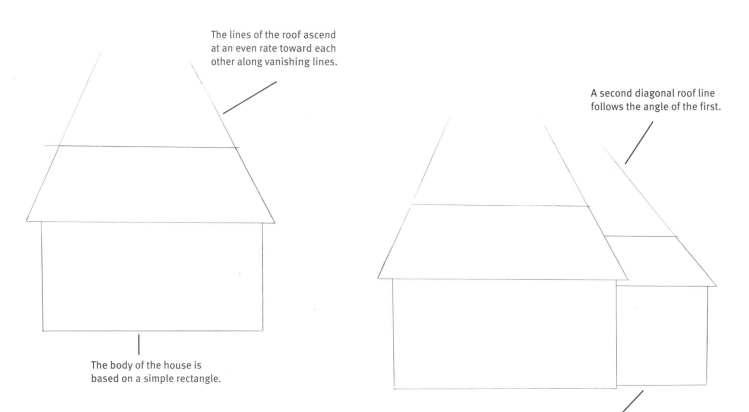

The lines of the roof ascend at an even rate toward each other along vanishing lines.

The body of the house is based on a simple rectangle.

A second diagonal roof line follows the angle of the first.

Draw a slightly smaller rectangle for the adjoining section of the house.

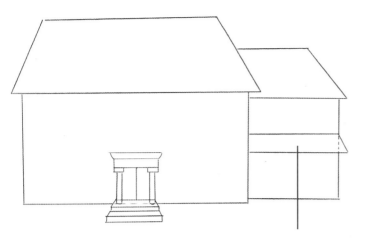

Draw and center a simple portico.

Draw a third, small and narrow roof over the garage.

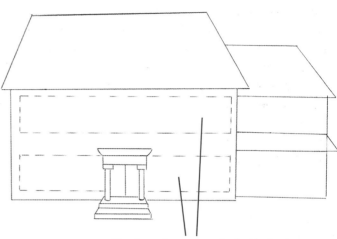

Sketch two long rectangles inside the frame of the house. These are guidelines, within which the windows will be drawn.

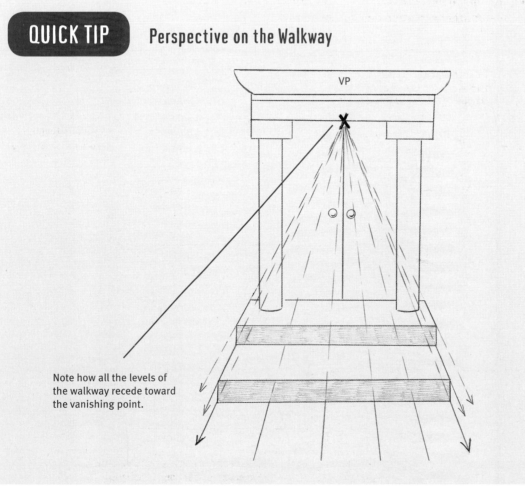

QUICK TIP Perspective on the Walkway

VP

Note how all the levels of the walkway recede toward the vanishing point.

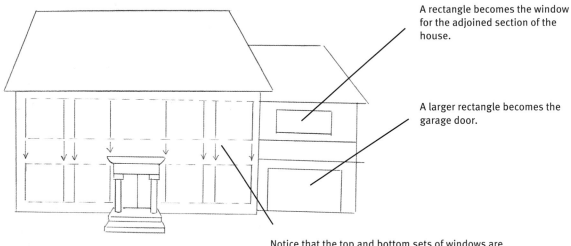

A rectangle becomes the window for the adjoined section of the house.

A larger rectangle becomes the garage door.

Notice that the top and bottom sets of windows are stacked evenly on top of each other.

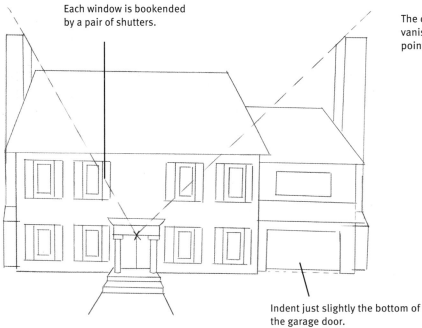

Each window is bookended by a pair of shutters.

The chimney lines travel back along vanishing lines toward the vanishing point on the portico.

Indent just slightly the bottom of the garage door.

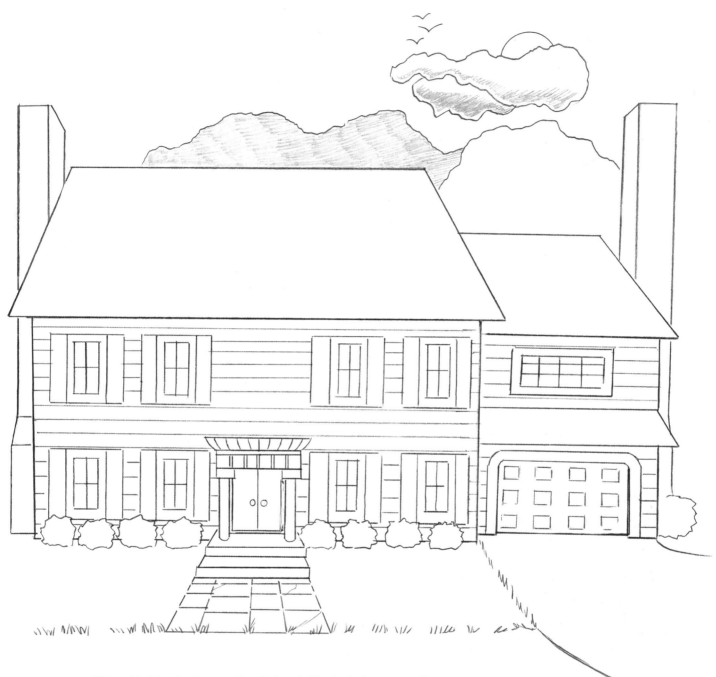

We've added the signature wooden clapboard siding to the house, as well as a few details to complete the scene. Notice that the stone walkway, too, is drawn in perspective, which leads the viewer's eye directly to the front door.

Dutch-Style Colonial

Unlike its grander cousin, the traditional colonial, the Dutch colonial is made with wider wooden slats. The house is usually divided into a main section and an adjoining section. The main section has a signature roof with a sort of "Dutch boy" haircut shape to it. I find these houses particularly charming.

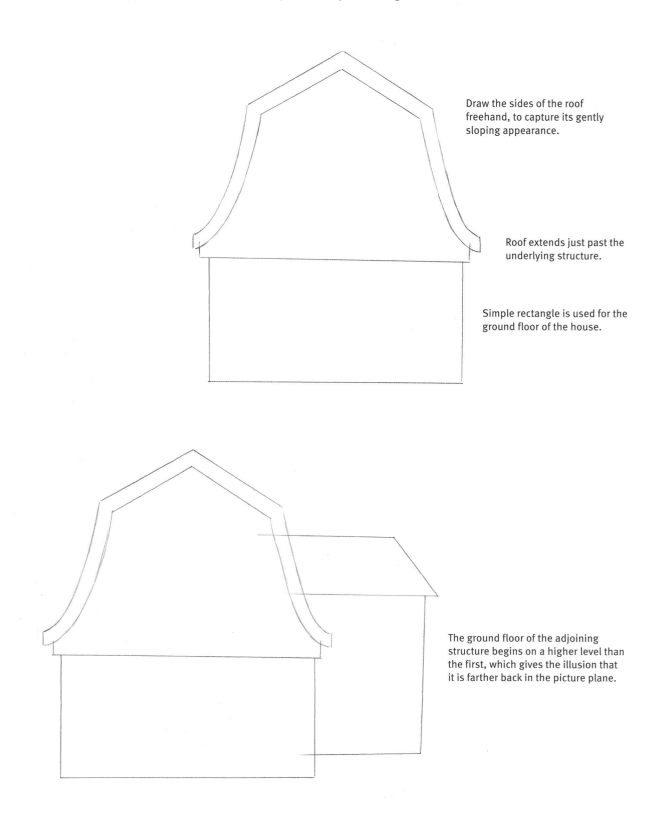

Draw the sides of the roof freehand, to capture its gently sloping appearance.

Roof extends just past the underlying structure.

Simple rectangle is used for the ground floor of the house.

The ground floor of the adjoining structure begins on a higher level than the first, which gives the illusion that it is farther back in the picture plane.

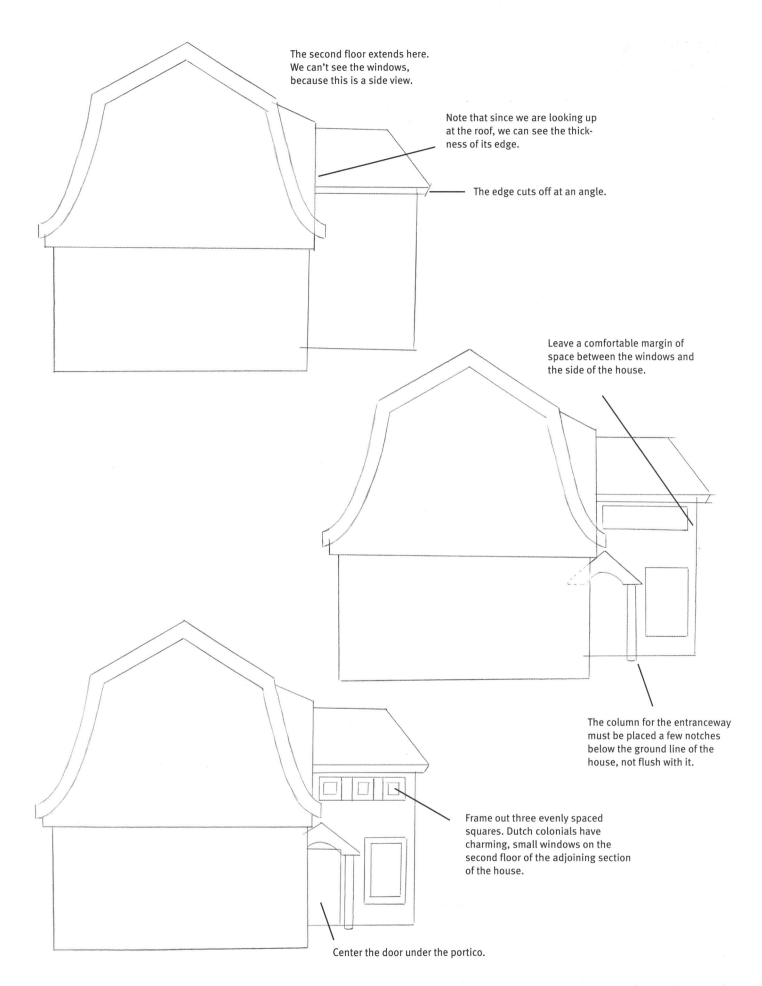

The second floor extends here. We can't see the windows, because this is a side view.

Note that since we are looking up at the roof, we can see the thickness of its edge.

The edge cuts off at an angle.

Leave a comfortable margin of space between the windows and the side of the house.

The column for the entranceway must be placed a few notches below the ground line of the house, not flush with it.

Frame out three evenly spaced squares. Dutch colonials have charming, small windows on the second floor of the adjoining section of the house.

Center the door under the portico.

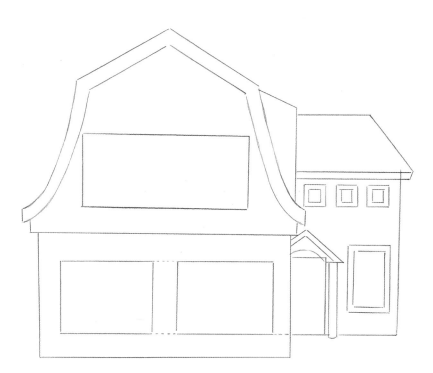

Draw and center a large rectangle on the ground floor, then divide this into two smaller rectangles. Use these for the guidelines for the windows. Do the same for the second floor.

Horizontal line
of chimney top

Diagonal line of
chimney top

Interior side
of chimney

Draw a decorative attic
window, centered.

Each window
is a "double
rectangle."

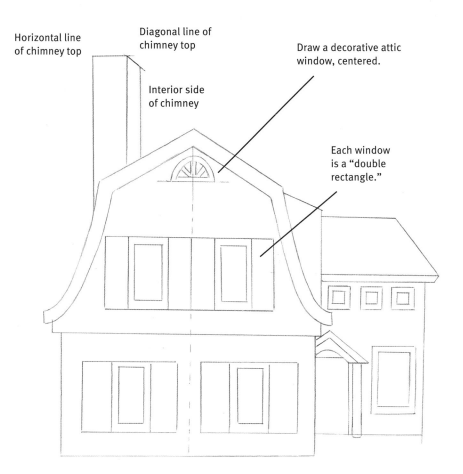

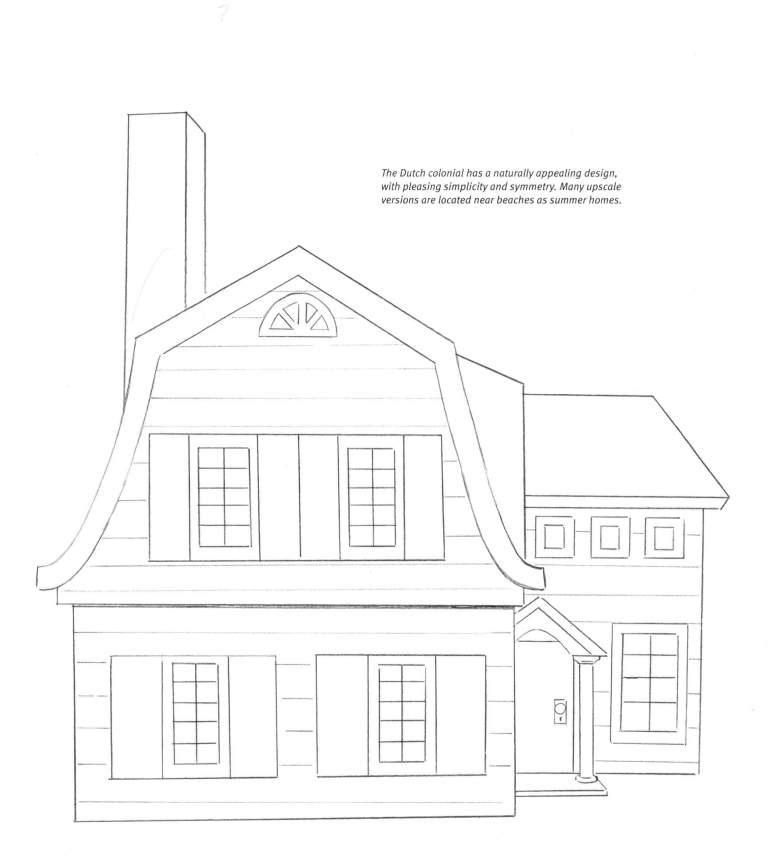

The Dutch colonial has a naturally appealing design, with pleasing simplicity and symmetry. Many upscale versions are located near beaches as summer homes.

Spanish-Style Villa

I find Spanish houses enjoyable to draw because no two of them are designed exactly alike. That means you get to create your own variations simply by repositioning an archway, changing the shape or size of the windows, or moving the entranceway.

Spanish houses typically have layered walls, which create different ground-level areas for you to draw. All the shifting levels could look confusing. In order to create a cohesive look, try to place windows, doors, and entryways along shared horizontal lines.

Start off with a simple rectangle for the base of the house. Add a base on top of the rectangle. This "top" indicates the foundation of the second floor.

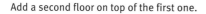

Add a second floor on top of the first one.

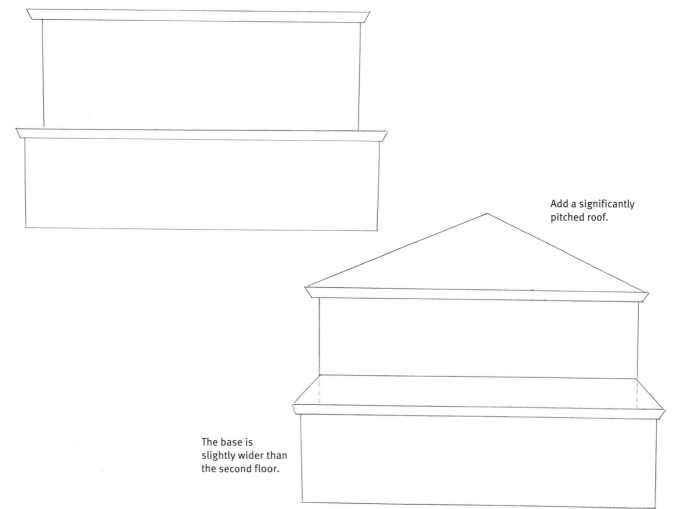

Add a significantly pitched roof.

The base is slightly wider than the second floor.

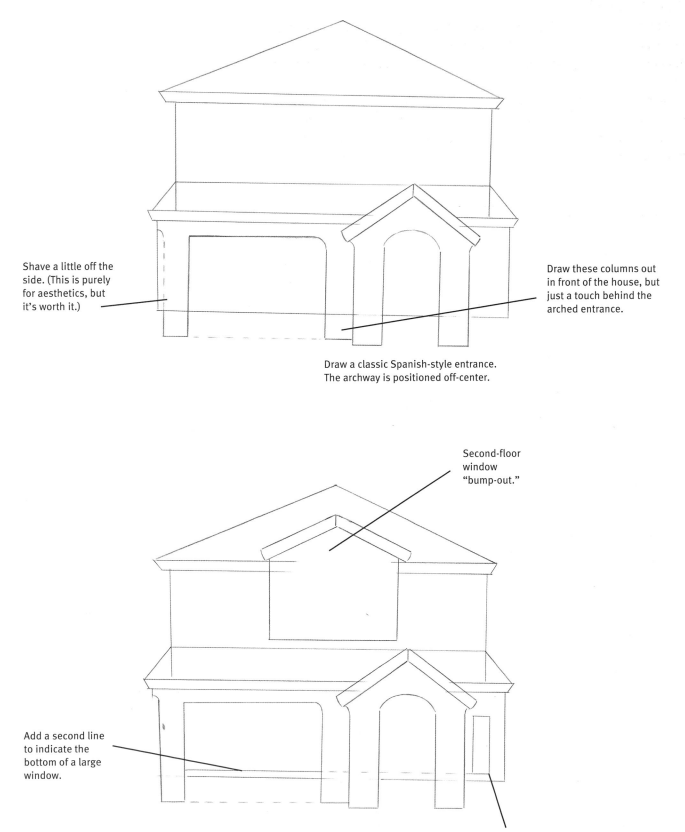

Shave a little off the side. (This is purely for aesthetics, but it's worth it.)

Draw these columns out in front of the house, but just a touch behind the arched entrance.

Draw a classic Spanish-style entrance. The archway is positioned off-center.

Second-floor window "bump-out."

Add a second line to indicate the bottom of a large window.

The bottom of this vertical window should be drawn on the same level as the line of the large window on the left side of the house. This unifies the design.

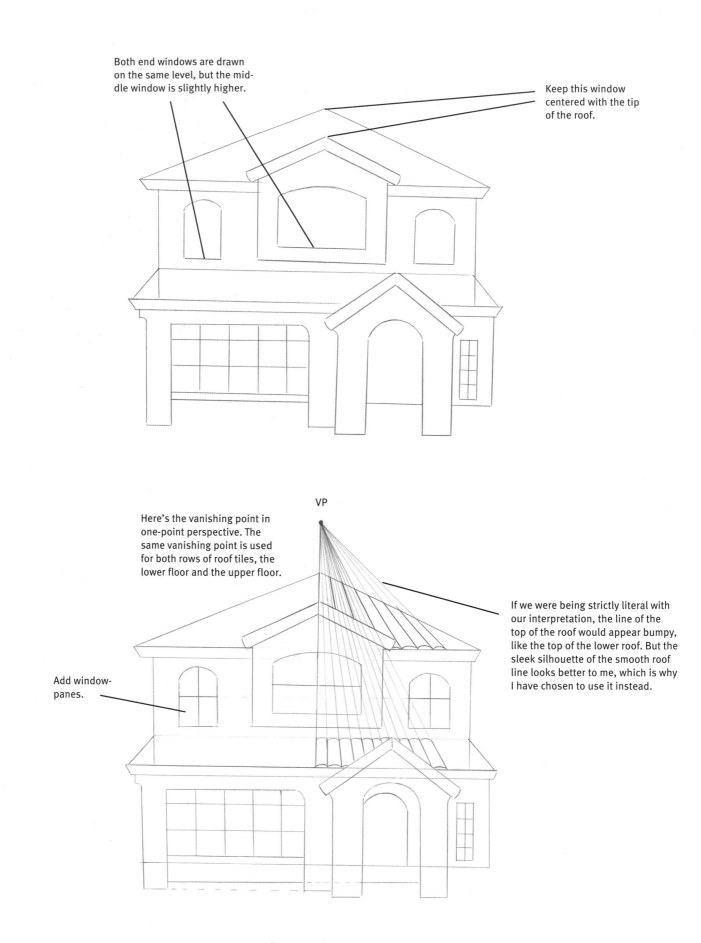

Both end windows are drawn on the same level, but the middle window is slightly higher.

Keep this window centered with the tip of the roof.

Here's the vanishing point in one-point perspective. The same vanishing point is used for both rows of roof tiles, the lower floor and the upper floor.

VP

If we were being strictly literal with our interpretation, the line of the top of the roof would appear bumpy, like the top of the lower roof. But the sleek silhouette of the smooth roof line looks better to me, which is why I have chosen to use it instead.

Add window-panes.

QUICK TIP Windows and Roof Tiles

Incorrectly Articulated Individual Tiles. The tiles are going in the wrong direction; they curve forward, opposing the direction of the opening of the cylinder.

Incorrect Arched Windows. Do not draw a completely rounded outline.

Correct Arched Windows. Draw both sides ruler-straight; then draw freehand the top portion only.

Correctly Articulated Individual Tiles. The tiles curve back, just like the curve at the mouth of the cylinder.

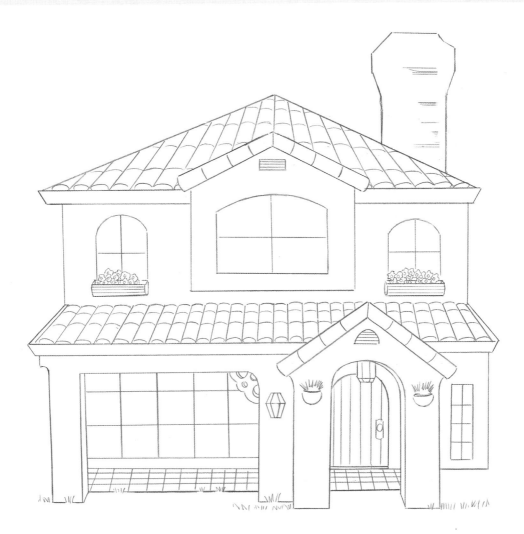

Note that the door is positioned slightly to the left of the archway. This adjusts for perspective.

THE STILL LIFE

A still-life drawing is a work of art typically depicting commonplace objects. The composition of the scene is as much a part of the viewer's experience as is the detail and treatment of the objects.

First, the viewer takes in the overall composition of the picture, but as the viewer's eye lingers, it focuses on individual elements. Therefore, each piece in a still life must be carefully rendered.

Bowl of Fruit

A bowl of fruit is an excellent starting place. You can create a reference model of it in your house in about five minutes. The shapes are familiar, the subject matter is pleasing. It's easy to draw, and it lends itself to creative shading.

As a general rule of thumb, the fruit should appear to be:

- **Easily recognizable.** For example, avoid choosing things like whole oranges. They are hard to distinguish in black-and-white drawings, as their shape is generic.
- **Ripe.** You want to show each piece of fruit at its plumpest.
- **Fresh.** Make them appear either moist or dewy or with a shine or glow, and shade to suggest a deep, vibrant color.
- **Bountiful.** No sparsely distributed grapes or berries, for example.

GRAPES

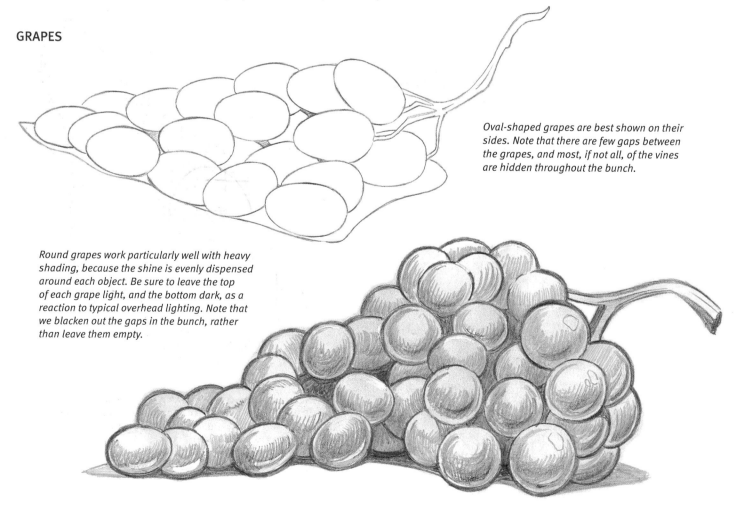

Oval-shaped grapes are best shown on their sides. Note that there are few gaps between the grapes, and most, if not all, of the vines are hidden throughout the bunch.

Round grapes work particularly well with heavy shading, because the shine is evenly dispensed around each object. Be sure to leave the top of each grape light, and the bottom dark, as a reaction to typical overhead lighting. Note that we blacken out the gaps in the bunch, rather than leave them empty.

BANANA

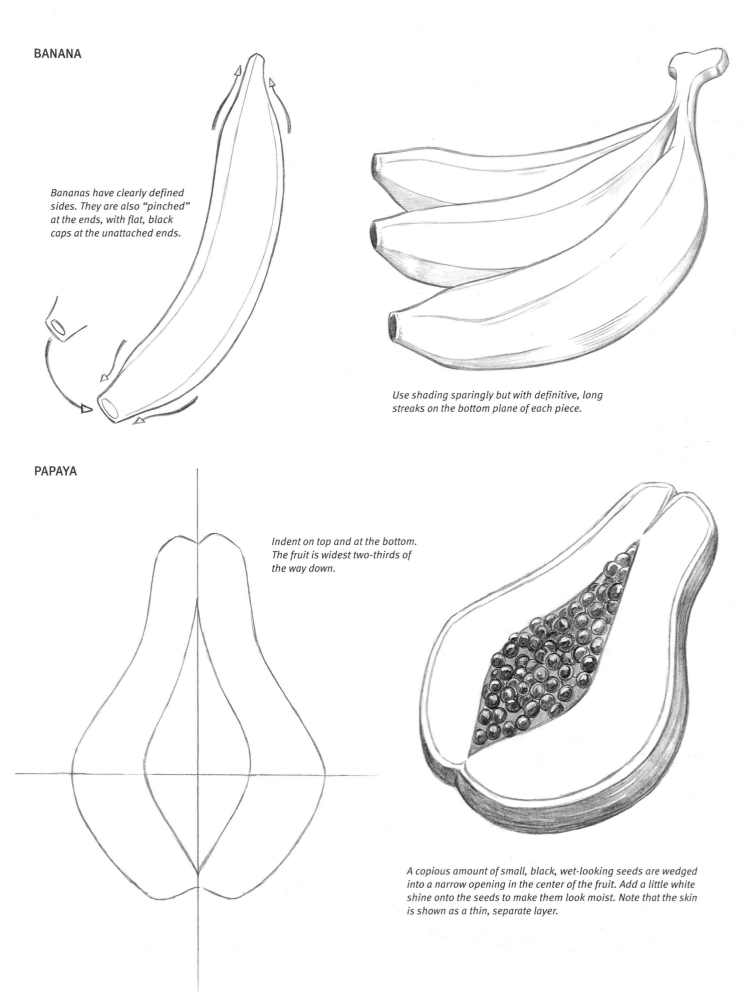

Bananas have clearly defined sides. They are also "pinched" at the ends, with flat, black caps at the unattached ends.

Use shading sparingly but with definitive, long streaks on the bottom plane of each piece.

PAPAYA

Indent on top and at the bottom. The fruit is widest two-thirds of the way down.

A copious amount of small, black, wet-looking seeds are wedged into a narrow opening in the center of the fruit. Add a little white shine onto the seeds to make them look moist. Note that the skin is shown as a thin, separate layer.

WATERMELON

Watermelons are cut in many different yet signature styles. Each cut features a little bit of an angle, which calls for a touch of perspective.

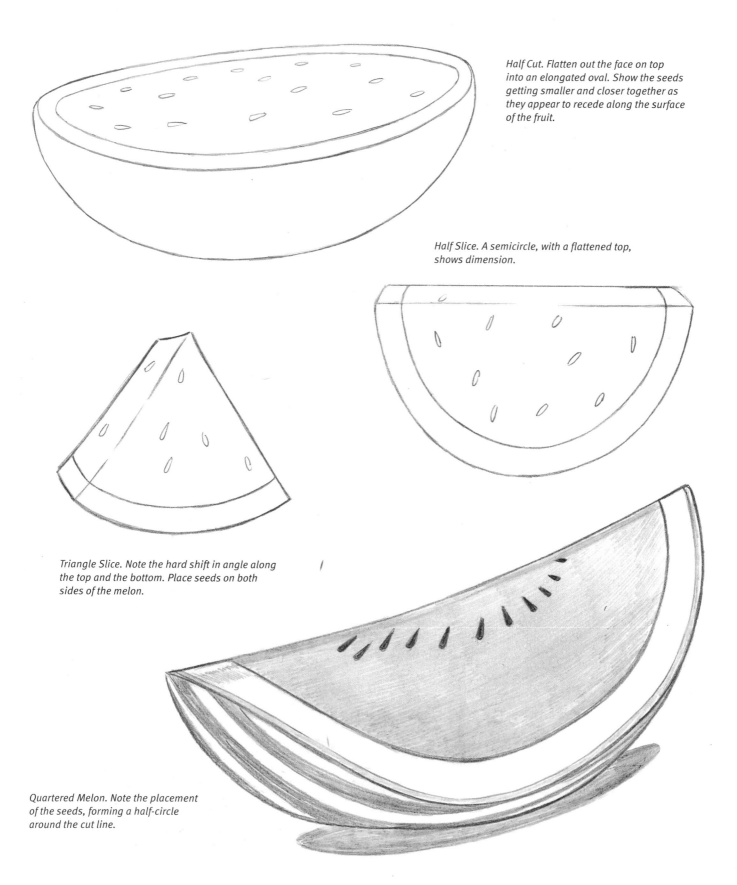

Half Cut. Flatten out the face on top into an elongated oval. Show the seeds getting smaller and closer together as they appear to recede along the surface of the fruit.

Half Slice. A semicircle, with a flattened top, shows dimension.

Triangle Slice. Note the hard shift in angle along the top and the bottom. Place seeds on both sides of the melon.

Quartered Melon. Note the placement of the seeds, forming a half-circle around the cut line.

PEAR

The pear is an often overlooked fruit in art, which is too bad, because it is a very recognizable form. It's also a forgiving shape—you can draw it a little lopsided, and it will still come out looking like a pear!

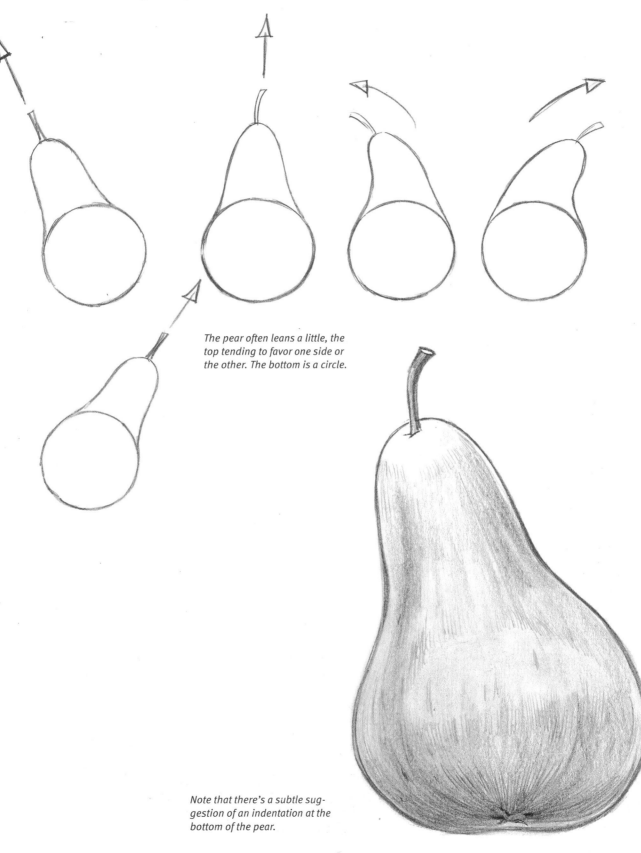

The pear often leans a little, the top tending to favor one side or the other. The bottom is a circle.

Note that there's a subtle suggestion of an indentation at the bottom of the pear.

GRAPEFRUIT

The grapefruit is almost unrecognizable, unless it is shown cut in half. Think of the face of the fruit as a wheel on its side and the middle as the hub.

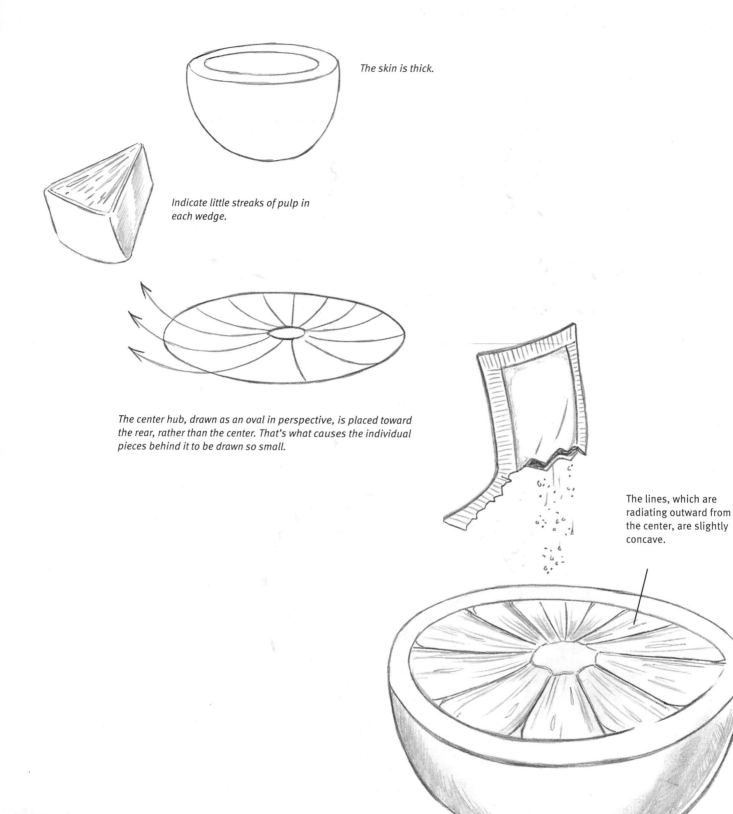

The skin is thick.

Indicate little streaks of pulp in each wedge.

The center hub, drawn as an oval in perspective, is placed toward the rear, rather than the center. That's what causes the individual pieces behind it to be drawn so small.

The lines, which are radiating outward from the center, are slightly concave.

APPLE

Apples are a good, strong shape. But don't settle for a circle with a stem, or you'll wind up with something that looks like a cherry that grew next to a nuclear power plant. Here are a few hints for drawing a more realistic apple:

Correct. The stem occurs inside of the outline of the apple.

Incorrect. The stem is flush with the outline of the apple.

Vary the shading of the skin of the apple, showing streaks.

Stem is curved.

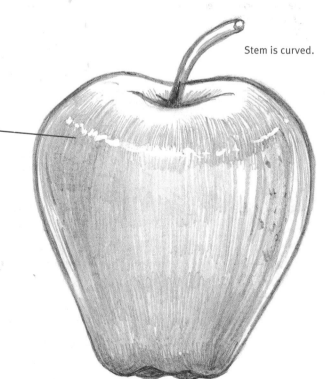

The bottom is bumpy. It is also the darkest area of the skin.

PINEAPPLE

There's no mistaking the pineapple for any other type of fruit. The trick is in establishing its vaselike shape at the outset.

Each individual "tile" is crossed with two lines and has a small, ragged, starlike shape at the center. Wait to add this last detail until you have the rest of the pineapple finished.

The pineapple is shaped like a crystal-cut vase. The cross-hatching is drawn on two opposing diagonals. Be sure to use slightly curved lines.

The layered plant top is of considerable length. Don't underestimate it.

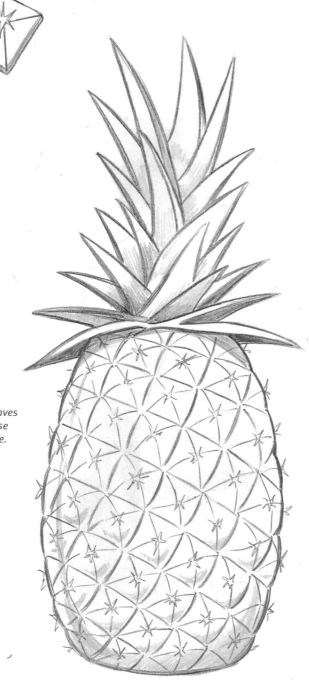

Note that the underside of the leaves have been shaded darkly, because overhead light cannot reach there.

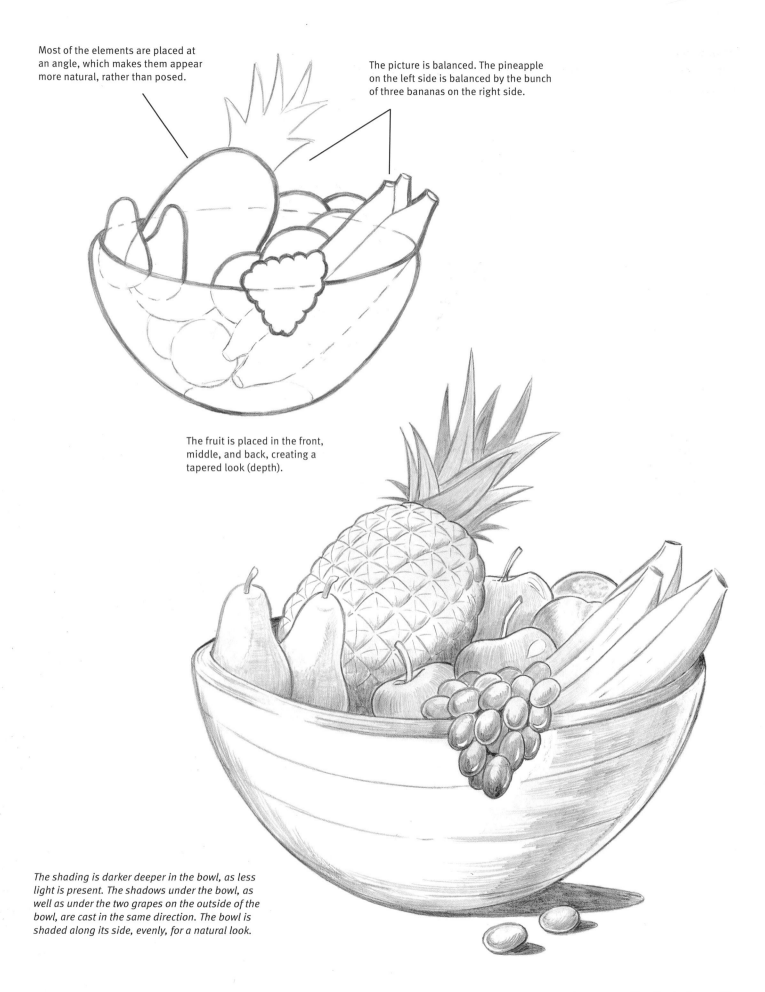

Most of the elements are placed at an angle, which makes them appear more natural, rather than posed.

The picture is balanced. The pineapple on the left side is balanced by the bunch of three bananas on the right side.

The fruit is placed in the front, middle, and back, creating a tapered look (depth).

The shading is darker deeper in the bowl, as less light is present. The shadows under the bowl, as well as under the two grapes on the outside of the bowl, are cast in the same direction. The bowl is shaded along its side, evenly, for a natural look.

Classic Tea Set

A tea set is an elegant and refined subject for still life. Like the bowl of fruit, these are somewhat forgiving shapes. If your teapot looks a little wider, or taller, than mine, that's okay. In addition to the aesthetics of the individual pieces, you can turn them to whatever angle you choose to create an attractive composition.

Take note of the angle at which we are viewing the tea set. We, the viewers, are positioned at eye level with the cups (seen starting on the facing page). This means that we are barely able to look over the top and into the openings. Therefore, the circumference around the cups must be drawn as slender ovals.

You can also ensure that each teapot appears round and symmetrical by drawing two ovals inside the initial constructions (see page 25).

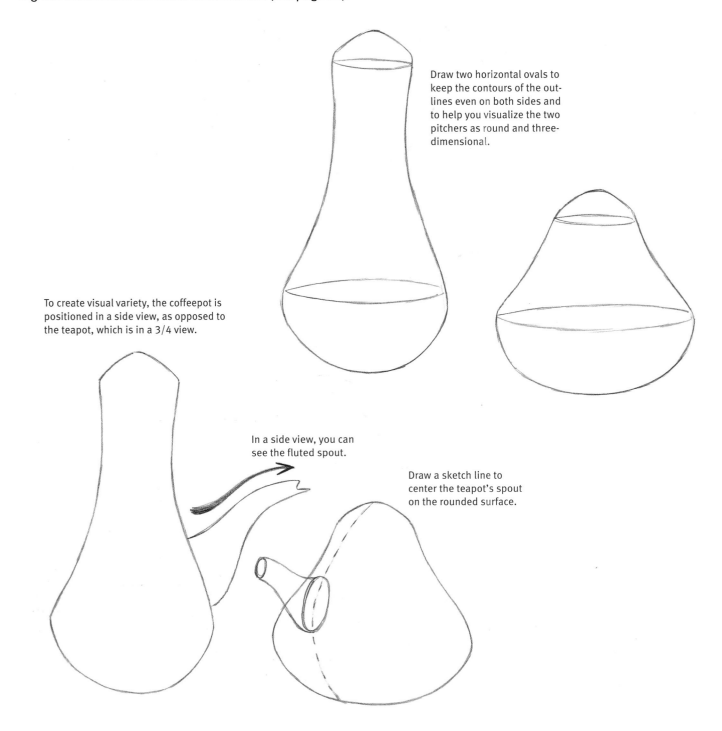

Draw two horizontal ovals to keep the contours of the outlines even on both sides and to help you visualize the two pitchers as round and three-dimensional.

To create visual variety, the coffeepot is positioned in a side view, as opposed to the teapot, which is in a 3/4 view.

In a side view, you can see the fluted spout.

Draw a sketch line to center the teapot's spout on the rounded surface.

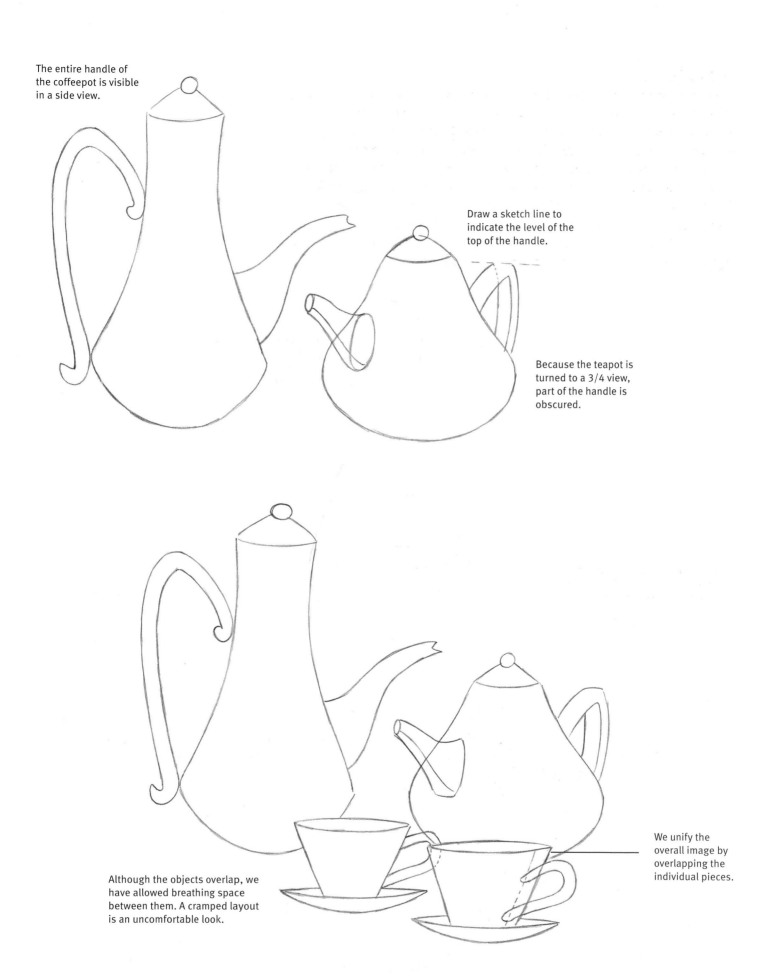

The entire handle of the coffeepot is visible in a side view.

Draw a sketch line to indicate the level of the top of the handle.

Because the teapot is turned to a 3/4 view, part of the handle is obscured.

We unify the overall image by overlapping the individual pieces.

Although the objects overlap, we have allowed breathing space between them. A cramped layout is an uncomfortable look.

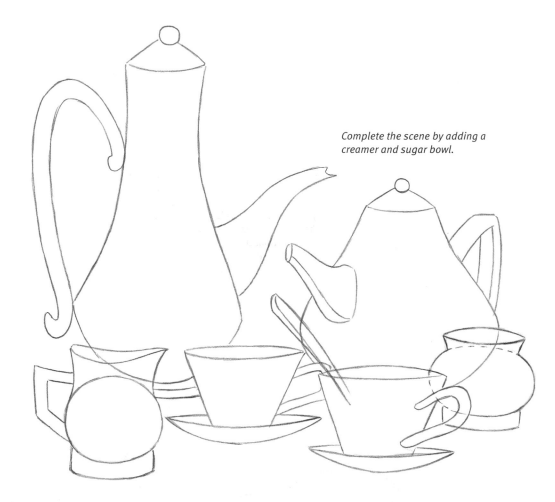

Complete the scene by adding a creamer and sugar bowl.

Lighting

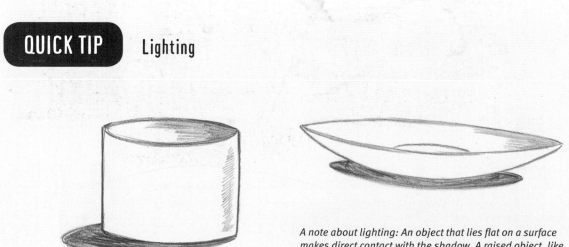

A note about lighting: An object that lies flat on a surface makes direct contact with the shadow. A raised object, like the circumference of the saucer, does not make contact with its own shadow.

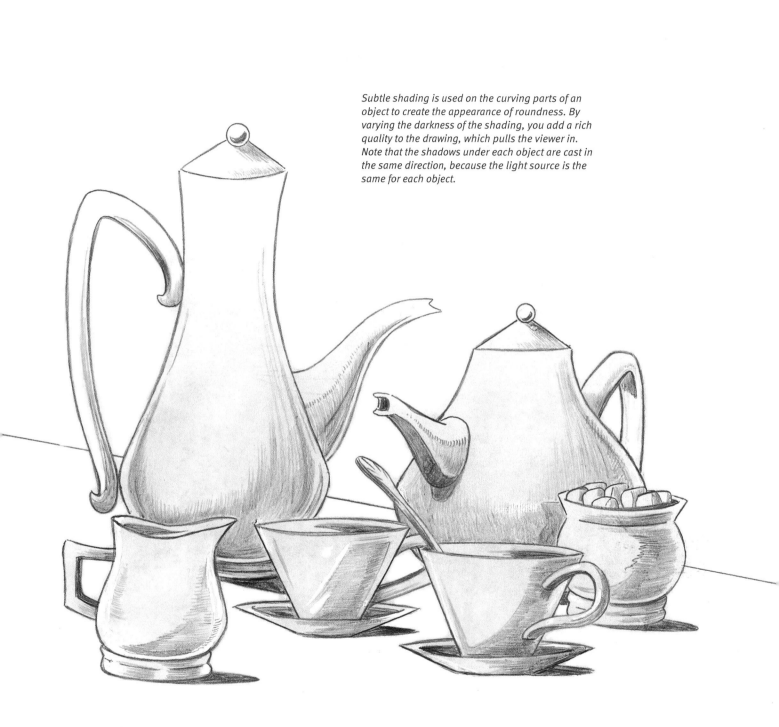

Subtle shading is used on the curving parts of an object to create the appearance of roundness. By varying the darkness of the shading, you add a rich quality to the drawing, which pulls the viewer in. Note that the shadows under each object are cast in the same direction, because the light source is the same for each object.

Bread Basket

At first glance, the position of the elements in this still life might look random. The truth is, it requires a bit of work to make objects appear as though they naturally arrived in their rhythmic, harmonious positions. Let's examine the thought process that goes into composing a still life that looks accidental, but is posed.

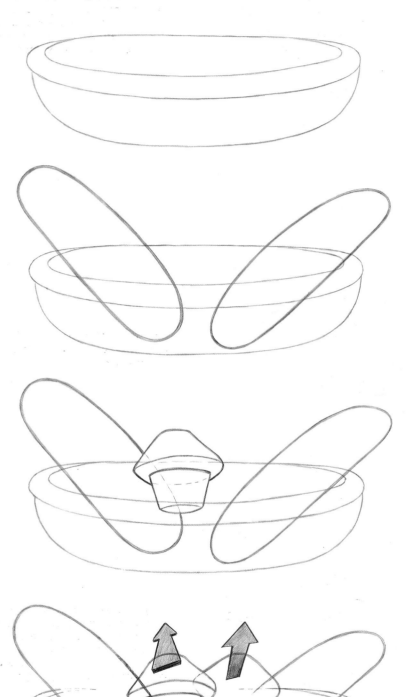

Begin with the basket. It will serve as the frame for all the other elements.

We'll start the composition symmetrically, using the two large loaves as bookends. Tilting them outward will make room for the rest of the items that will fill the bowl.

To add a feeling of "fullness" to the objects in the basket, place the muffin up high, as if the basket were overflowing with goodies.

Place the second muffin in front of the first to create depth. This muffin will tilt toward us, while the first tilts away, creating a dynamic push and pull.

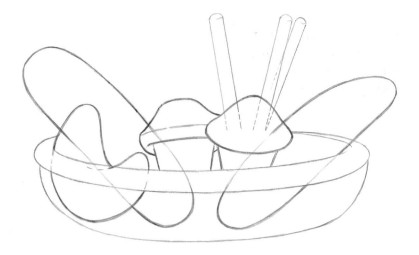

Note how the croissant and the breadsticks, placed on opposite sides of the basket, balance each other. The breadsticks are purposely stacked unevenly, to break up the symmetry, rather than all bunched together.

The bold pencil lines indicate the woven design of the basket, which is in the foreground.

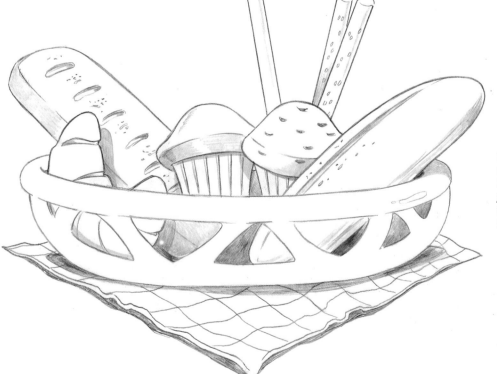

This final step adds a variety of different textures to the surfaces of the breads and muffins. I've shaded the bottom of the basket darkly to further add to the illusion of fullness. Crinkle up the napkin underneath the bowl to keep it from looking like a sheet of graph paper.

Objects from Study

Strategically arranging objects that share a common theme is another popular method for creating a still life. In this approach, the arrangement often appears studied, even conspicuous. It's all part of a rich atmosphere in a controlled setting.

This theme involves three classical fields of study in the Renaissance: anatomy, world exploration, and astronomy. Each field is represented by a relevant icon that evokes a past refined and dignified era.

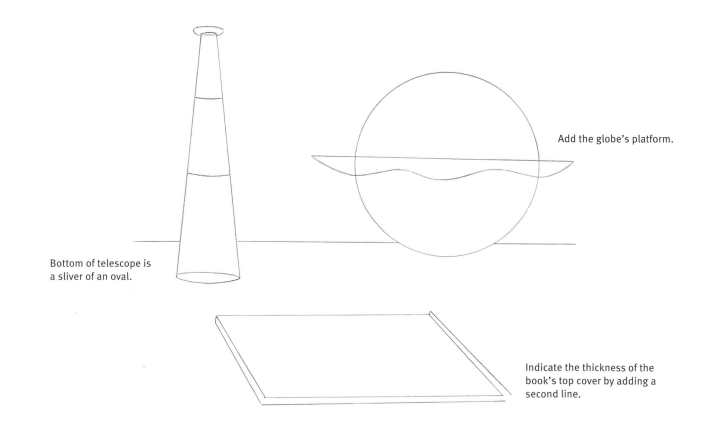

Telescope, based on the shape of a cone.

Globe is an obvious sphere.

Don't forget the horizon line, or the objects will all appear to be floating.

Book is based on a rectangle, drawn in perspective.

Add the globe's platform.

Bottom of telescope is a sliver of an oval.

Indicate the thickness of the book's top cover by adding a second line.

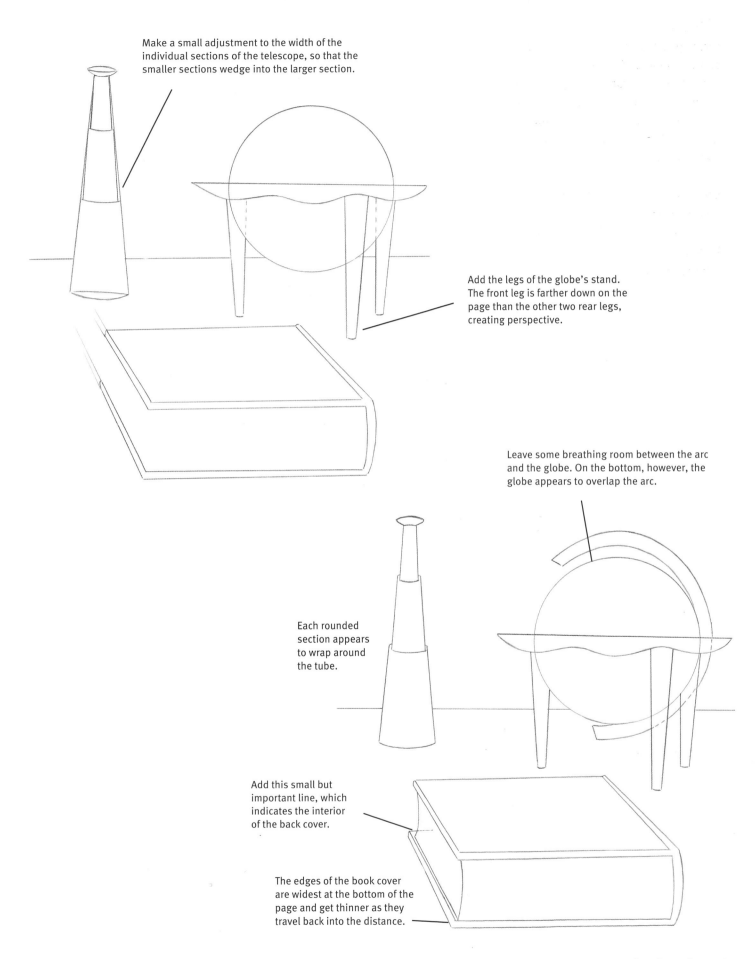

Make a small adjustment to the width of the individual sections of the telescope, so that the smaller sections wedge into the larger section.

Add the legs of the globe's stand. The front leg is farther down on the page than the other two rear legs, creating perspective.

Leave some breathing room between the arc and the globe. On the bottom, however, the globe appears to overlap the arc.

Each rounded section appears to wrap around the tube.

Add this small but important line, which indicates the interior of the back cover.

The edges of the book cover are widest at the bottom of the page and get thinner as they travel back into the distance.

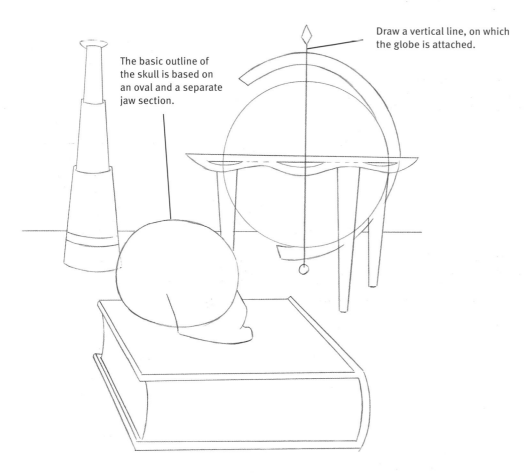

Draw a vertical line, on which the globe is attached.

The basic outline of the skull is based on an oval and a separate jaw section.

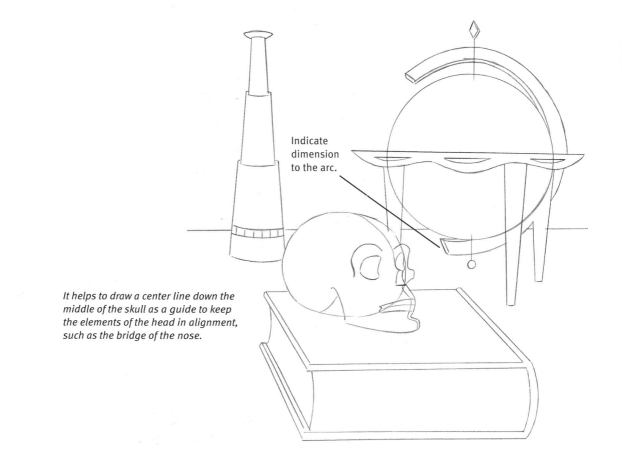

Indicate dimension to the arc.

It helps to draw a center line down the middle of the skull as a guide to keep the elements of the head in alignment, such as the bridge of the nose.

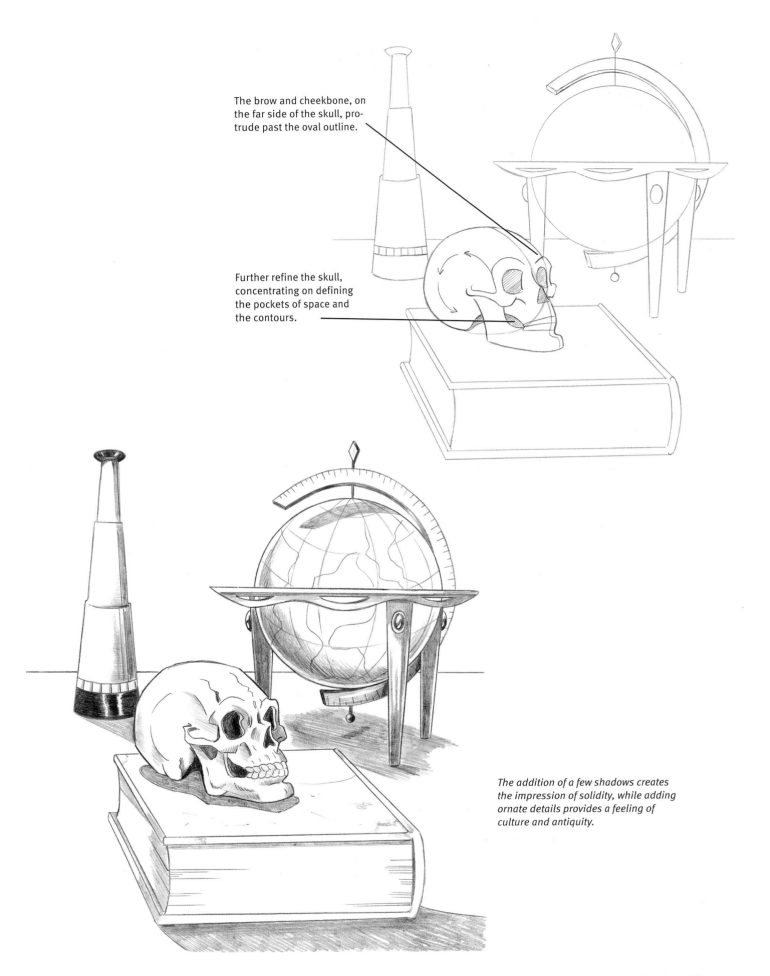

The brow and cheekbone, on the far side of the skull, protrude past the oval outline.

Further refine the skull, concentrating on defining the pockets of space and the contours.

The addition of a few shadows creates the impression of solidity, while adding ornate details provides a feeling of culture and antiquity.

PRACTICE: Indoor/Outdoor Still Life

You can add depth and expanse to a still life by using the outdoors as a backdrop. A view through the window opens up the scene. The picture is drawn in one-point perspective, as indicated by the X on the diagram. Note how the vanishing lines of the table and the painting converge at the center of the picture. This center spot is also where you could draw the horizon line (a horizontal guideline that goes across the page from left to right). But with so few objects using vanishing lines, the perspective middle is all we really need to indicate. Why clutter up the drawing with a lot of guidelines if you don't have to?

You might be wondering why the horizon line is at the X and not where the sky meets the hill. That's because the hill is elevated and, therefore, above the horizon. Additionally, you can see that a corner of the house faces toward you. As mentioned earlier, this means it's drawn in two-point perspective. Its vanishing lines travel downward, toward the level of the "X."

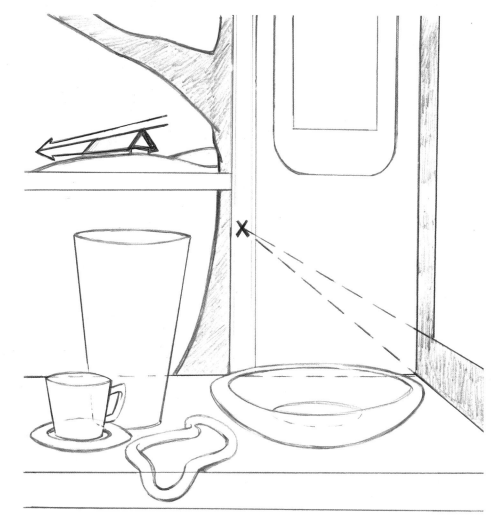

Simple Composition Hints

Instead of just tossing the various elements together, you should organize them using a few basic principles of composition. These techniques keep the picture from appearing cluttered and give it a visual rhythm. Here are some things to note and use in your artwork:

TANGENTS

Basically, tangents are points where one object touches another. In drawings, you mostly want to avoid creating these spots, because they look awkward. Notice how the far edge of the bowl rises slightly above the horizontal line of the table rather than stopping precisely on the line. Likewise, the top of the cup. And to avoid another tangent, the roof of the house doesn't touch the line of the hill but stops just short of it.

OVERLAP

Overlapping conveys the feeling of depth. Note how the string of pearls looks real. That's due to its being overlapped. The cup and vase are also overlapped, as is the house by the hill.

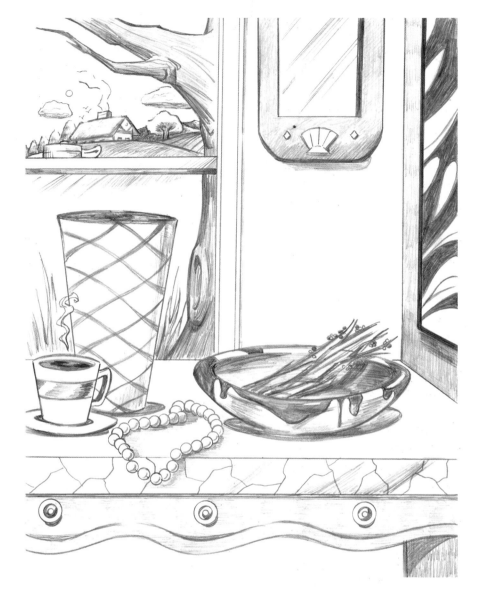

DIAGONALS

This is a very symmetrical scene, which gives it a feeling of stateliness; however, you can infuse an understated dynamic with energy by applying diagonals. The hill, house, and tree all use diagonals and, therefore, add energy to the scene.

PACING AND GROUPING

Instead of everything being spaced evenly apart, the objects appear randomly placed, which is more interesting. The vase and cup are grouped together, the bowl is solitary and placed toward the rear, and the pearls are placed toward the front in a casual manner.

SHADOW

Note that the right wall, which is drawn at an angle, is shaded. This differentiates it from the adjoining wall and gives the appearance of depth.

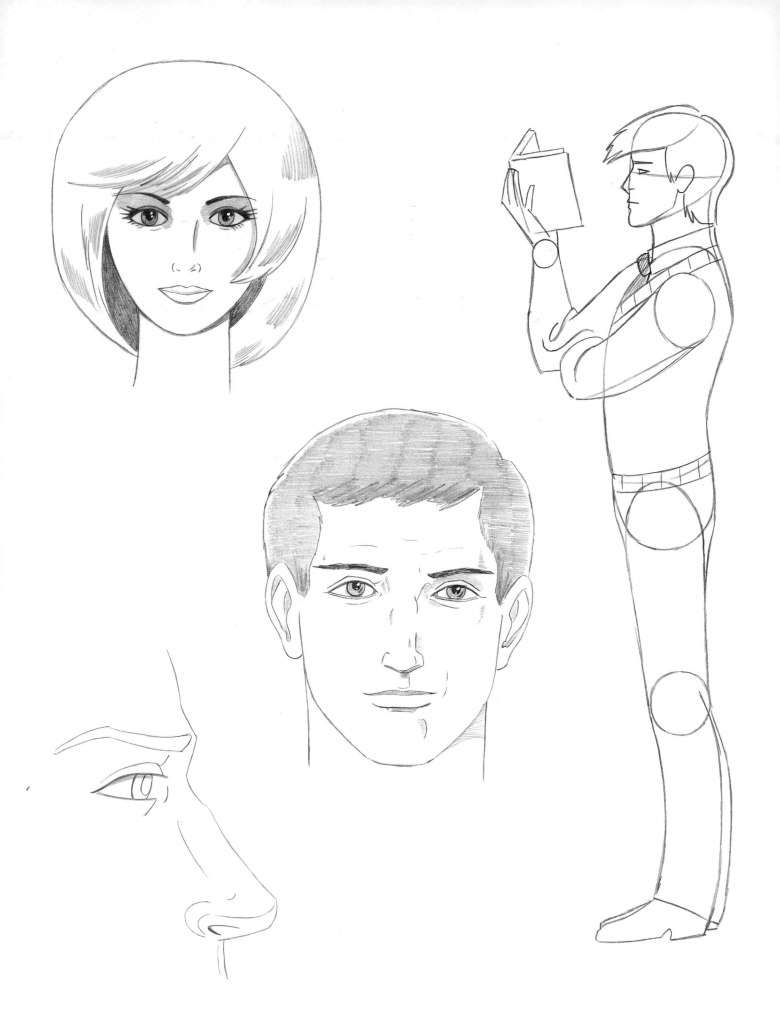

Drawing the Human Figure

All artists need to know how to draw people. Life drawing is considered one of the foundations for all art, and has been for centuries. Rather than focus on the minute details of the human anatomy, we'll focus on overarching concepts such as the correct placement of features, basic body construction, foreshortening, and balance. Combined with your already substantial knowledge of perspective, line flow, and harmonious composition, these skills will allow you to draw the human figure with confidence. Our gradually progressive steps are designed to help you succeed in this important section, too.

THE HEAD

Now that we've covered the essentials of drawing the features, we'll create the framework in which to put them. The foundation shape of the human head is a simple egg, turned so that the wide end is on top and the narrower end is on the bottom.

We can see immediately that the forehead takes up a good deal of space. This fact is often concealed by the hairline. For artists, it is important to become familiar with the head's true proportions and not allow details such as hair to alter the underlying structure.

Front View

In the front view, it's very important to line up all the features symmetrically, which means placing them on an even level so that the face doesn't appear lopsided. The eyes are on an even level; so are the ears and nostrils. The mouth is centered, unless an expression tugs it to one side. Use the vertical center line and the horizontal eye line as guideposts.

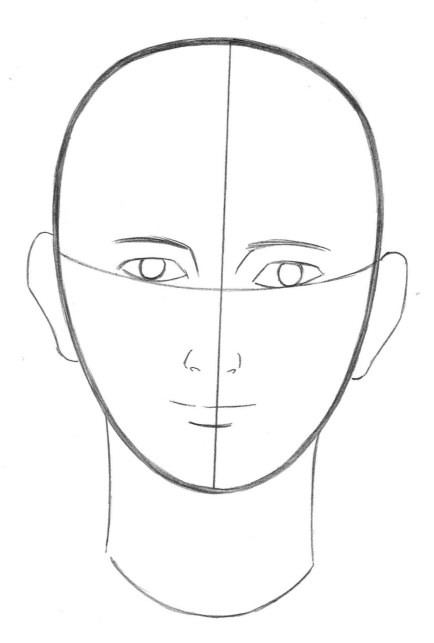

3/4 View

When the head is in a 3/4 view, the center line runs down the face in a curve. This occurs because the face plate is round, not flat.

The bridge of the nose goes at the intersection where the vertical and horizontal guidelines cross.

Due to perspective, more of the mouth appears on the near side of the center line than on the far side of it.

Side View

To make the anatomy appear correct, we add some mass to the back of the egg-shaped head, building out the skull. We also build out the brow and chin. In fact, the entire front of the face needs to be modeled including the nose, lips, and chin.

The ear appears approximately halfway across the head. (Most beginners assume the ear goes much farther back.)

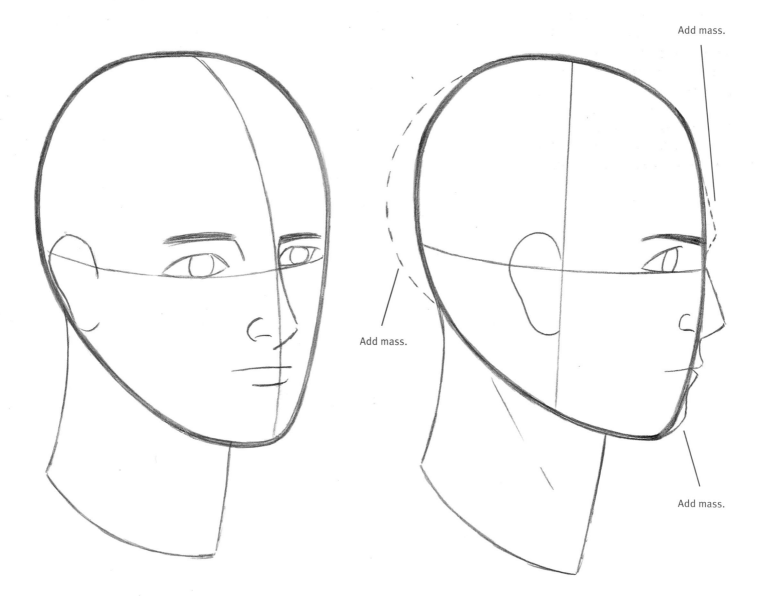

Add mass.

Add mass.

Add mass.

THE FEATURES OF THE FACE

The importance of facial features can't be overemphasized when learning to draw people, but many books that focus on drawing the human figure pay scant attention to them. This presents a problem for the beginning artist, who has little chance of having an enjoyable experience drawing the rest of the figure if he or she gets frustrated when it comes to the face.

The following examples are idealized versions of a variety of male and female features. They are good examples from which to learn the principles. Adjust them as you desire to create an individual look.

EYES

Front View — Male

The male eyebrow typically doesn't have a pronounced arch like the female's but is rather straight. It also slopes down toward the bridge of the nose.

Note that the upper eyelid is not a mirror image of the lower eyelid. Each line follows a different path around the curve of the eye.

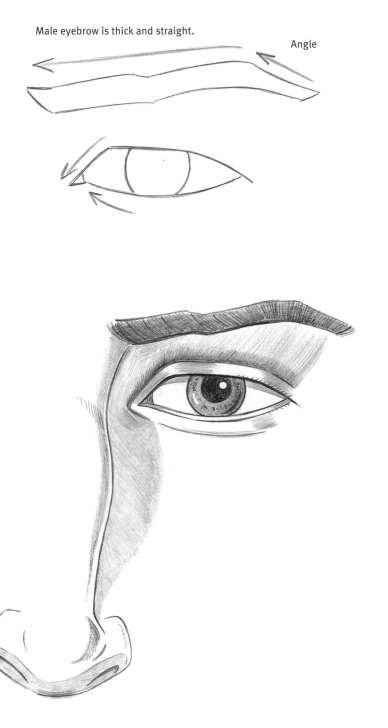

Male eyebrow is thick and straight.

Angle

The shine in the eye is always off to one side. If you place it dead center, it will appear that the person is looking into oncoming headlights.

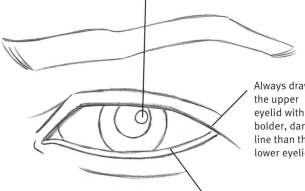

Always draw the upper eyelid with a bolder, darker line than the lower eyelid.

Show thickness of lower eyelid when character is close up.

Side View — Male

Many less-experienced artists attempt to draw a "front-view" eye on a "side-view" face, and naturally, it doesn't work. The eye must be severely shortened, perhaps even more than at first feels natural in the side view.

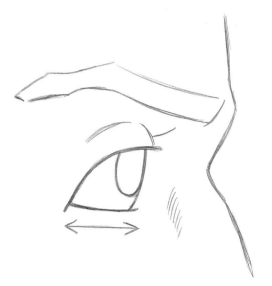

Correct Side-View Eye. Eye in profile at the correct length.

Incorrect Side-View Eye. This is a common mistake—drawing a front-view eye in a profile-view face. It's easy to see that the eye is too long.

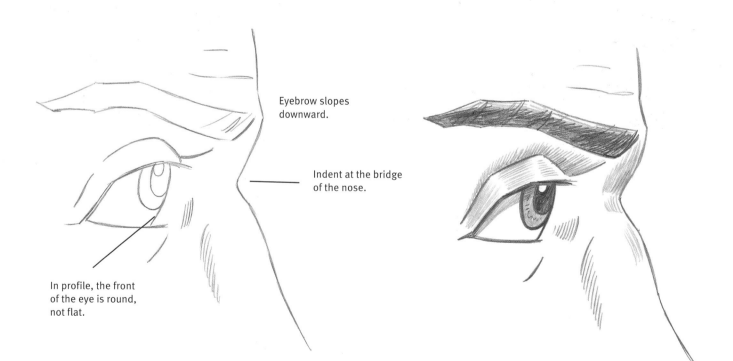

Eyebrow slopes downward.

Indent at the bridge of the nose.

In profile, the front of the eye is round, not flat.

Front View — Female

The female's eyes are wide in the middle but narrow at the ends. The eyebrow is narrow and often severely arched high on the forehead. Both the top and bottom eyelids are drawn with dark lines.

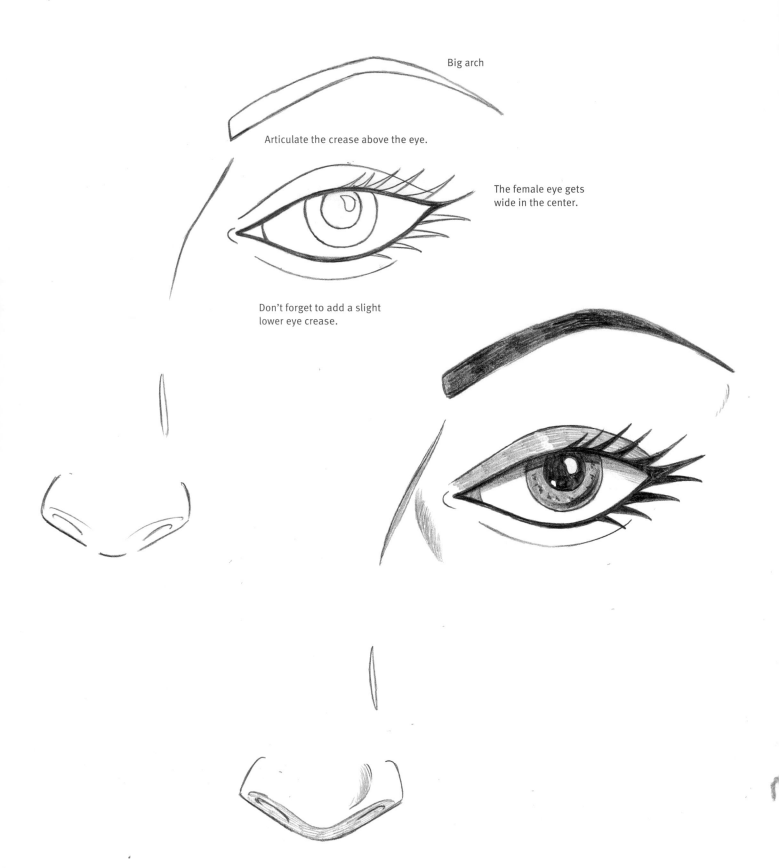

Big arch

Articulate the crease above the eye.

The female eye gets wide in the center.

Don't forget to add a slight lower eye crease.

Side View — Female

The eyelashes protrude in front and extend past the length of the eye. The high arch of the eyebrow is repeated in the side view. The lower eyelid is drawn more horizontally than the upper eyelid, which is drawn at a 45-degree angle.

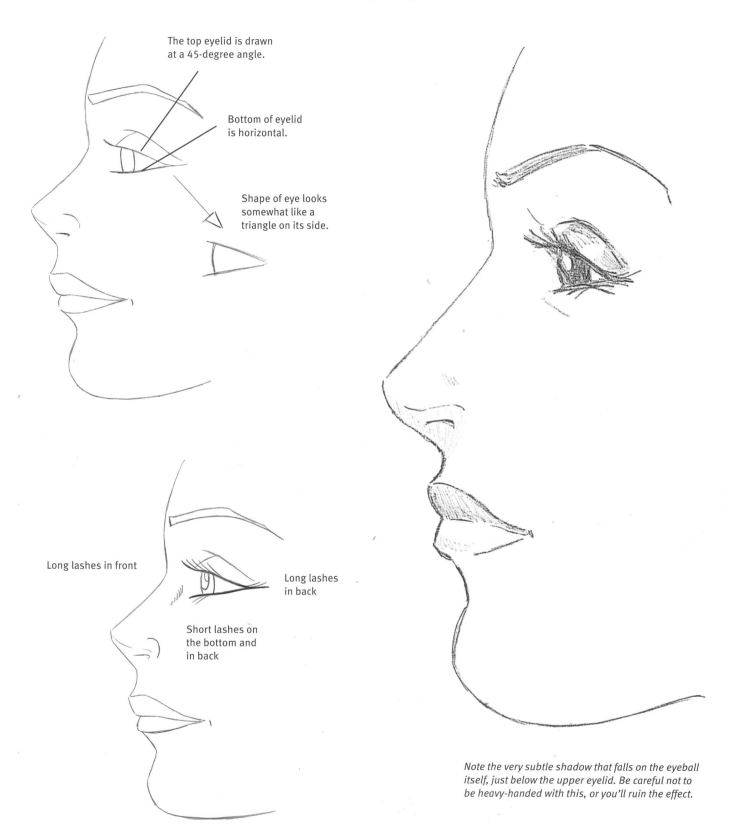

The top eyelid is drawn at a 45-degree angle.

Bottom of eyelid is horizontal.

Shape of eye looks somewhat like a triangle on its side.

Long lashes in front

Long lashes in back

Short lashes on the bottom and in back

Note the very subtle shadow that falls on the eyeball itself, just below the upper eyelid. Be careful not to be heavy-handed with this, or you'll ruin the effect.

NOSE

Front View — Male

The nose is made up of two distinct sections: the bony part just below the bridge of the nose and the ball of cartilage at the end of the nose. Neither should be heavily defined in your drawings, but they should contribute to the subtle contours of the outline.

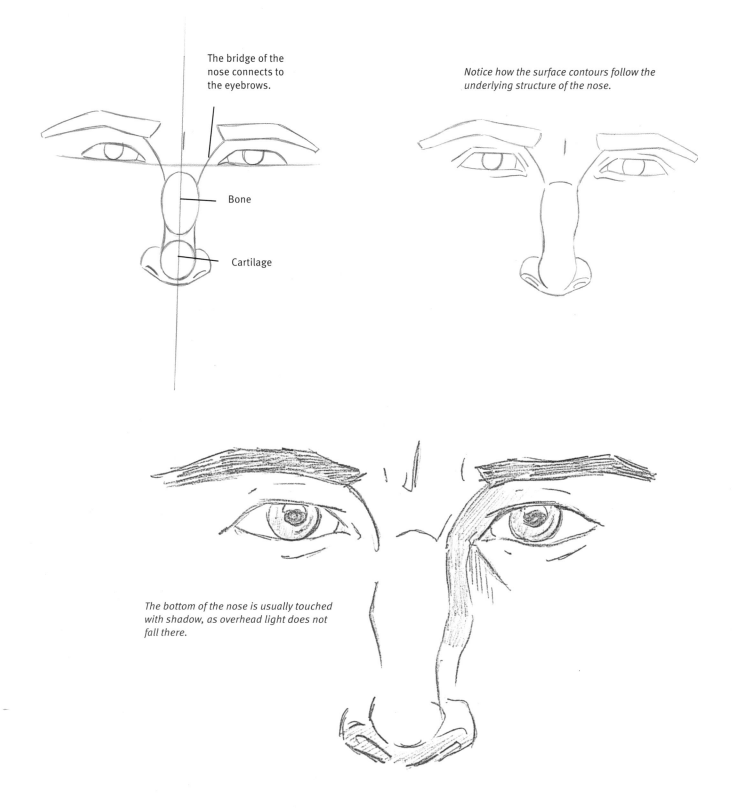

The bridge of the nose connects to the eyebrows.

Bone

Cartilage

Notice how the surface contours follow the underlying structure of the nose.

The bottom of the nose is usually touched with shadow, as overhead light does not fall there.

Side View — Male

The bridge of the male nose in the side view looks like a mini ski slope. At this angle, the brow of the forehead, just above the eyebrow, protrudes.

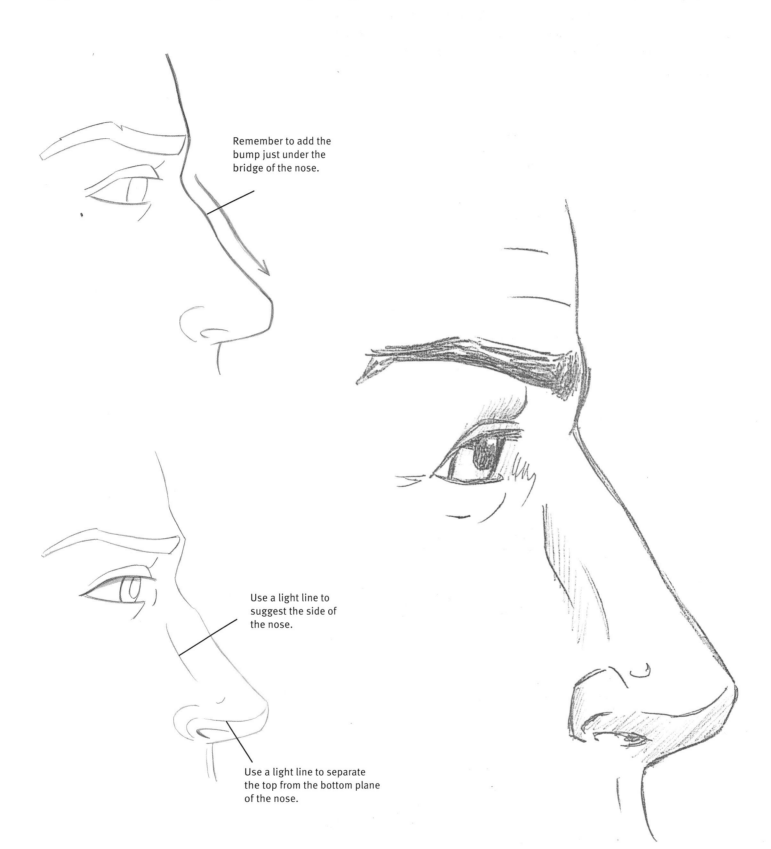

Remember to add the bump just under the bridge of the nose.

Use a light line to suggest the side of the nose.

Use a light line to separate the top from the bottom plane of the nose.

3/4 View — Male

The 3/4 view is an entirely different construction for the nose than we've drawn thus far. The placement of the nose in this angle affects the eyes, and they must be adjusted for the new perspective. As the head turns away from the viewer, it causes one eye to appear closer and one eye to appear farther away.

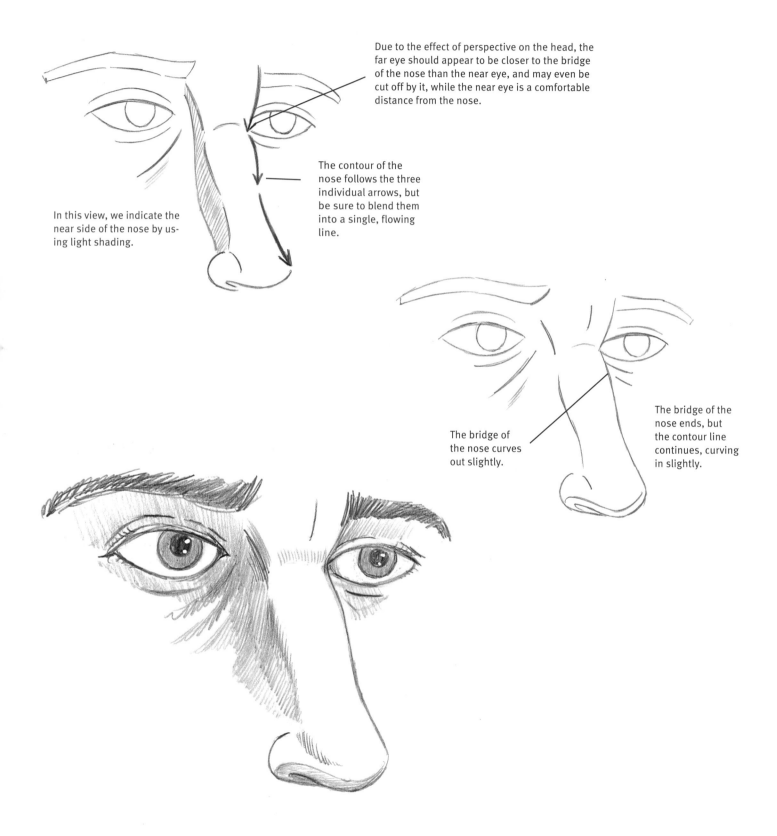

Due to the effect of perspective on the head, the far eye should appear to be closer to the bridge of the nose than the near eye, and may even be cut off by it, while the near eye is a comfortable distance from the nose.

The contour of the nose follows the three individual arrows, but be sure to blend them into a single, flowing line.

In this view, we indicate the near side of the nose by using light shading.

The bridge of the nose curves out slightly.

The bridge of the nose ends, but the contour line continues, curving in slightly.

Front View — Female

The female nose is treated quite differently from the male nose, in that the definition between the bone and cartilage areas isn't as defined. Instead, it is often quite smooth, which is what makes it appear feminine. The chiseled look is a masculine look. Note that the ball at the end of the female nose is small and subtle.

Structure of the female nose

In practice, artists often omit much of the definition of the female nose, especially the bridge. This results in a softer overall appearance to the face.

It's a stylistic choice among experienced illustrators to indicate only one side of the bridge of the nose, omitting the line on the other side.

Side View – Female

Compare the smooth profile of the female nose to that of the male nose. The male's heavy brow has also been eliminated on the female forehead. It has been replaced with a soft, round shape. The entire profile has been simplified, resulting in a softer and more feminine appearance.

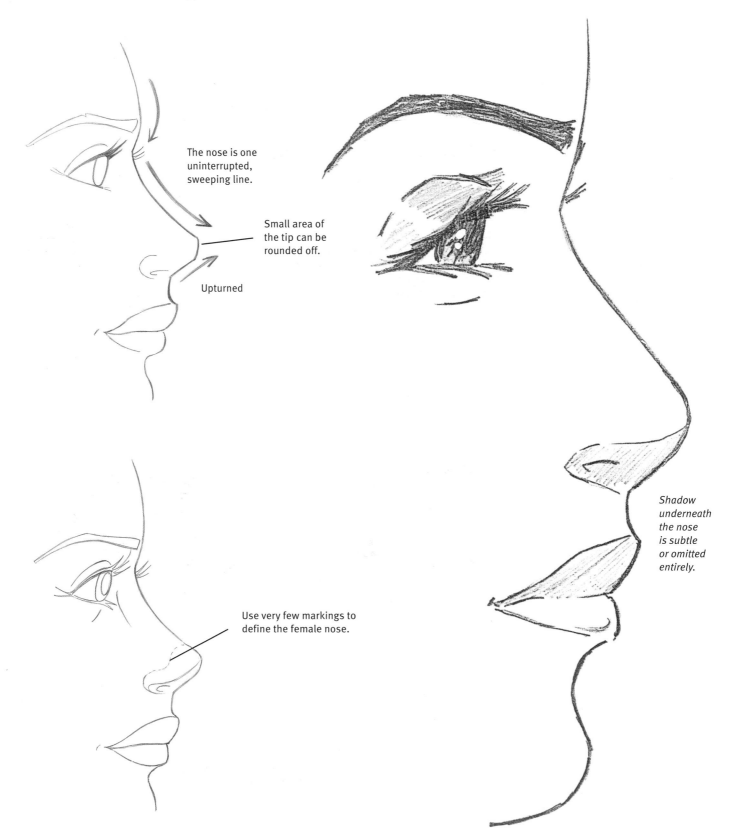

The nose is one uninterrupted, sweeping line.

Small area of the tip can be rounded off.

Upturned

Use very few markings to define the female nose.

Shadow underneath the nose is subtle or omitted entirely.

3/4 View — Female

The female nose in the 3/4 view glides down from the eyebrows to the tip of the nose in one sweeping line. The ball of the nose is small, and the nostrils have been drawn with only the barest amount of detail necessary. Articulating the holes in the nostrils may be accurate, but it often looks unattractive and therefore is done lightly.

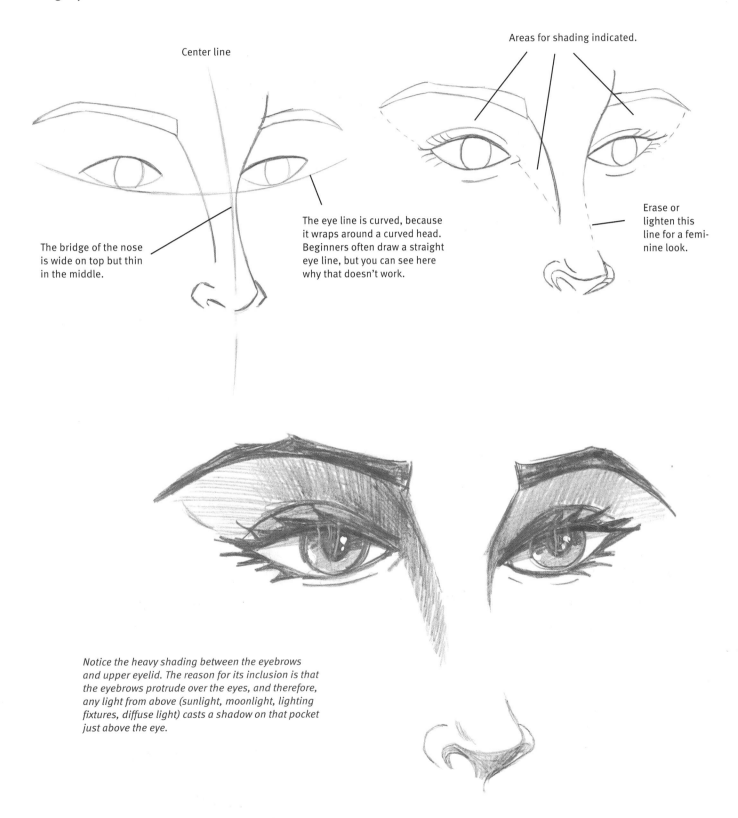

Center line

Areas for shading indicated.

The bridge of the nose is wide on top but thin in the middle.

The eye line is curved, because it wraps around a curved head. Beginners often draw a straight eye line, but you can see here why that doesn't work.

Erase or lighten this line for a feminine look.

Notice the heavy shading between the eyebrows and upper eyelid. The reason for its inclusion is that the eyebrows protrude over the eyes, and therefore, any light from above (sunlight, moonlight, lighting fixtures, diffuse light) casts a shadow on that pocket just above the eye.

MOUTH

Front View — Male

Beginning artists often think of male lips as two lines with no contours. The truth is that male lips have contours as well as thickness, but we've got to treat them subtly so that they don't appear too feminine. Let's take a look at how it's done.

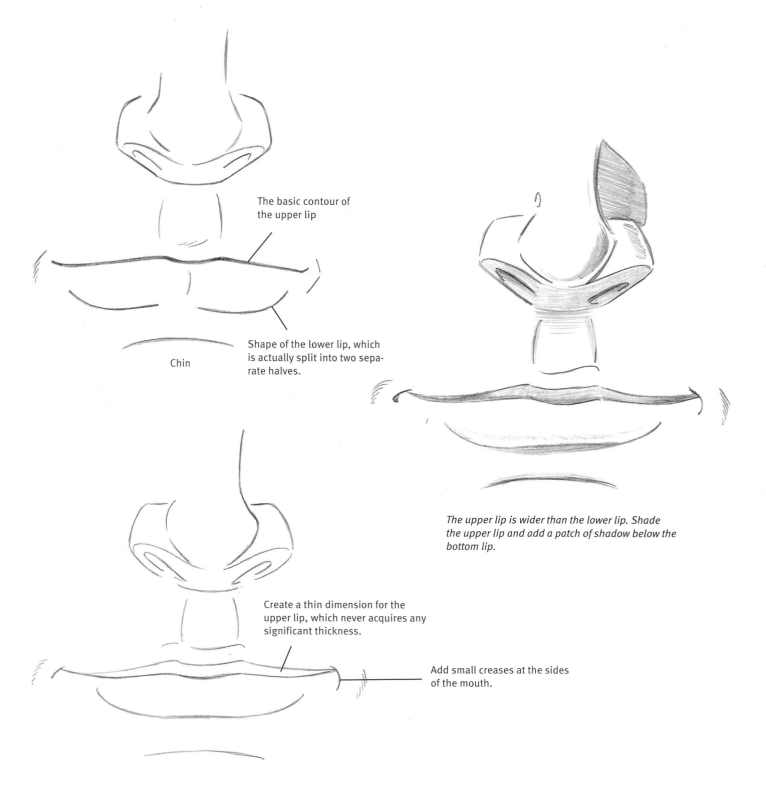

The basic contour of the upper lip

Shape of the lower lip, which is actually split into two separate halves.

Chin

Create a thin dimension for the upper lip, which never acquires any significant thickness.

Add small creases at the sides of the mouth.

The upper lip is wider than the lower lip. Shade the upper lip and add a patch of shadow below the bottom lip.

Side View — Male

Novice artists often stumble at the profile—specifically the lower half of the face. It's an area that requires a little troubleshooting. The outline of the front of the face below the nose is never a flowing line; it's a line with many abrupt shifts in angles. Even the lips possess their own separate planes.

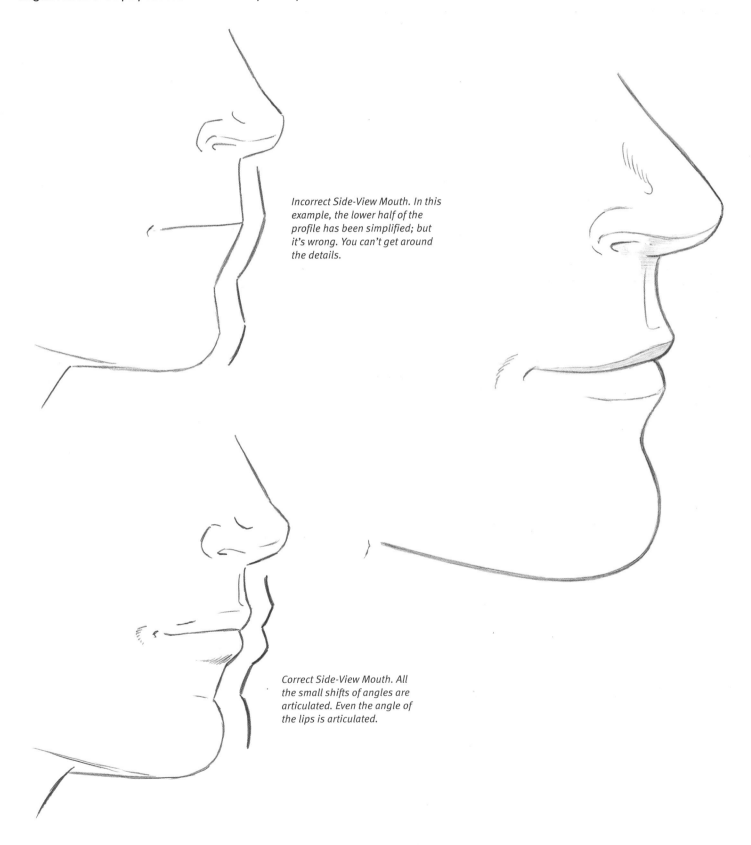

Incorrect Side-View Mouth. In this example, the lower half of the profile has been simplified; but it's wrong. You can't get around the details.

Correct Side-View Mouth. All the small shifts of angles are articulated. Even the angle of the lips is articulated.

Front View — Female

Many people find drawing attractive female lips challenging. Just remember: Keep the upper and lower lips looking smooth with only subtle curves, and you'll do well. Mistakes often occur from trying to get too fancy.

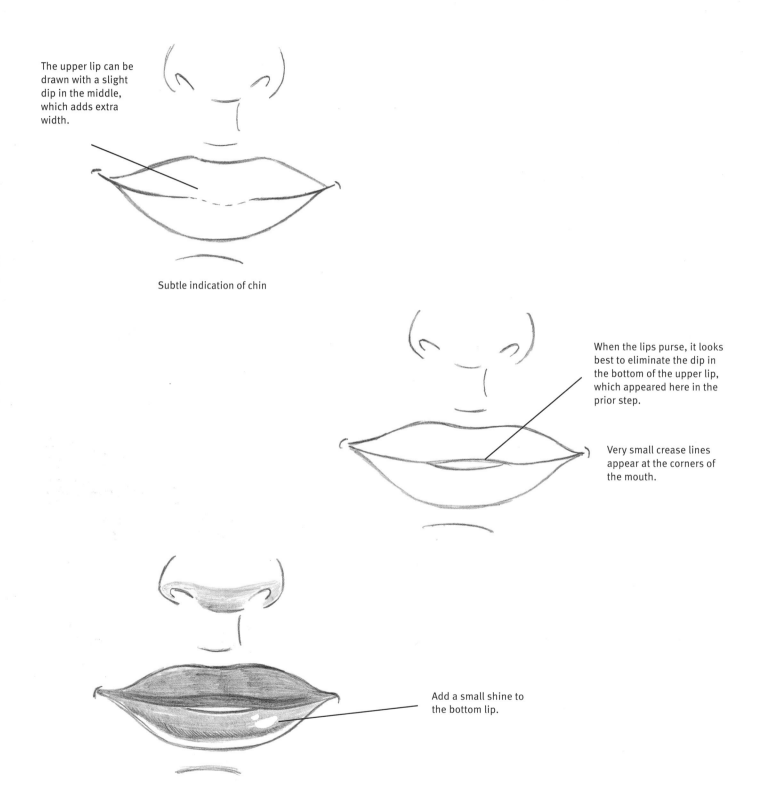

The upper lip can be drawn with a slight dip in the middle, which adds extra width.

Subtle indication of chin

When the lips purse, it looks best to eliminate the dip in the bottom of the upper lip, which appeared here in the prior step.

Very small crease lines appear at the corners of the mouth.

Add a small shine to the bottom lip.

Side View — Female

Female lips, in the side view, require a delicate touch to appear attractive. Fortunately, there are a few easy-to-follow rules of thumb that produce classic beautiful lips. First, never draw thin lips—always full. Second, avoid symmetry: In other words, make one lip thicker than the other. It doesn't matter which; in this example, I've chosen the bottom. And third, keep the length short, but the width thick.

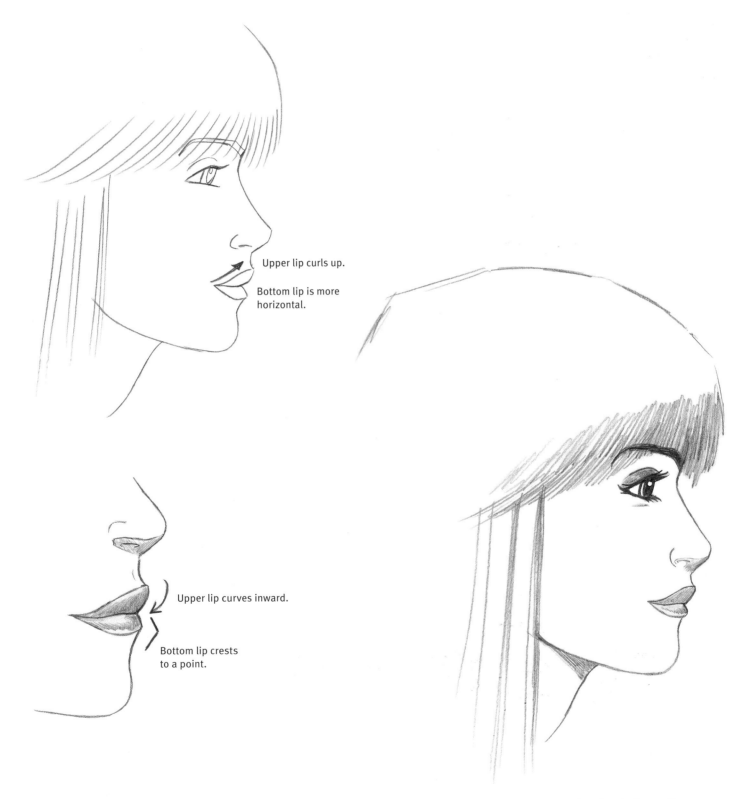

Upper lip curls up.

Bottom lip is more horizontal.

Upper lip curves inward.

Bottom lip crests to a point.

EARS

Because there's no significant difference between the construction of male ears and female ears, we'll use one example to represent both sexes. Don't be frustrated if you don't get it on the first try. Ears are deceptively difficult to draw. We'll try to make it easy by labeling the components in lay terms, rather than in their Latin names.

Side View

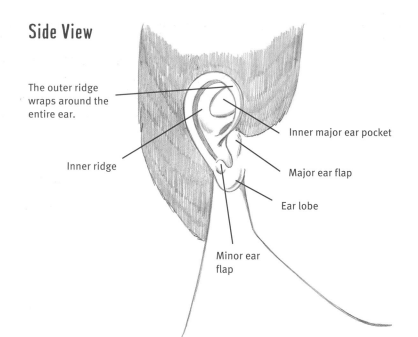

The outer ridge wraps around the entire ear.

Inner ridge

Inner major ear pocket

Major ear flap

Ear lobe

Minor ear flap

3/4 View

Note how the entire shape of the ear narrows—not unlike the way an oval narrows as it turns to the side—in perspective.

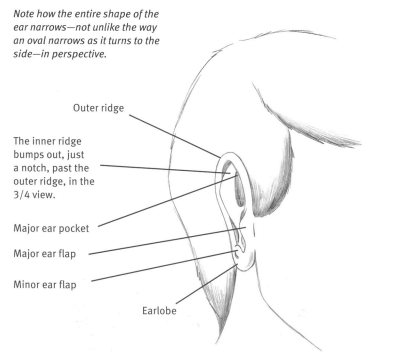

Outer ridge

The inner ridge bumps out, just a notch, past the outer ridge, in the 3/4 view.

Major ear pocket

Major ear flap

Minor ear flap

Earlobe

Rear View

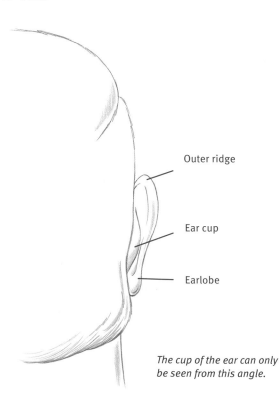

Outer ridge

Ear cup

Earlobe

The cup of the ear can only be seen from this angle.

THE PROPORTIONS OF THE FACE

Individuals exhibit subtle differences in their own head and body proportions, which make them unique—and interesting. One person may have smallish eyes. Another may have a particularly wide smile. So the "takeaway" is this: Familiarize yourself with guidelines, and follow them in general, but feel free to make adjustments and to experiment in order to arrive at more individualized personalities.

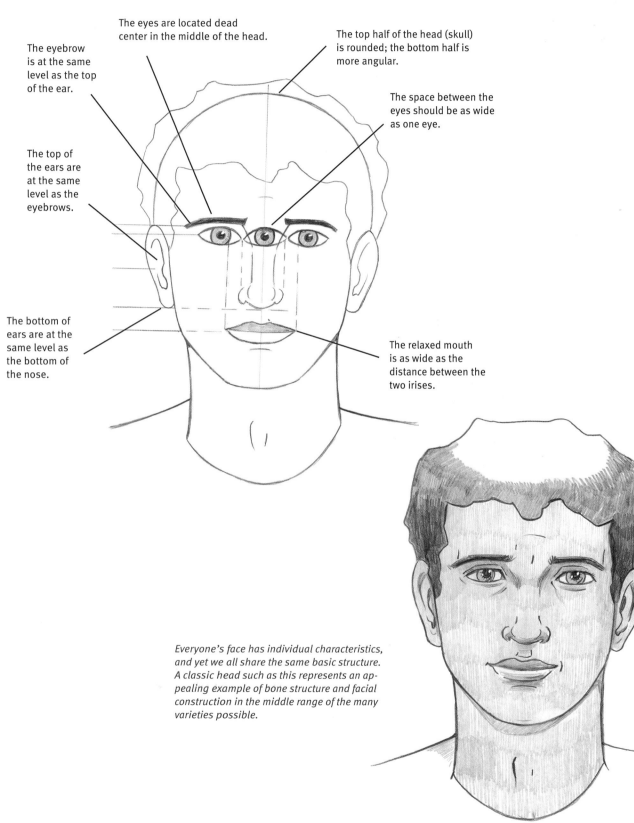

The eyebrow is at the same level as the top of the ear.

The eyes are located dead center in the middle of the head.

The top of the ears are at the same level as the eyebrows.

The top half of the head (skull) is rounded; the bottom half is more angular.

The space between the eyes should be as wide as one eye.

The bottom of ears are at the same level as the bottom of the nose.

The relaxed mouth is as wide as the distance between the two irises.

Everyone's face has individual characteristics, and yet we all share the same basic structure. A classic head such as this represents an appealing example of bone structure and facial construction in the middle range of the many varieties possible.

SHADING THE HEAD

In addition to contributing to the mood, shadows serve to effectively highlight the contours of the face, which further defines its shape. Some artists use a great deal of shadow—so much, in fact, that they allow some of the facial features to become subsumed into a pool of blackness. This can be an effective stylistic technique. Other artists use shadows sparingly, only as accents. The manner in which you use shadow is a matter of taste and may become a significant part of your personal style if you choose.

It's essential to first decide where the light source is coming from before one begins to shade an object. The position of the light determines the direction of the resulting shadows. Light causes shadows. Shadows are not random events.

No Directional Lighting
The face is not a flat surface. It is made up of three different planes, and various protruding surfaces, each of which interacts with the light in a different way. The three planes of the face are:

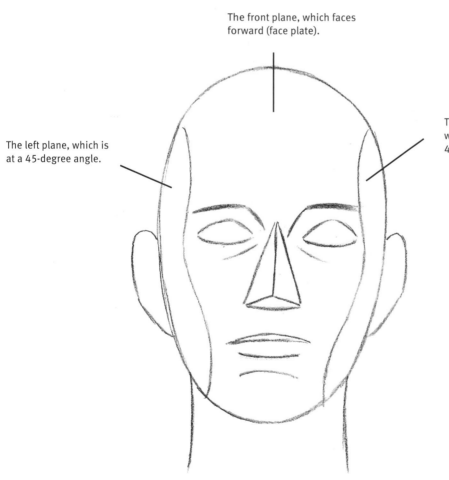

The front plane, which faces forward (face plate).

The left plane, which is at a 45-degree angle.

The right plane, which is also at a 45-degree angle.

Overhead Lighting

Overhead lighting is the default mode for artists. That's because it's what we assume the lighting condition is, unless otherwise indicated. Overhead lighting comes in so many familiar forms, from ceiling fixtures, sunlight, moonlight, and even interior ambient light.

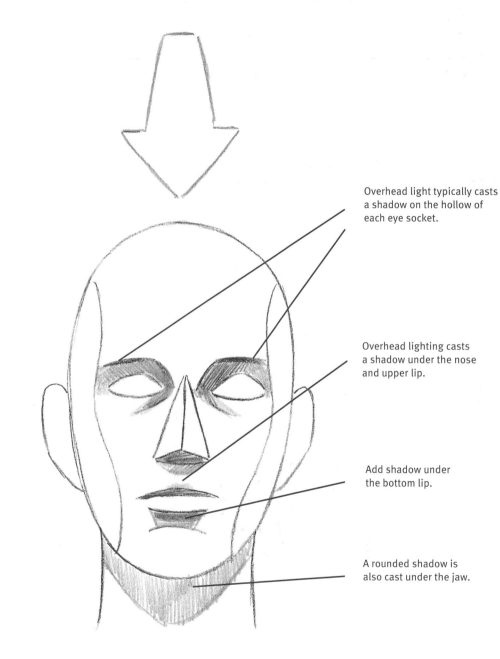

Overhead light typically casts a shadow on the hollow of each eye socket.

Overhead lighting casts a shadow under the nose and upper lip.

Add shadow under the bottom lip.

A rounded shadow is also cast under the jaw.

High-Angle Lighting

This light effect could be from indoor lighting from a table lamp or from late-afternoon sun. Note how one side of the face catches the light, while the other half is bathed in shadow.

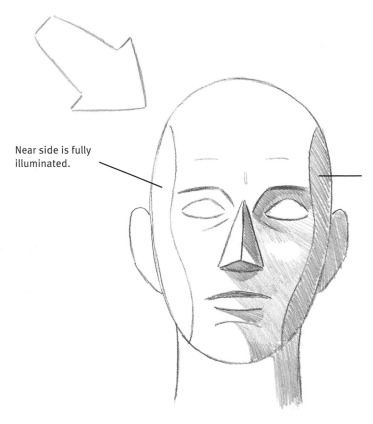

Near side is fully illuminated.

Far side, blocked from the light, falls into shadow.

Sidelighting

This technique is used to convey drama. The sidelit face does not progress gradually from light, to gray, to dark. Instead, it's more abrupt. This stark juxtaposition of light and dark adds an intensity to the mood. This is a personal favorite of mine. It's also a popular movie effect, frequently captured by storyboard artists.

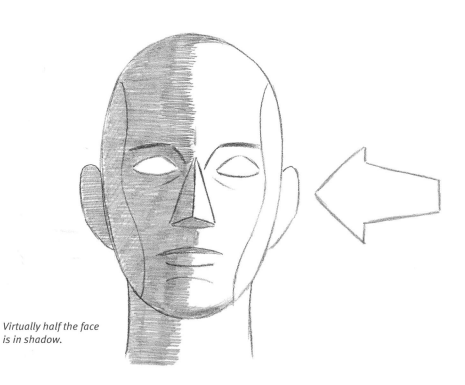

Virtually half the face is in shadow.

Bottom Lighting

This technique is reminiscent of someone holding a flashlight to his face as he tells a ghost story. Bottom lighting results in unsettling, creepy shadows.

Cast shadow from minor protrusions of the skull

Shadow

Cast shadow from chin

Both planes of nose are in shadow.

Cast shadow from Adam's apple

Light source

Opposing Light Sources

Light sources on either side of the head cause shadows to gather along an uneven, vertical streak in the middle. This strange and captivating effect results in an a mystical image. This is an excellent noir look used in graphic novels and comics illustration.

PORTRAIT VARIATIONS

Now that we've covered the basics for drawing the human head, it's time to put them into practice.

We'll start off with an easy-to-draw front view and then move on to other popular angles of the head. The key to being able to draw faces at any angle is establishing the foundation shape of the head correctly from the outset and then using the center line and eye line to lock the features into place. If you concentrate on these things first, you'll increase your chances for a successful drawing.

THE FRONT VIEW

Male

Believe it or not, symmetrical features of the face, like the eyes and ears, are not always as symmetrical as they appear to be. If you were to look very closely at another person, you would discover small differences in the symmetry of these features. Therefore, if you end up with minor, immaterial differences in the symmetry of your drawings, don't worry.

Still, it's good practice to do a quick spot check before you finish your drawings. Are both eyes the same amount of space away from the edge of the head? Are the ears on the same level? How about the eyebrows? Do they start off high and then angle downward toward the bridge of the nose at a similar angle?

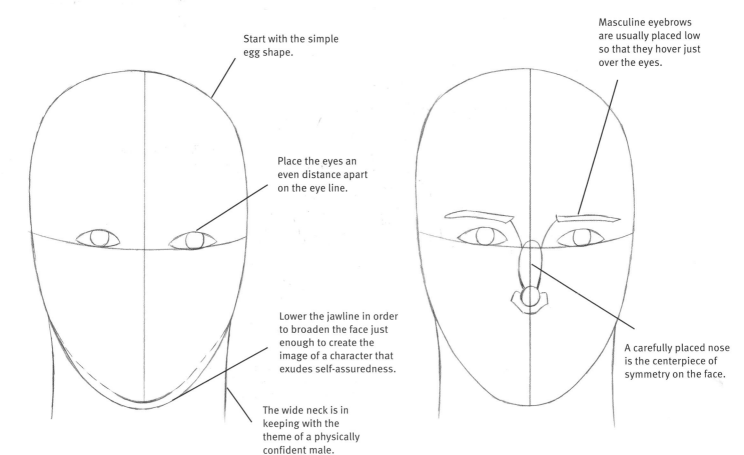

Start with the simple egg shape.

Place the eyes an even distance apart on the eye line.

Lower the jawline in order to broaden the face just enough to create the image of a character that exudes self-assuredness.

The wide neck is in keeping with the theme of a physically confident male.

Masculine eyebrows are usually placed low so that they hover just over the eyes.

A carefully placed nose is the centerpiece of symmetry on the face.

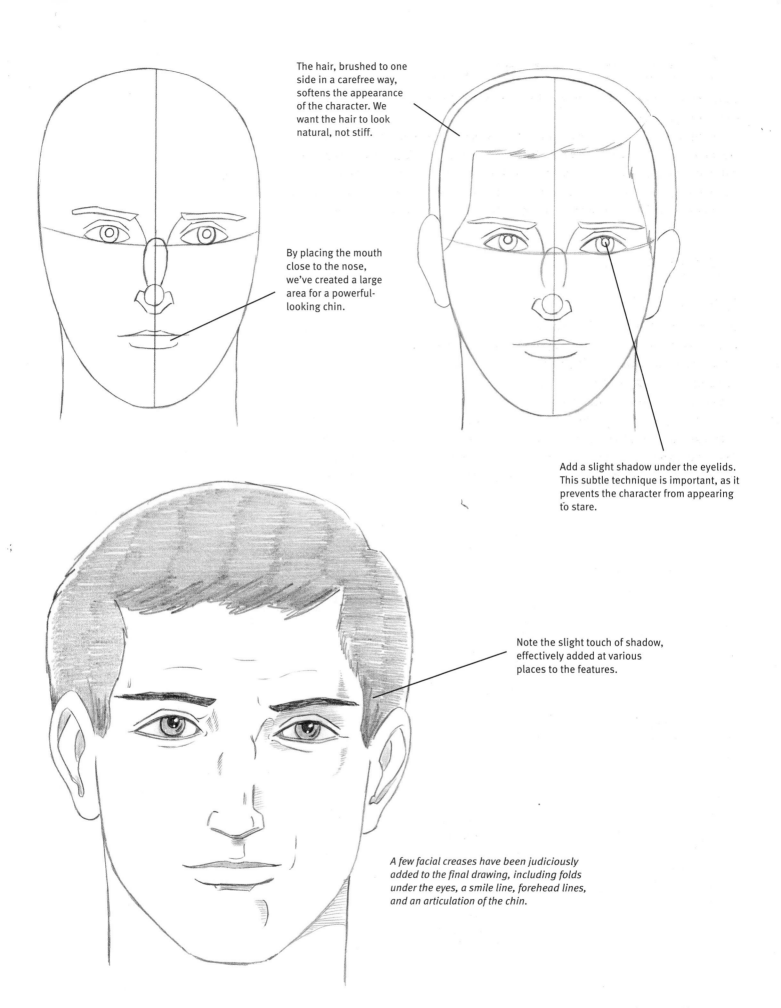

The hair, brushed to one side in a carefree way, softens the appearance of the character. We want the hair to look natural, not stiff.

By placing the mouth close to the nose, we've created a large area for a powerful-looking chin.

Add a slight shadow under the eyelids. This subtle technique is important, as it prevents the character from appearing to stare.

Note the slight touch of shadow, effectively added at various places to the features.

A few facial creases have been judiciously added to the final drawing, including folds under the eyes, a smile line, forehead lines, and an articulation of the chin.

Female

When drawing a front view, don't shy away from portraying the subject as though she were looking directly at the viewer. The straight-ahead look communicates a degree of openness. That said, it's not a requirement that a character make eye contact. Eyes cast downward read as reflective, or even sad. Eyes looking into the distance can appear hopeful or wistful. Keep in mind, though, that a hard shift of the eyes to the side in a front view can be misinterpreted as cunning or scheming.

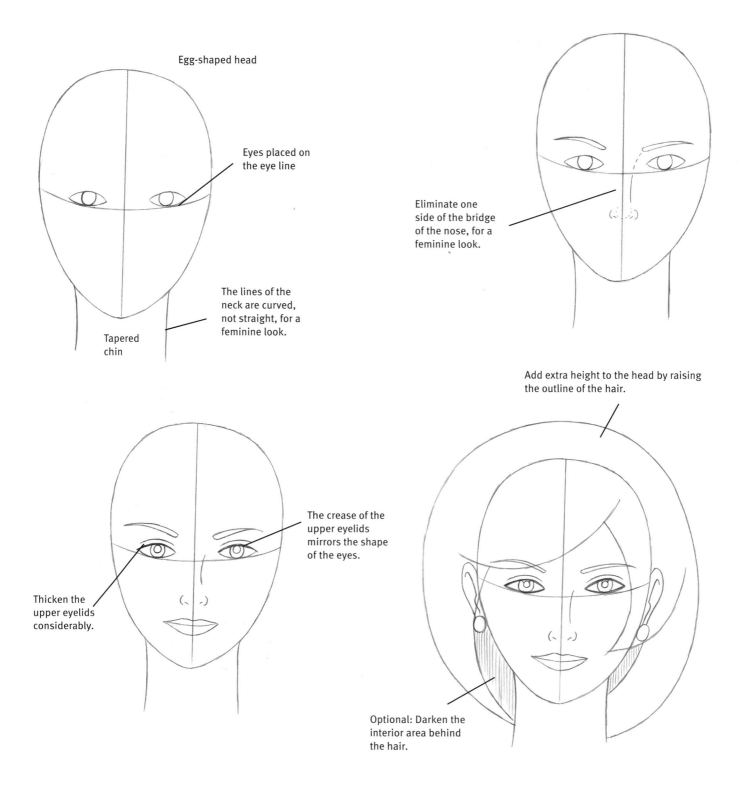

Egg-shaped head

Eyes placed on the eye line

The lines of the neck are curved, not straight, for a feminine look.

Tapered chin

Eliminate one side of the bridge of the nose, for a feminine look.

Add extra height to the head by raising the outline of the hair.

The crease of the upper eyelids mirrors the shape of the eyes.

Thicken the upper eyelids considerably.

Optional: Darken the interior area behind the hair.

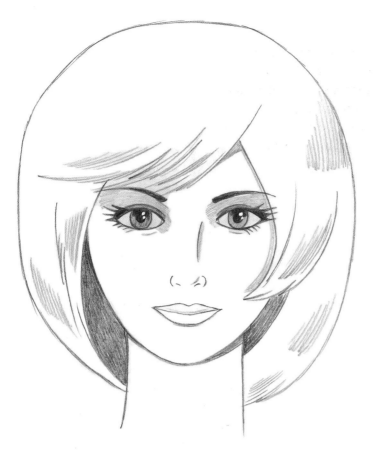

I've added a very dark tone to the eyelashes, which causes the eyes to stand out. There is also a sliver of shadow placed under the jaw (on the right side), which separates the head from the neck.

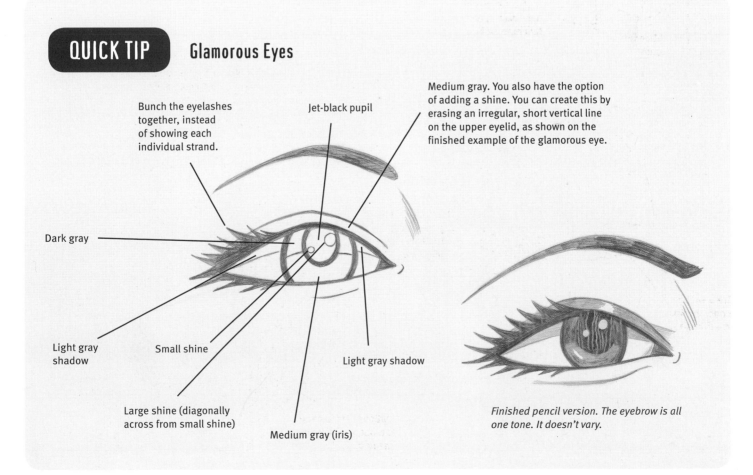

QUICK TIP **Glamorous Eyes**

Bunch the eyelashes together, instead of showing each individual strand.

Jet-black pupil

Medium gray. You also have the option of adding a shine. You can create this by erasing an irregular, short vertical line on the upper eyelid, as shown on the finished example of the glamorous eye.

Dark gray

Light gray shadow

Small shine

Large shine (diagonally across from small shine)

Medium gray (iris)

Light gray shadow

Finished pencil version. The eyebrow is all one tone. It doesn't vary.

THE SIDE VIEW

Male

A two-dimensional side view (profile) tends to flatten out the image. Therefore, it forces us to shift the emphasis of our technique from creating the illusion of roundness to articulating well-drawn features. Think of the head as a block of clay. We illustrators are like sculptors, using our pencil to slice away some mass here and add some mass there, until the face clearly reveals all of its planes and angles.

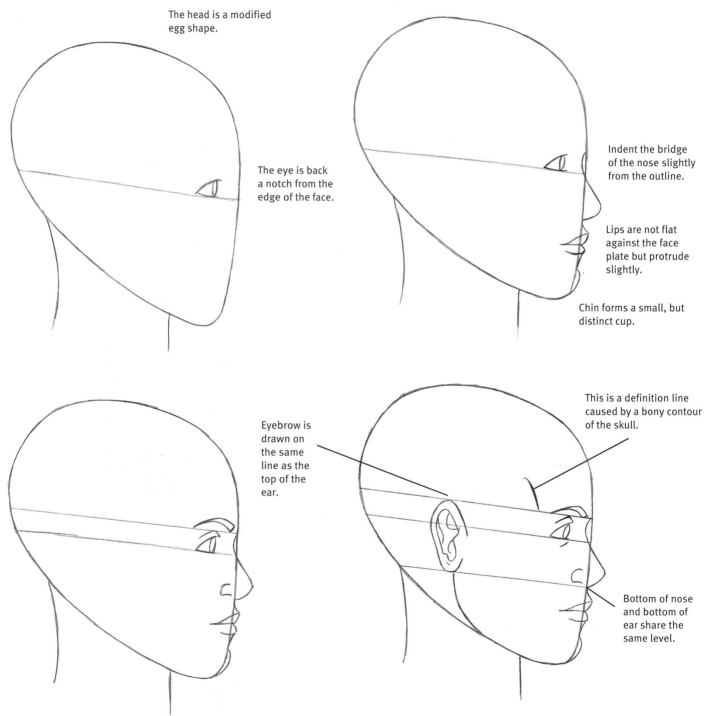

The head is a modified egg shape.

The eye is back a notch from the edge of the face.

Indent the bridge of the nose slightly from the outline.

Lips are not flat against the face plate but protrude slightly.

Chin forms a small, but distinct cup.

Eyebrow is drawn on the same line as the top of the ear.

This is a definition line caused by a bony contour of the skull.

Bottom of nose and bottom of ear share the same level.

This cut represents the classic hair-line. A fuller hairstyle camouflages the hairline but doesn't change it.

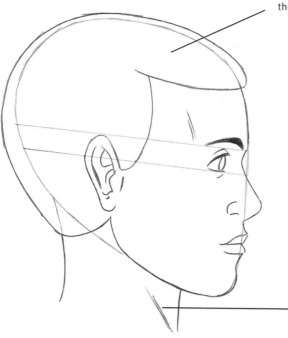

The main neck muscle travels from the collarbone to just below the earlobe at a diagonal. It only needs to be partially articulated in a relaxed pose.

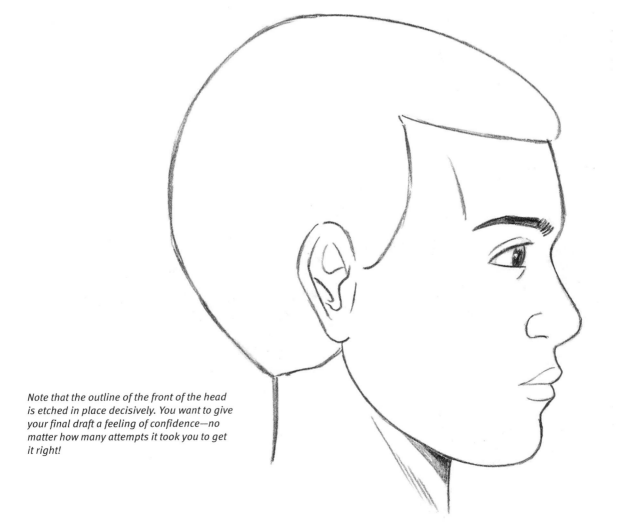

Note that the outline of the front of the head is etched in place decisively. You want to give your final draft a feeling of confidence—no matter how many attempts it took you to get it right!

Female

When drawing original characters from your imagination, you'll find that it's often most effective to begin by making small adjustments to the generic head type, rather than by starting off in a completely new direction. For example, this woman's head began with the standard egg shape. But with a few adjustments to her nose, lips, chin, and neck, coupled with a redesigned hairstyle, she has become an appealing character with her own individual look.

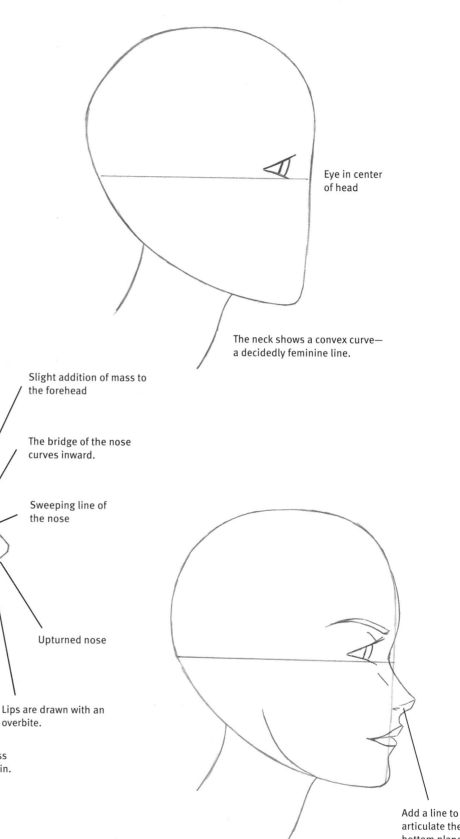

Eye in center of head

The neck shows a convex curve—a decidedly feminine line.

Slight addition of mass to the forehead

The bridge of the nose curves inward.

Sweeping line of the nose

Upturned nose

Lips are drawn with an overbite.

A tiny bit of mass added to the chin.

Add a line to articulate the bottom plane of the nose.

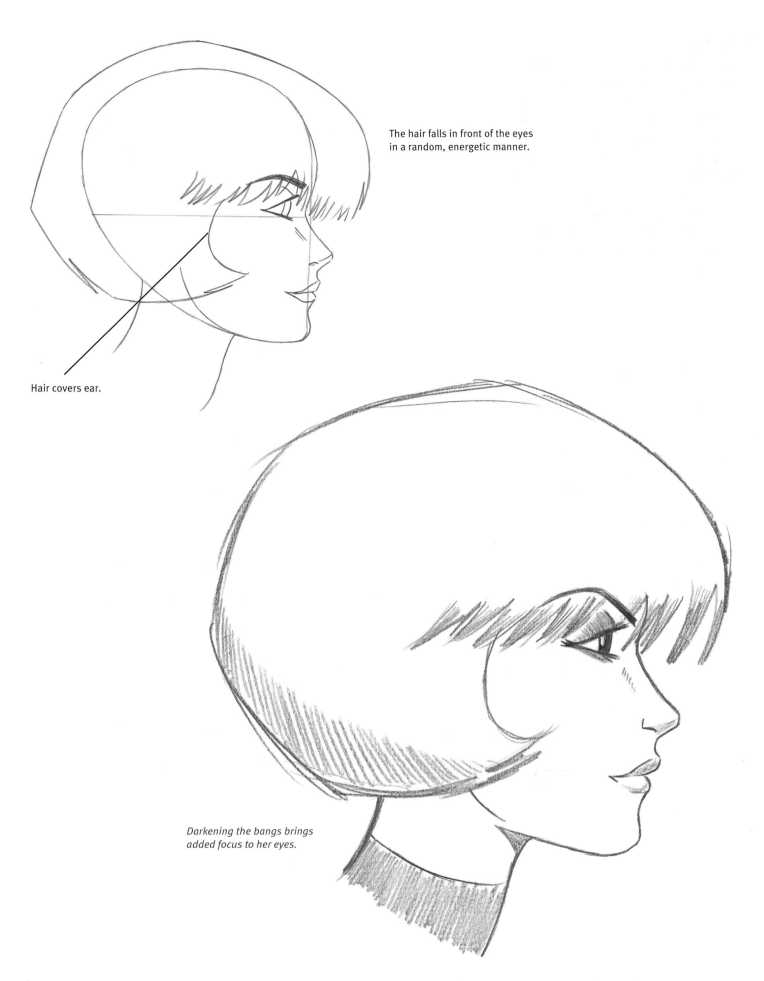

The hair falls in front of the eyes in a random, energetic manner.

Hair covers ear.

Darkening the bangs brings added focus to her eyes.

THE 3/4 VIEW

Male

At this point in the book, you may feel like an old hand at using the center line and the eye line and, therefore, may have begun to omit them when starting each drawing of the head. But the 3/4 view is a different animal than the front and side views, with its own quirky complications, including some of the effects of perspective. Therefore, neglecting to start off with guidelines when drawing this angle may result in a head that strikes the viewer as vaguely wrong.

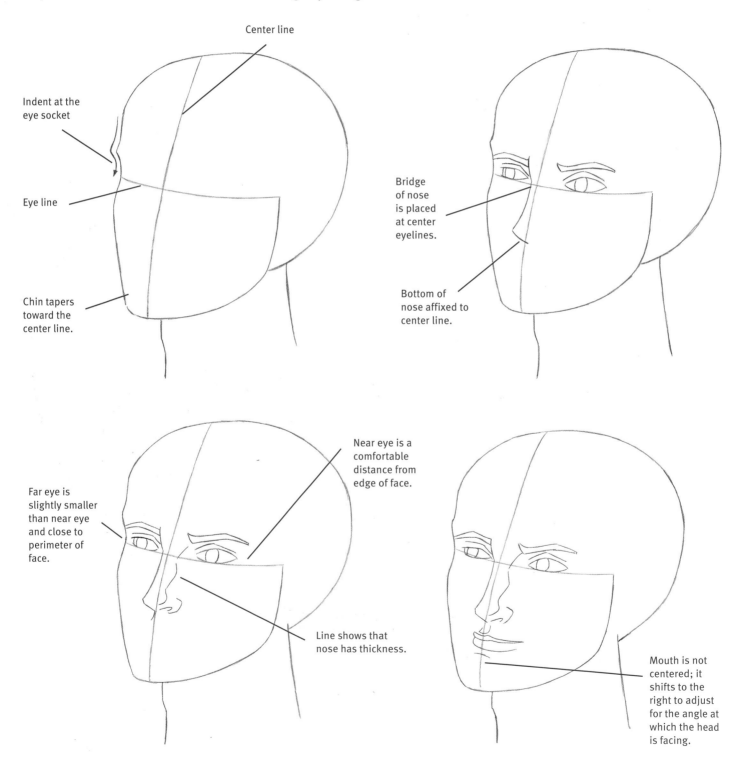

Center line

Indent at the eye socket

Eye line

Chin tapers toward the center line.

Bridge of nose is placed at center eyelines.

Bottom of nose affixed to center line.

Far eye is slightly smaller than near eye and close to perimeter of face.

Near eye is a comfortable distance from edge of face.

Line shows that nose has thickness.

Mouth is not centered; it shifts to the right to adjust for the angle at which the head is facing.

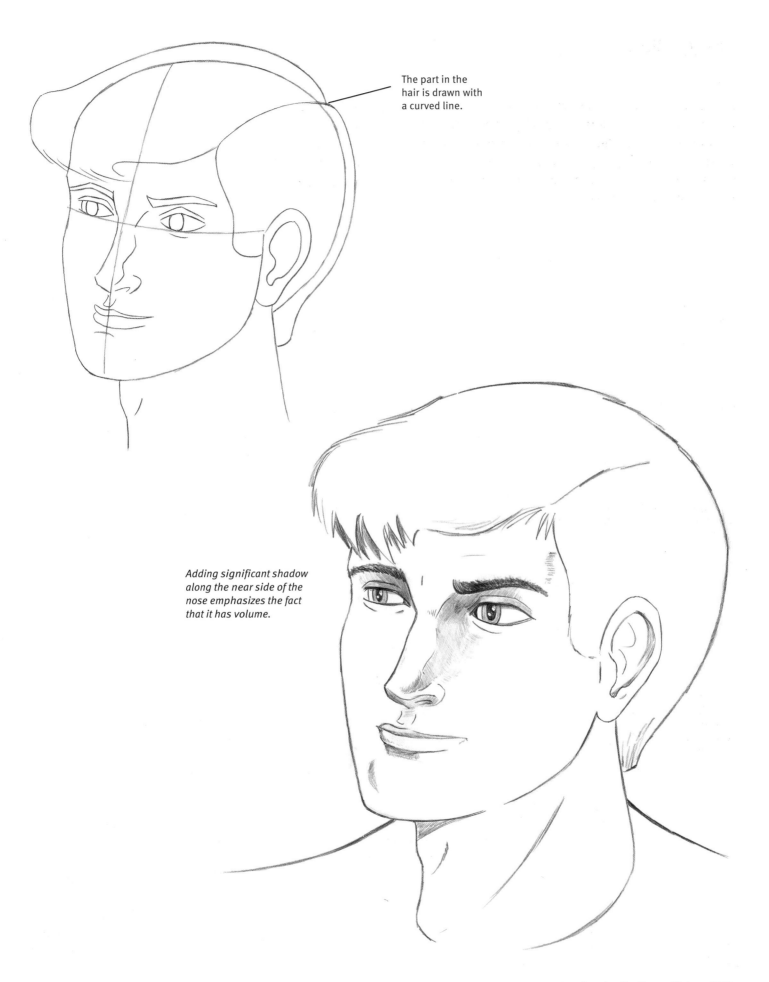

The part in the hair is drawn with a curved line.

Adding significant shadow along the near side of the nose emphasizes the fact that it has volume.

Female

An often overlooked, but important, tool to create the illusion of depth is the principle of *overlapping*. Why does overlapping create depth? Because our eye understands that there must be some degree of distance between layered objects.

In this example, the strands of hair that hang in front of and behind the model's face create two layers. The head is the middle layer. In effect, this constitutes a foreground, a middle ground, and a background. In addition, the bridge of the nose overlaps the far eye, which also creates a feeling of depth.

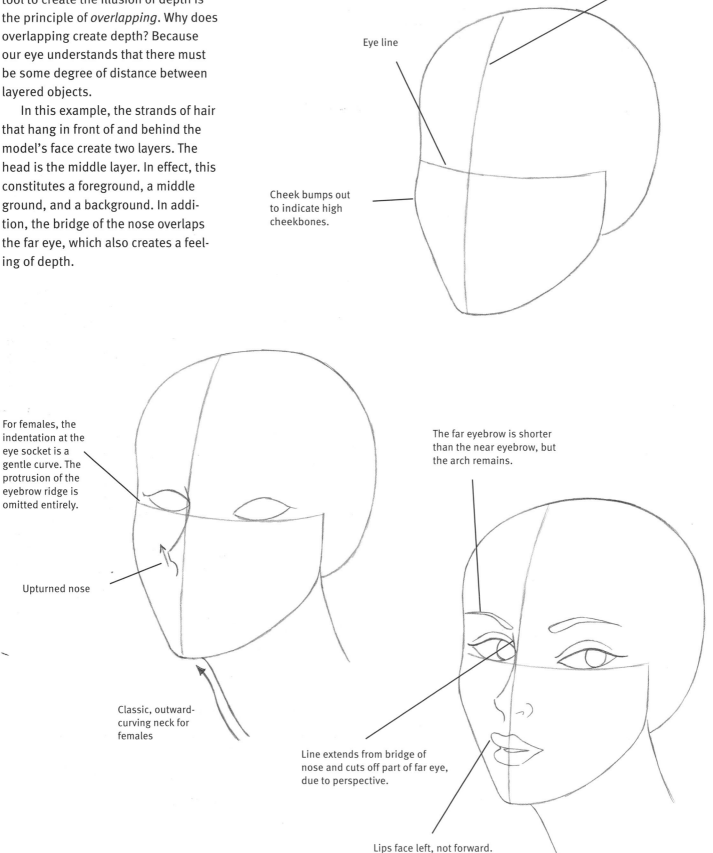

Center line

Eye line

Cheek bumps out to indicate high cheekbones.

For females, the indentation at the eye socket is a gentle curve. The protrusion of the eyebrow ridge is omitted entirely.

Upturned nose

Classic, outward-curving neck for females

The far eyebrow is shorter than the near eyebrow, but the arch remains.

Line extends from bridge of nose and cuts off part of far eye, due to perspective.

Lips face left, not forward.

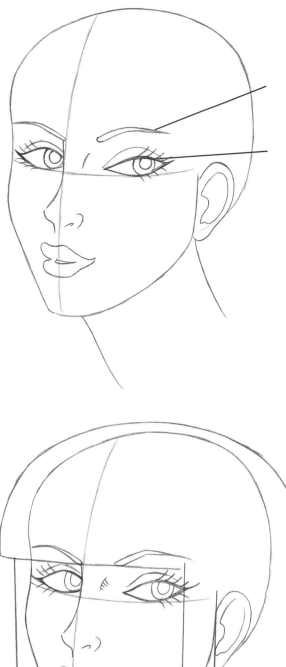

Sharpen the eyebrows for a stylish look.

Add details: The eyelashes brush away from the eyes.

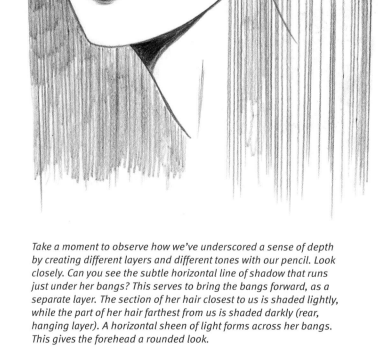

The hair is always drawn after the basic head is constructed. The hair is not part of the foundation structure.

Take a moment to observe how we've underscored a sense of depth by creating different layers and different tones with our pencil. Look closely. Can you see the subtle horizontal line of shadow that runs just under her bangs? This serves to bring the bangs forward, as a separate layer. The section of her hair closest to us is shaded lightly, while the part of her hair farthest from us is shaded darkly (rear, hanging layer). A horizontal sheen of light forms across her bangs. This gives the forehead a rounded look.

THE 7/8 VIEW

Male

There are four basic head "tilts," or positions, that every artist should know. They include the front view, the side view, the 3/4 view, and one more, which is curiously absent in most drawing books: the 7/8 view. The 7/8 angle creates a particularly appealing portrait and is also commonly seen in various forms of illustration and in many classical portrait paintings by the masters, which are displayed in museums. In this view, the face appears highly chiseled and well defined. This angle enhances the stature of the subject.

The most important step in drawing this angle is the first one: the correct placement of the center line. The center line must be placed far to one side of the head and, likewise, the bridge of the nose. Then all the other features will fall into place.

To demonstrate the 7/8 angle, we'll use a simple globe with vertical and horizontal axes to represent the human head:

Front View. Where the lines cross is the center. The center faces directly at the viewer.

3/4 Angle. Turned slightly, but not enough to be in a profile (a side view), the globe is at a 45-degree angle.

7/8 Angle. Now the globe is turned just as far as it can go, before turning into a complete side view. So the 7/8 angle is a step exactly between a 3/4 angle and a profile.

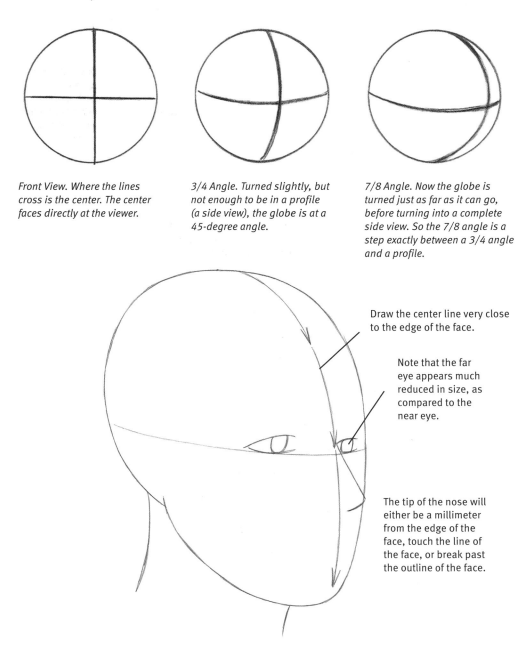

Draw the center line very close to the edge of the face.

Note that the far eye appears much reduced in size, as compared to the near eye.

The tip of the nose will either be a millimeter from the edge of the face, touch the line of the face, or break past the outline of the face.

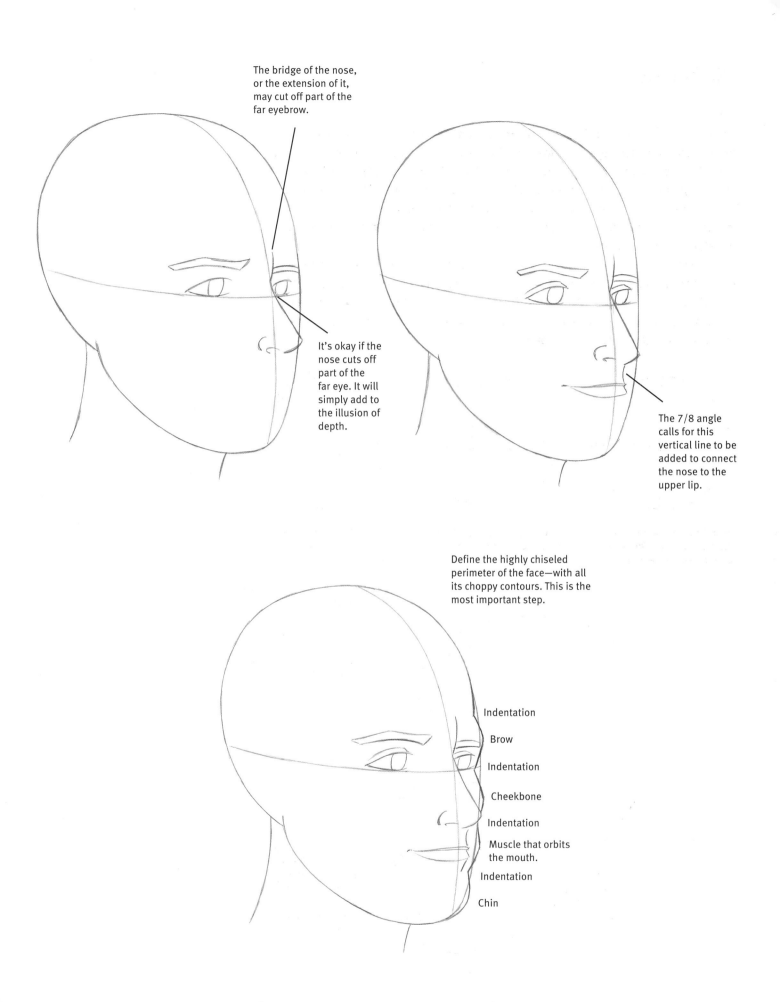

The bridge of the nose, or the extension of it, may cut off part of the far eyebrow.

It's okay if the nose cuts off part of the far eye. It will simply add to the illusion of depth.

The 7/8 angle calls for this vertical line to be added to connect the nose to the upper lip.

Define the highly chiseled perimeter of the face—with all its choppy contours. This is the most important step.

Indentation

Brow

Indentation

Cheekbone

Indentation

Muscle that orbits the mouth.

Indentation

Chin

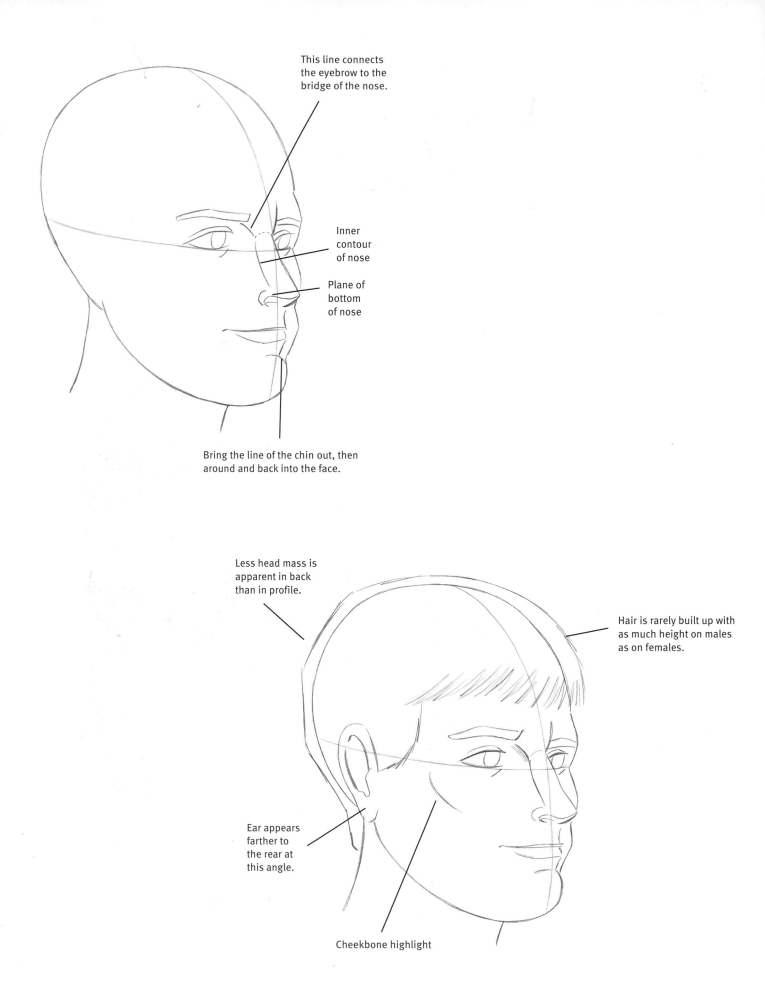

This line connects the eyebrow to the bridge of the nose.

Inner contour of nose

Plane of bottom of nose

Bring the line of the chin out, then around and back into the face.

Less head mass is apparent in back than in profile.

Hair is rarely built up with as much height on males as on females.

Ear appears farther to the rear at this angle.

Cheekbone highlight

The Facial Outline in 7/8 View

Unique to the 7/8 angle is its emphasis on the far outline of the face. The bridge of the nose cuts off part of the far eye. The tip of the nose is drawn either very close to the outline of the face or slightly past it.

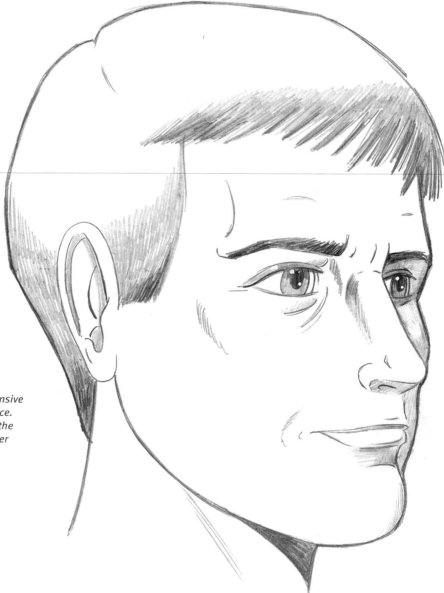

You'll notice that we've applied a fairly extensive variety of gray tones to the far side of the face. This creates the illusion that the far side of the face is receding from us and that the brighter side is closer to us.

SIMPLIFIED ANATOMY

We're going to take a look at the front, side, and back positions of the basic body. I have emphasized certain important muscle groups over smaller obscure groups, to keep this section practical and easy to learn.

Males and females have identical muscles. So why are we showing examples of both genders? Because the shape of their physiques and the distribution of muscle mass differ, sometimes to a considerable extent.

We'll use simplified models to demonstrate the building blocks of the human figure. These are not typical "muscle charts," that feature countless illustrations of obscure muscles and their impossible-to-pronounce Latin names. These models are much more practical, combining basic muscle groups and major bones along with the instructions you need to bring your figures to life.

MALE ANATOMY

Front View — Male

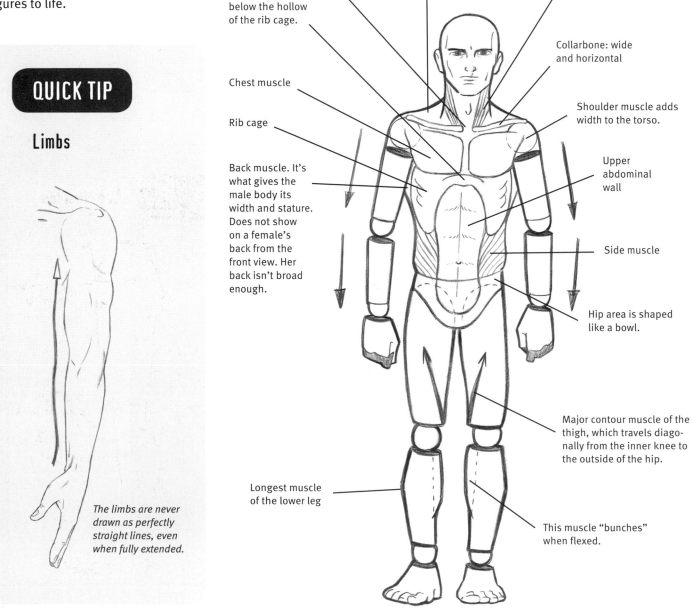

QUICK TIP

Limbs

The limbs are never drawn as perfectly straight lines, even when fully extended.

This muscle connects the neck to the shoulders.

Gap between the two collarbones

The major neck muscles

Sternum, just below the hollow of the rib cage.

Collarbone: wide and horizontal

Chest muscle

Shoulder muscle adds width to the torso.

Rib cage

Upper abdominal wall

Back muscle. It's what gives the male body its width and stature. Does not show on a female's back from the front view. Her back isn't broad enough.

Side muscle

Hip area is shaped like a bowl.

Major contour muscle of the thigh, which travels diagonally from the inner knee to the outside of the hip.

Longest muscle of the lower leg

This muscle "bunches" when flexed.

Side View — Male

Major muscles of the front of the neck

Muscle connecting neck to shoulder

The end of the collarbone creates a visible "bump" on top of each shoulder.

Back muscle (as seen through arm)

Side muscle

Lower back is always curved. This is very important in creating a lifelike posture in any stance.

Direction of side muscle, near upper thigh joint

Rear line of the lower leg curves outward.

Chest muscle wedges into the shoulder muscle.

Chest muscle

Directional "flow line" of the legs

Front line of calf is straight or curves inward.

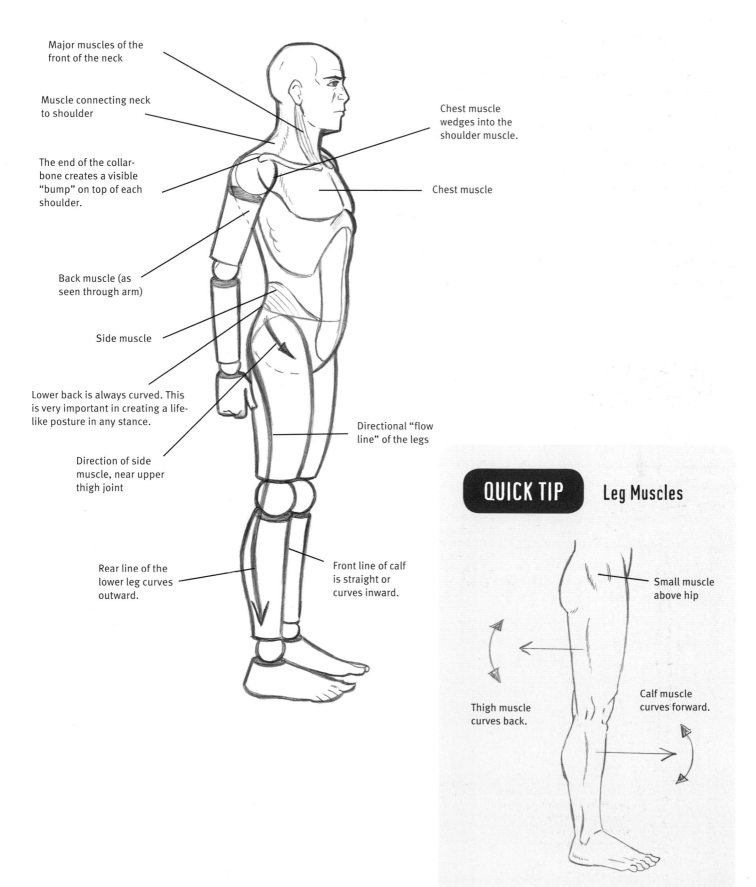

QUICK TIP Leg Muscles

Small muscle above hip

Thigh muscle curves back.

Calf muscle curves forward.

Rear View — Male

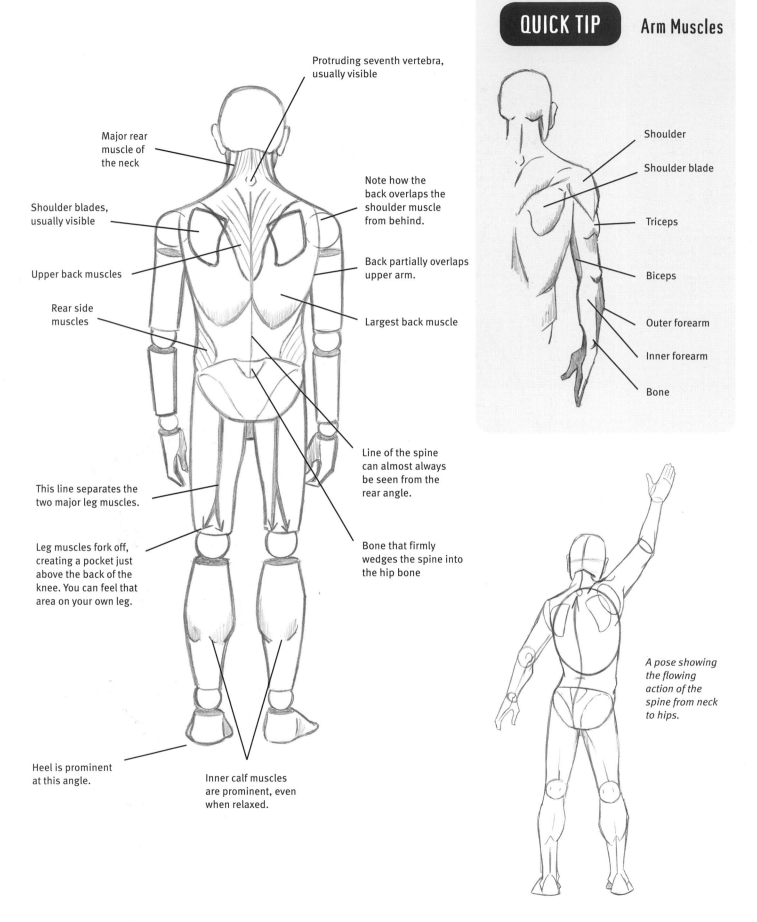

Protruding seventh vertebra, usually visible

Major rear muscle of the neck

Shoulder blades, usually visible

Upper back muscles

Rear side muscles

Note how the back overlaps the shoulder muscle from behind.

Back partially overlaps upper arm.

Largest back muscle

This line separates the two major leg muscles.

Leg muscles fork off, creating a pocket just above the back of the knee. You can feel that area on your own leg.

Line of the spine can almost always be seen from the rear angle.

Bone that firmly wedges the spine into the hip bone

Heel is prominent at this angle.

Inner calf muscles are prominent, even when relaxed.

QUICK TIP Arm Muscles

Shoulder

Shoulder blade

Triceps

Biceps

Outer forearm

Inner forearm

Bone

A pose showing the flowing action of the spine from neck to hips.

FEMALE ANATOMY

Front View — Female

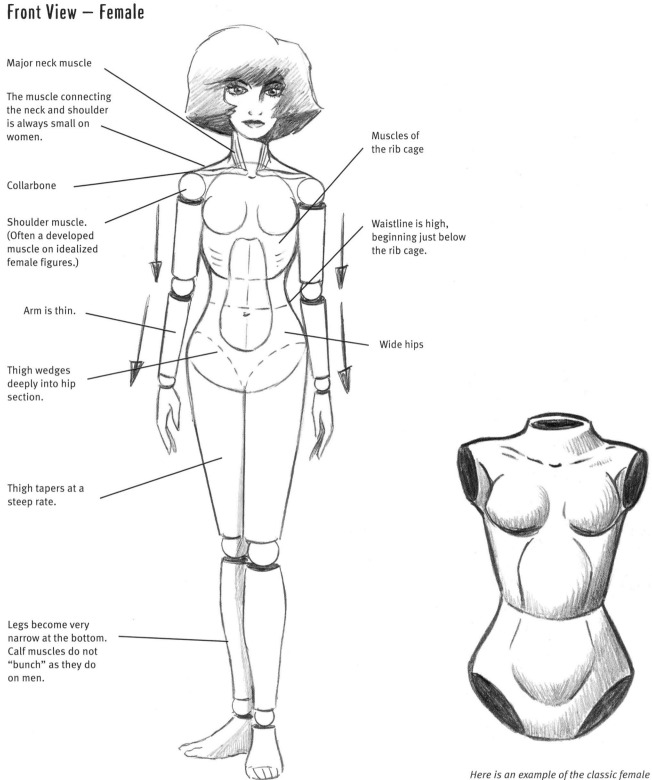

Major neck muscle

The muscle connecting the neck and shoulder is always small on women.

Collarbone

Shoulder muscle. (Often a developed muscle on idealized female figures.)

Arm is thin.

Thigh wedges deeply into hip section.

Thigh tapers at a steep rate.

Legs become very narrow at the bottom. Calf muscles do not "bunch" as they do on men.

Muscles of the rib cage

Waistline is high, beginning just below the rib cage.

Wide hips

Here is an example of the classic female torso. Shading has been applied to help in visualizing the form as three-dimensional.

Side View — Female

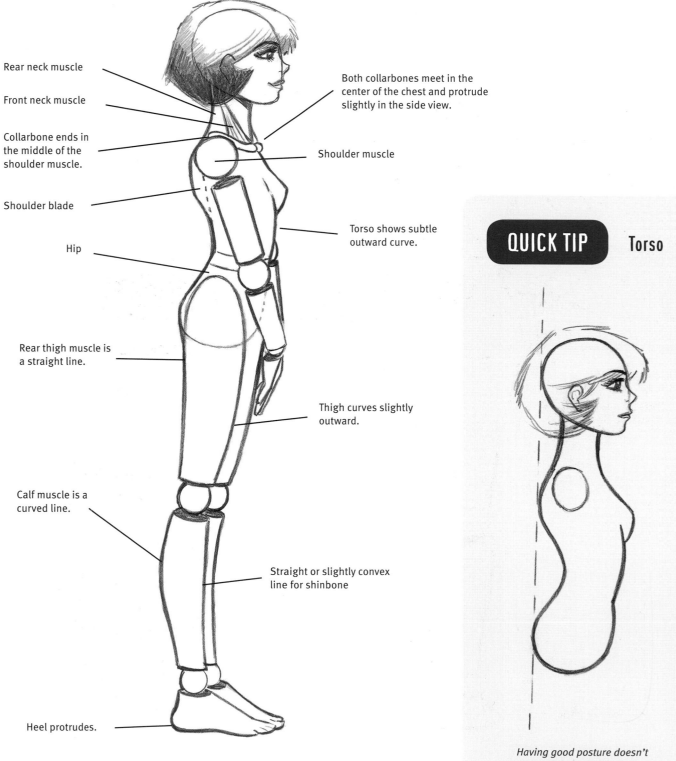

Rear neck muscle

Front neck muscle

Collarbone ends in the middle of the shoulder muscle.

Shoulder blade

Hip

Rear thigh muscle is a straight line.

Calf muscle is a curved line.

Heel protrudes.

Both collarbones meet in the center of the chest and protrude slightly in the side view.

Shoulder muscle

Torso shows subtle outward curve.

Thigh curves slightly outward.

Straight or slightly convex line for shinbone

QUICK TIP Torso

Having good posture doesn't necessarily mean having a straight back. It can also mean that the head is held up in a straight line, while the body retains its natural curves.

Rear View — Female

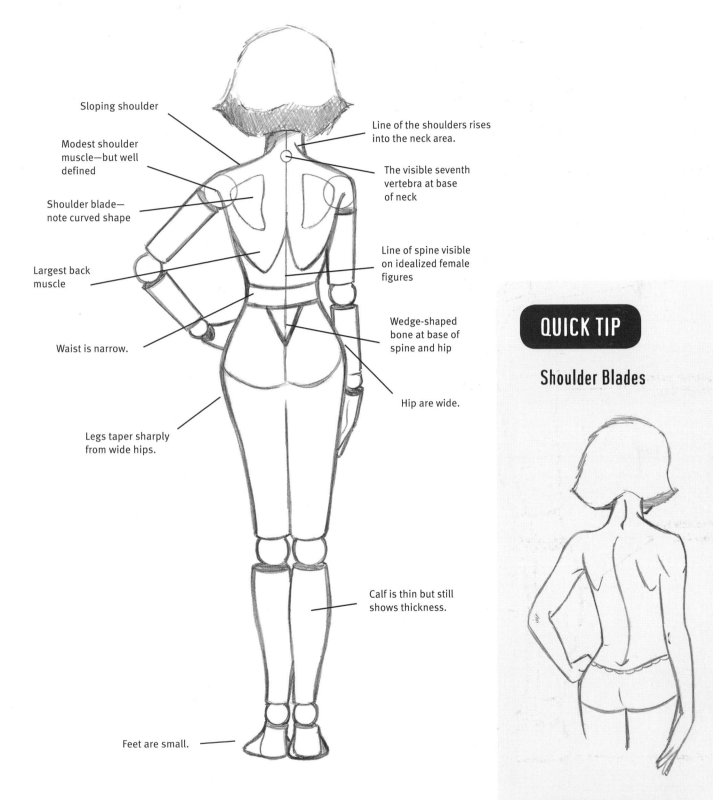

Sloping shoulder

Modest shoulder muscle—but well defined

Shoulder blade— note curved shape

Largest back muscle

Waist is narrow.

Legs taper sharply from wide hips.

Feet are small.

Line of the shoulders rises into the neck area.

The visible seventh vertebra at base of neck

Line of spine visible on idealized female figures

Wedge-shaped bone at base of spine and hip

Hip are wide.

Calf is thin but still shows thickness.

QUICK TIP

Shoulder Blades

Indicate the shoulder blades, the spine, and perhaps one or two indentations on the lower back to define a female back. But use a light touch in showing definition.

FIGURE DRAWING

A beginning artist might look at the following finished drawings and think, "I can't draw that!" But by now, you have acquired the awareness that the heavy lifting takes place in the early stages of the construction. And we've learned that the constructions are built on simple shapes that you can draw. Seen in this way, even complex drawings begin to reveal themselves.

Standing Pose — Side View — Male

To the untrained eye, drawing an effective standing pose seems like a mystery. But to the experienced artist, the answer lies in the dynamic posture. Most beginners don't see any dynamic forces at work in a standing profile; it looks static to them. Let's take a closer look.

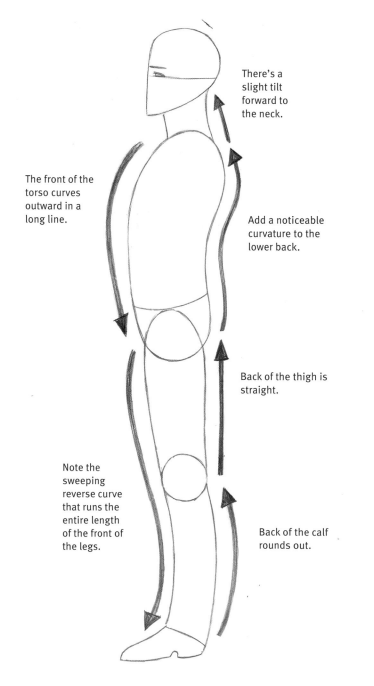

The front of the torso curves outward in a long line.

There's a slight tilt forward to the neck.

Add a noticeable curvature to the lower back.

Back of the thigh is straight.

Note the sweeping reverse curve that runs the entire length of the front of the legs.

Back of the calf rounds out.

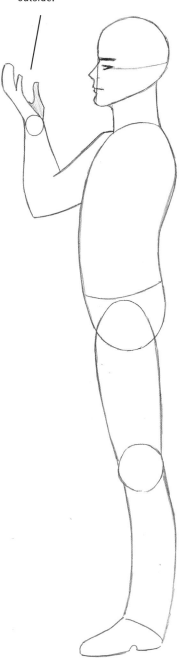

Arm is turned palm in. Thumb appears on the outside.

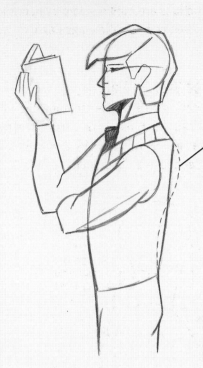

The dotted line represents the correct posture. The straight line is how many beginners draw the back in a side view.

Note how stiff and awkward a straight back will look on a finished figure.

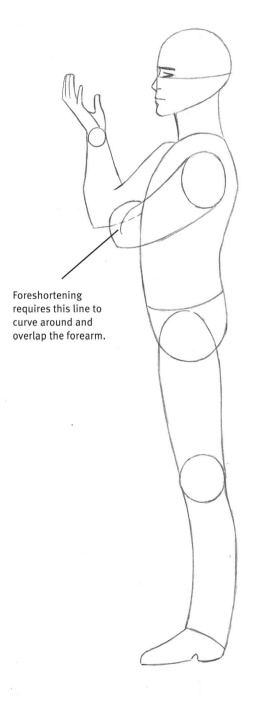

Foreshortening requires this line to curve around and overlap the forearm.

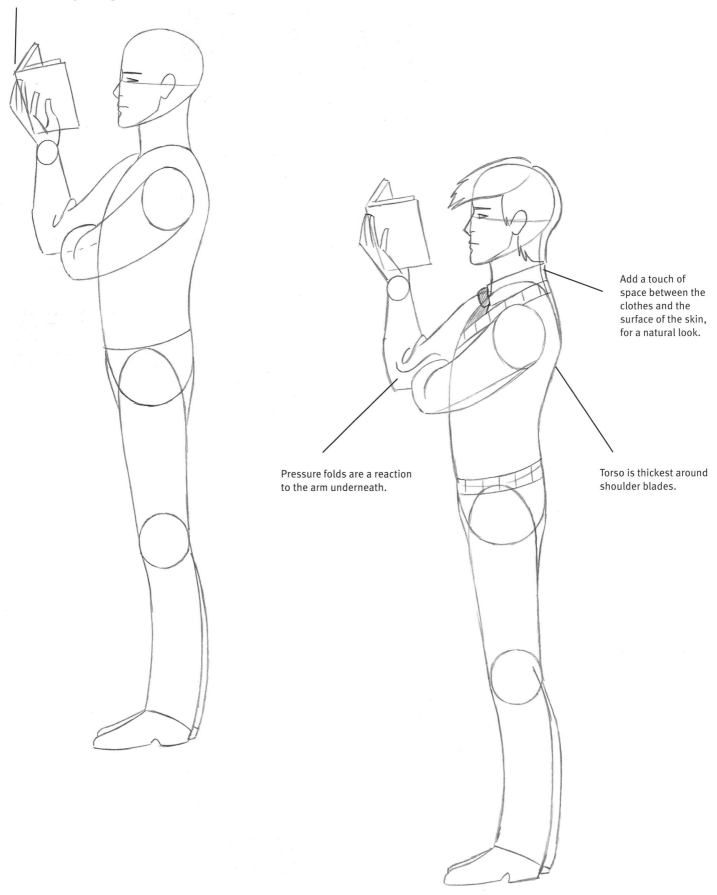

Position the book deep into the palm, so it appears as if the model is actually holding it.

Add a touch of space between the clothes and the surface of the skin, for a natural look.

Pressure folds are a reaction to the arm underneath.

Torso is thickest around shoulder blades.

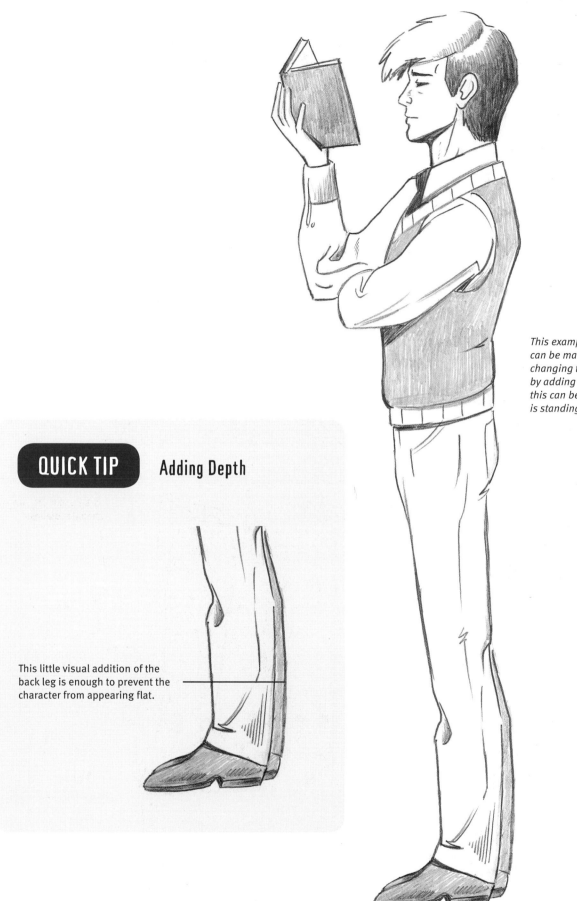

This example shows that any pose can be made to look natural not by changing the stance, necessarily, but by adding flow to the posture. And this can be done whether the subject is standing, sitting, or reclining.

QUICK TIP Adding Depth

This little visual addition of the back leg is enough to prevent the character from appearing flat.

Standing Pose — 3/4 View — Female

The 3/4 view of the figure is an excellent choice for portraying depth. At this angle, the body shows a near side and a far side. Placement of the centerline is essential in getting the pose right. The centerline also dictates the direction the body is facing.

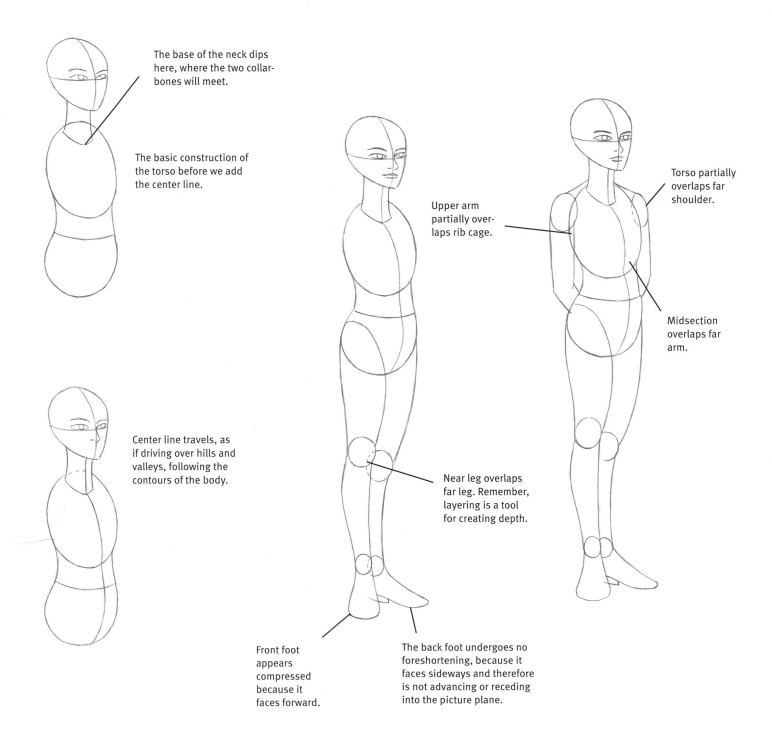

The base of the neck dips here, where the two collarbones will meet.

The basic construction of the torso before we add the center line.

Center line travels, as if driving over hills and valleys, following the contours of the body.

Upper arm partially overlaps rib cage.

Near leg overlaps far leg. Remember, layering is a tool for creating depth.

Front foot appears compressed because it faces forward.

The back foot undergoes no foreshortening, because it faces sideways and therefore is not advancing or receding into the picture plane.

Torso partially overlaps far shoulder.

Midsection overlaps far arm.

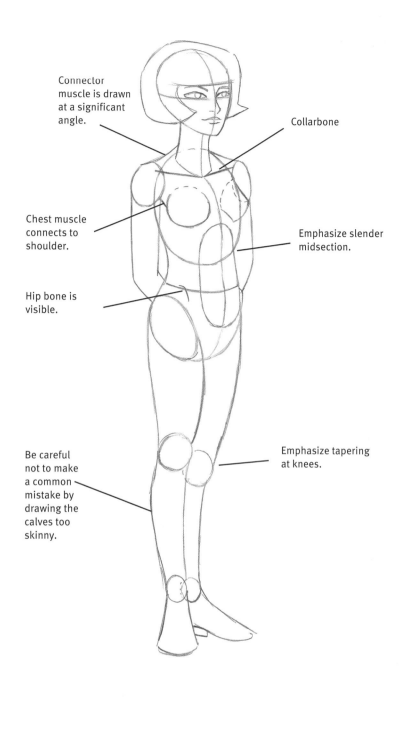

Connector muscle is drawn at a significant angle.

Collarbone

Chest muscle connects to shoulder.

Emphasize slender midsection.

Hip bone is visible.

Be careful not to make a common mistake by drawing the calves too skinny.

Emphasize tapering at knees.

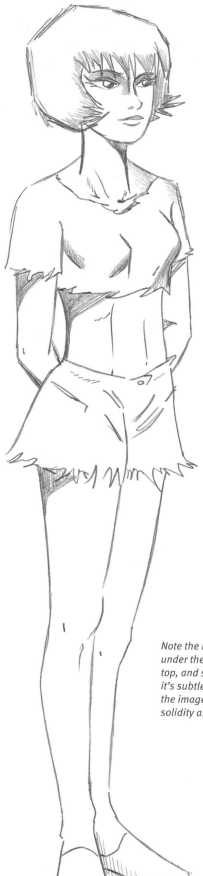

Note the use of cast shadows under the neck, sleeves, shirt top, and shorts. Even though it's subtle, it's important, as the image would otherwise lack solidity and impact.

Walking Pose — Side View — Male

Walking in midstride, hands in pockets, is a very natural pose. The shoulders are down, so he doesn't look tense or stiff. The upper body tilts forward. The extended leg always draws the tip of the foot back and appears to make contact with the ground, heel first.

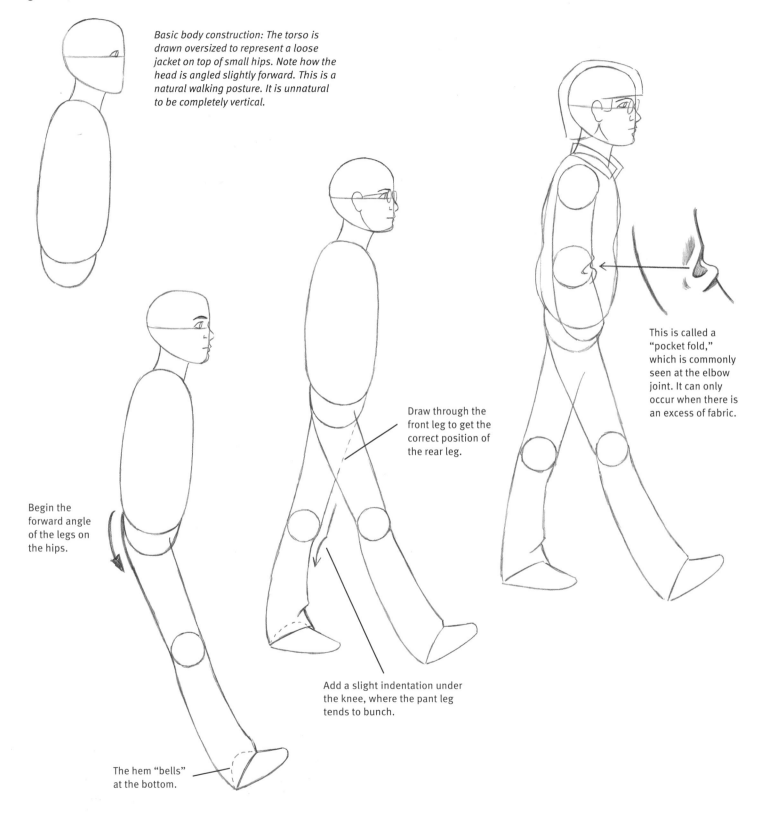

Basic body construction: The torso is drawn oversized to represent a loose jacket on top of small hips. Note how the head is angled slightly forward. This is a natural walking posture. It is unnatural to be completely vertical.

This is called a "pocket fold," which is commonly seen at the elbow joint. It can only occur when there is an excess of fabric.

Draw through the front leg to get the correct position of the rear leg.

Begin the forward angle of the legs on the hips.

Add a slight indentation under the knee, where the pant leg tends to bunch.

The hem "bells" at the bottom.

Angles of the Foot

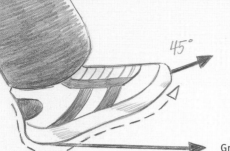

45°

Ground level

We're all aware that the instep of the foot, sneaker, or shoe is curved, with a significant arch. But did you know that the exterior of the foot is also drawn with a curved line? When the heel first makes contact with the ground, the toes point at a 45-degree angle.

Sometimes giving an image a little presence is as simple as adding areas of tone, such as the darkened slacks.

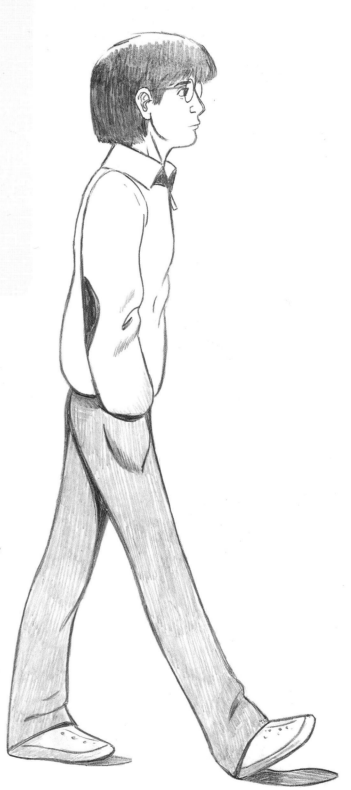

Walking Pose — 3/4 Rear View — Female

Here's an interesting angle for you to try. The body construction is standard—the challenge is in being able to visualize the perspective affecting the model.

Continue to use the center line to help clarify the construction. Now let's talk about how perspective affects this figure. She appears to be walking away from us. As a result, her left foot appears higher than her right foot. We also have to be mindful to keep a comfortable amount of space between both of her feet, or her stride will appear to mimic that of a tightrope walker.

Line indicates the plane of the back of the head.

Center line

Note the slender shape of the ear in the 3/4 rear view.

Do not place the leg too close to the center line.

REAR

Torso overlaps shoulder.

FRONT

Shoulder overlaps torso.

Allow the clothes room to breathe.

The hemline is curved, because the hem wraps around the torso, which is itself round.

The far foot is drawn higher than the near foot.

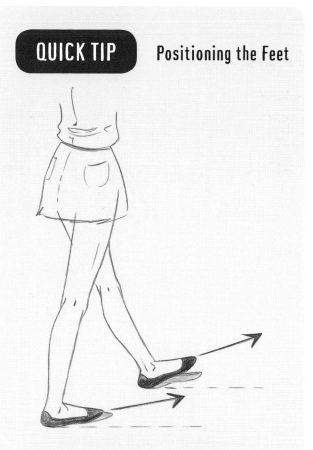

A 3/4 rear view is another way of saying "a view from behind." Therefore, both feet will point away from the viewer. Be careful not to allow the feet to slide back into a side view (the dotted line represents the angle a side view would take).

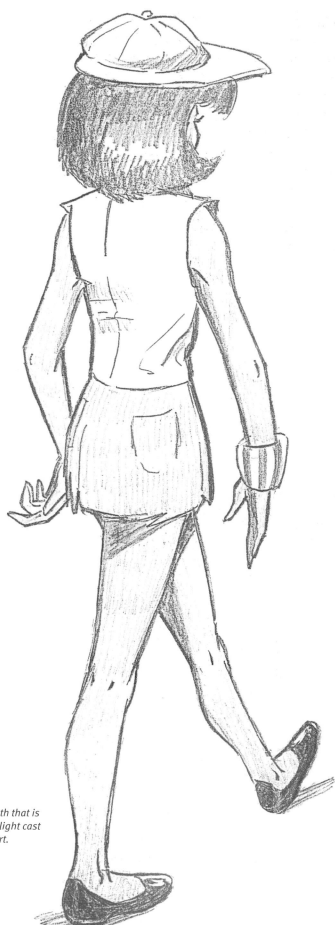

Note the sense of depth that is created by adding a slight cast shadow under the skirt.

Seated Pose with Foreshortening — Male

This is a pose many avoid because they have trouble drawing a knee in a front angle. It's understandable. It's hard to fake it. So let's learn the right technique, called *foreshortening*. Foreshortening is an artist's term that means compressing, or flattening out, an object, which is positioned as if it is coming toward you.

When you draw the leg, you'll have to resist every artist's normal impulse to draw too much. Foreshortening means severely truncating the leg, such as the thigh, which becomes nothing more than a mere oval.

The five techniques used to foreshorten the figure are these:
1. Drawing shapes that overlap other shapes
2. Drawing shapes within larger shapes
3. Drawing lines that overlap other lines
4. Enlarging the near section of the foreshortened object
5. Shortening the object

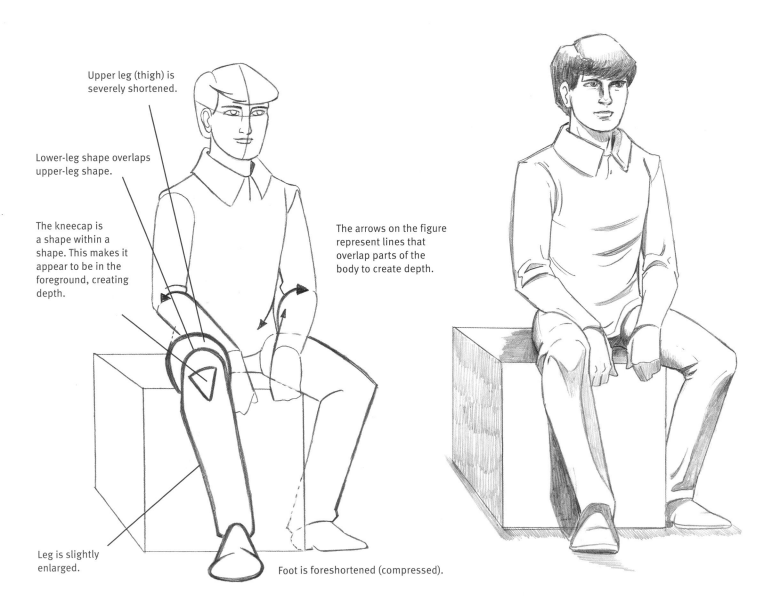

Upper leg (thigh) is severely shortened.

Lower-leg shape overlaps upper-leg shape.

The kneecap is a shape within a shape. This makes it appear to be in the foreground, creating depth.

The arrows on the figure represent lines that overlap parts of the body to create depth.

Leg is slightly enlarged.

Foot is foreshortened (compressed).

Seated Pose without Foreshortening — Female

This pose looks natural because we have avoided the artist's pitfall known as *twinning*. Twinning is when the arms or legs mirror each other in a pose. This can result in one leg appearing to hide behind the other, making the model look as if she has a missing limb! By moving the far knee up a few notches, the pose takes on an asymmetrical look.

The arms present no problem for us because they are spread apart and in no danger of masking one behind the other.

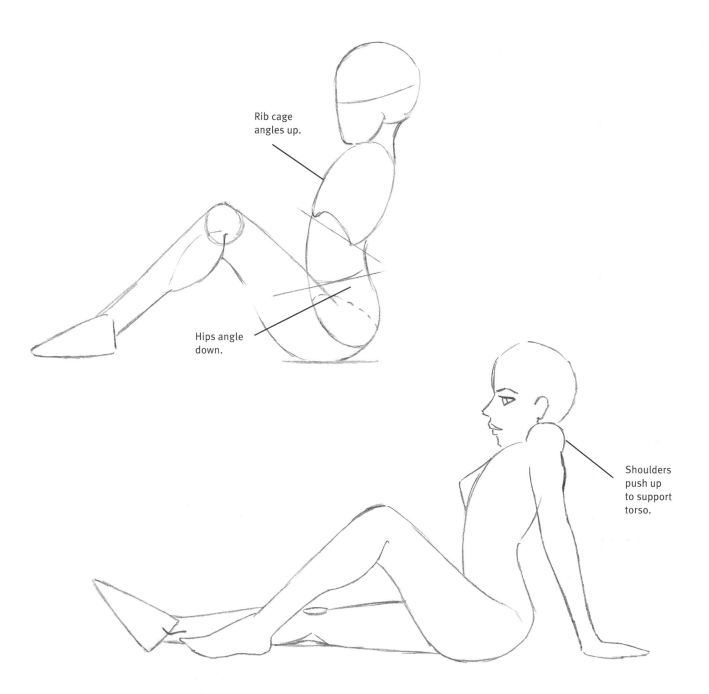

Rib cage
angles up.

Hips angle
down.

Shoulders
push up
to support
torso.

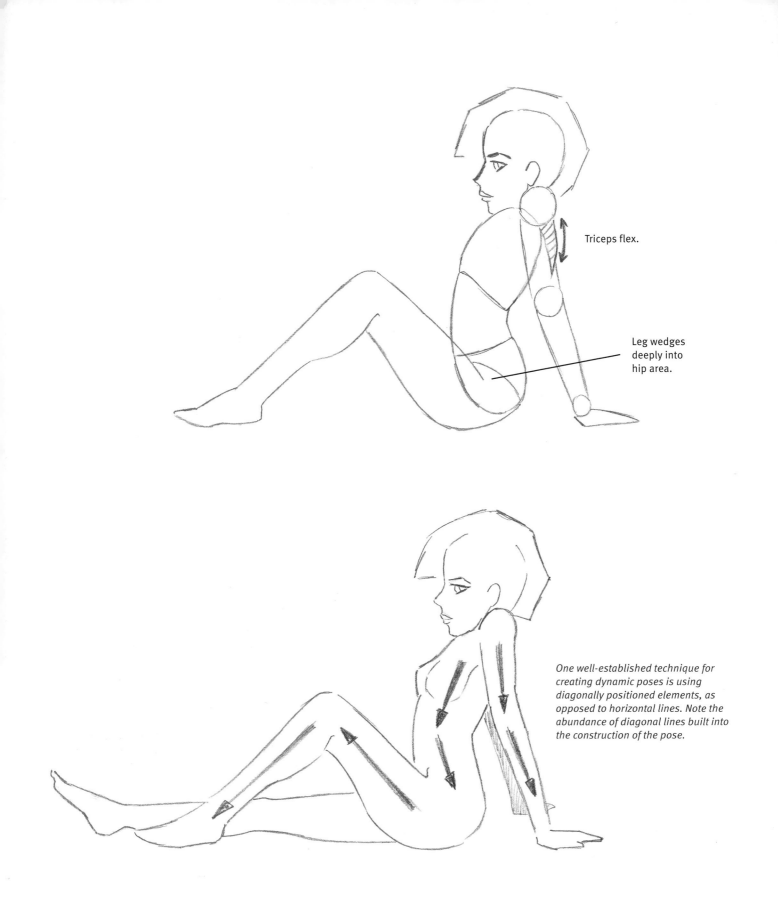

Triceps flex.

Leg wedges
deeply into
hip area.

*One well-established technique for
creating dynamic poses is using
diagonally positioned elements, as
opposed to horizontal lines. Note the
abundance of diagonal lines built into
the construction of the pose.*

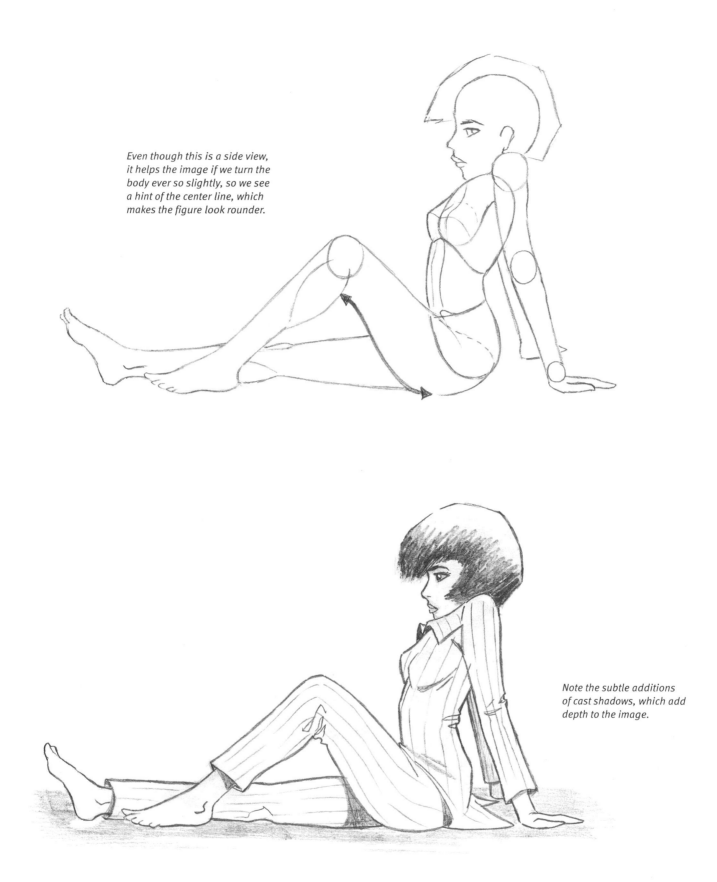

Even though this is a side view, it helps the image if we turn the body ever so slightly, so we see a hint of the center line, which makes the figure look rounder.

Note the subtle additions of cast shadows, which add depth to the image.

Reclined Pose — Female

This pose is fairly straightforward. However, it also includes some extreme fore-shortening at the arms, which needs to be handled correctly in order to appear effective. And surprisingly, that means simplifying it significantly.

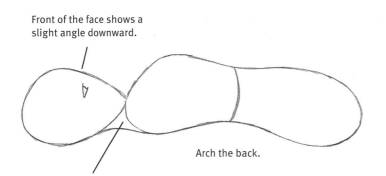

Front of the face shows a slight angle downward.

Arch the back.

Leave space here for the shoulder.

Eliminate forearm entirely.

Arm rises off the ground.

Shoulder protrudes significantly, and is drawn on the same level as the hips, which both make hard contact with the ground.

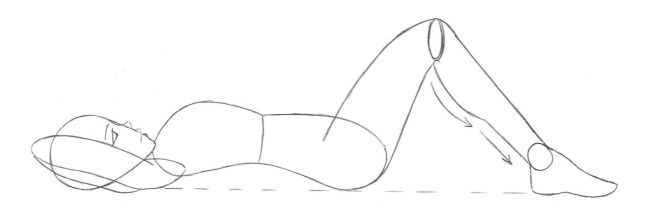

The dotted line indicates that the shoulder, hips, and foot all appear on the same level. Sometimes I'll even use a light sketch line to indicate the floor before I begin to draw the figure in order to ensure that my sketch keeps everything on the same plane.

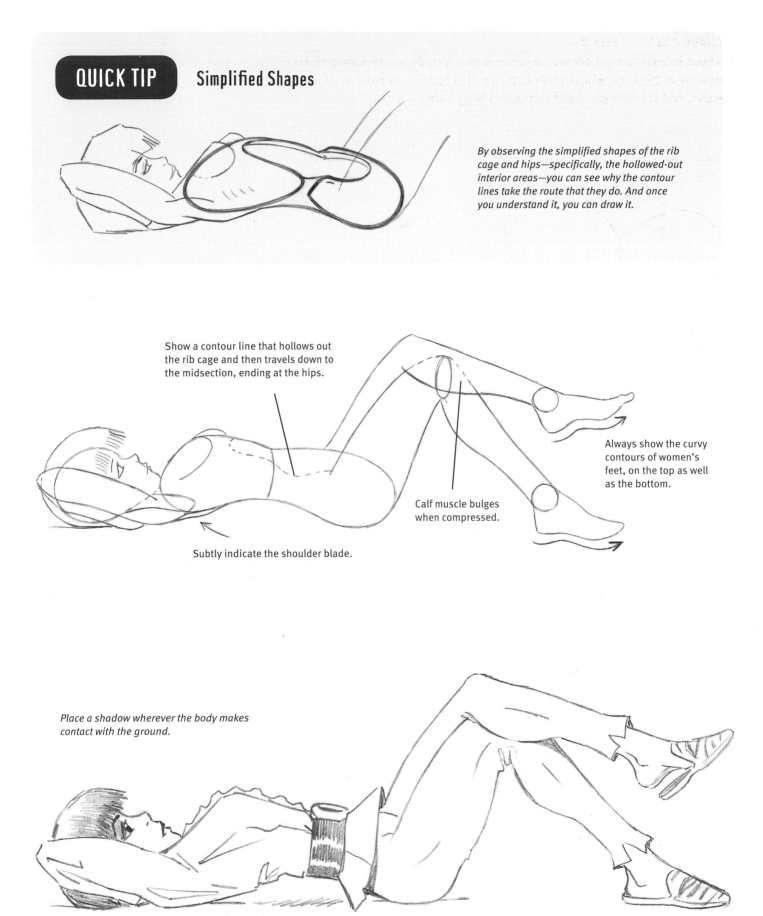

Simplified Shapes

By observing the simplified shapes of the rib cage and hips—specifically, the hollowed-out interior areas—you can see why the contour lines take the route that they do. And once you understand it, you can draw it.

Show a contour line that hollows out the rib cage and then travels down to the midsection, ending at the hips.

Always show the curvy contours of women's feet, on the top as well as the bottom.

Calf muscle bulges when compressed.

Subtly indicate the shoulder blade.

Place a shadow wherever the body makes contact with the ground.

PRACTICE: **Drawing a Dynamic Life Figure**

By adding a few new elements to your conventional figure, from interpretive shadows to an abstract background, you can produce artwork that is original, appealing, and creatively satisfying.

For our final figure, I've taken a dramatic pose and captured it at a key moment in time. The viewer senses that the figure cannot hold this pose, which creates a feeling of anticipation.

In order to evoke more from the subject, we'll apply expressive rather than literal shading. I've enlarged the shaded areas and connected them so that they bleed into one another.

Once that's done, I've blackened them, eliminating any shades of gray. The effect obliterates much of the line work, which then becomes implied rather than articulated. As a result, the figure attains a mythic, sun-scorched appearance.

You may choose to draw this as shown here, or without the interpretive effects, if you wish, which would result in a standard figure drawing. But perhaps you'd enjoy a third option: Consider coming up with your own interpretive shadows by imagining the light source on the upper left side of the page, instead of coming from the upper right side, where it is now.

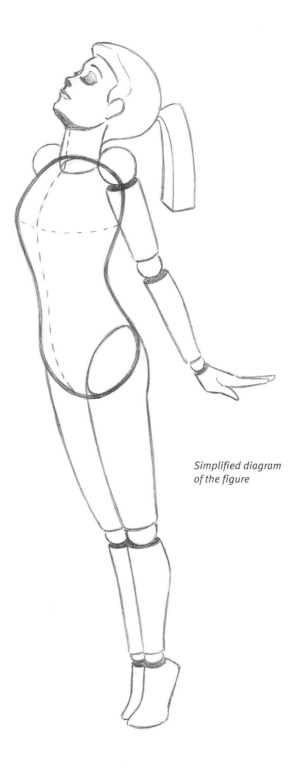

Simplified diagram of the figure

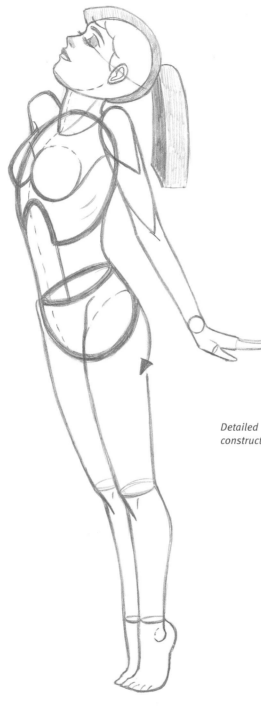

Detailed construction

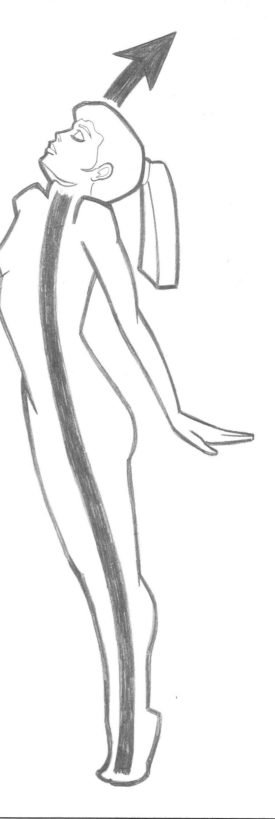

Note the natural "flow" of the pose (the classic "reverse curve").

QUICK TIP Building the Foot

Detail of the foot in position. Note the outward curve of the bridge of the foot. It's a feminine look.

Construction of the foot. Note that the bridge of the foot wedges into the top of the toes. The toes are drawn along a curved guideline.

Using only line work, outline where you would like the shadows to fall by generally following the contours of the body. Indicate other shadowed areas where the body blocks the light. To do this, you have to choose the position of the light source. I imagine that the light is coming from overhead, somewhere off to the right. That means the shadows on the body will be cast to the left.

By blending the shadows together, they do more than just serve a function; they actually become part of the design.

Index